Through the Wilderness

Through the Wilderness

My Journey of Redemption and
Healing in the American Wild

BRAD ORSTED

ST. MARTIN'S
PRESS
NEW YORK

First published in the United States by St. Martin's Press,
an imprint of St. Martin's Publishing Group

THROUGH THE WILDERNESS. Copyright © 2023 by Brad Orsted. All rights reserved. Printed
in the United States of America. For information, address St. Martin's Publishing Group,
120 Broadway, New York, NY 10271.

www.stmartins.com

Designed by Steven Seighman

Library of Congress Cataloging-in-Publication Data

Names: Orsted, Brad, author.
Title: Through the wilderness : my journey of redemption and healing in the
 American wild / Brad Orsted.
Description: First edition. | New York : St. Martin's Press, 2023. |
Identifiers: LCCN 2022058099 | ISBN 9781250284693 (hardcover) |
 ISBN 9781250284709 (ebook)
Subjects: LCSH: Orsted, Brad. | Wildlife photographers—United
 States—Biography. | Alcoholics—United States—Biography. | Parental
 grief. | Adventure therapy. | Grizzly bear. | Yellowstone National Park.
Classification: LCC TR140.O77 A3 2023 | DDC 778.9/32092 [B]—
 dc23/eng/20230203
LC record available at https://lccn.loc.gov/2022058099

Our books may be purchased in bulk for promotional, educational, or business use.
Please contact your local bookseller or the Macmillan Corporate and Premium
Sales Department at 1-800-221-7945, extension 5442, or by email at
MacmillanSpecialMarkets@macmillan.com.

First Edition: 2023

10 9 8 7 6 5 4 3 2 1

For Marley and Martha

Contents

HERE
AND
NOW

September 19, 2020

find myself, improbably, standing on a film set just north of Yellowstone National Park. I'm not here by accident, though I have struggled with impostor syndrome all morning. (*Or maybe it actually is an accident.*) I go back and forth with this. I marvel at how I got here, codirecting *The Beast of Our Time,* a short film about grizzlies and climate change that Jeff Bridges will narrate, a fact that pushes my excitement to near-clipping levels. I don't really want to confess how many times I've imagined him saying my name. The film is personal—about something so close to my heart, it may be what beats my heart.

Grizzlies are the only reason I'm still standing anywhere, let alone on this floor, crisscrossed with wires and littered with cameras, mics, and people. When my baby daughter, Marley, died ten years ago during her first overnight visit with my mother, I tried to die. I gave it everything I had at the time, which wasn't all that much, as I was one of the walking wounded. Or *staggering* wounded, to be more accurate. I poured whiskey on my open wounds and downed prescription pills like the Rust Belt drug addict I had become. I spent hours dreaming up suicide scenarios that provided

some respite to my tortured soul, but I never had the courage (or cowardice?) to really act them out. Through it all, I kept upright long enough to follow my grieving wife and older daughters out to Yellowstone in an attempt to start over. It was here in this sacred wilderness, when a chance grizzly encounter set me on the path to recovery, that I learned a thing or two about living.

Doug Peacock, world-renowned grizzly expert, is waiting for the scene to start. We have invaded his house and set up a full production crew to eavesdrop on Doug and his decades-long friend, poet Terry Tempest Williams, during a breakfast conversation. Both are celebrated authors and creative forces in their own rights. We're almost ready. The audio is running, and both cameras A and B are rolling.

I peer through the viewfinder for one last look. It's framed perfectly. Doug and Terry having coffee at the table, a string of red chilies hanging overhead, and an orange late-summer sun blazing through the window behind. I take another peek. *Is it perfect?* Doug starts to fidget. It will have to be. I nod to my codirector.

"Action!" she calls.

Terry begins. "We have become so calloused to loss in the face of climate change, and now COVID, that we rarely pause to mourn anymore—we just move on. Thousands of people dying every day, along with entire species, and we just shrug."

Doug nods.

A hot wind blows behind them as fires from the Pacific Northwest fill the valley with smoke. The vista looks like a Russell Chatham landscape and reminds us that climate change is right there. *Right here.*

Terry's words settle heavily, shrouding me in loss. The ten-year anniversary of losing Marley has just passed. This is something I carry with me, and I pause for a moment to mourn her again and

also to note that I survived the date intact. I was armed with sobriety, a clear mind, and a clean conscience. And most importantly, I knew firsthand the importance of pausing to mourn loss, sometimes a very long pause—in the wild. Ten years ago, just after Marley died, I thought it was as bad as it was ever going to get, because I didn't know, or couldn't imagine, the depths of hell yet to come.

"The single biggest threat to grizzly bears *is* climate change," I hear Doug say, and it snaps me out of my reverie. The fact that Doug Peacock has entrusted us to tell his fifty-years-in-the-making story of grizzly bears is both daunting and humbling—not unlike sharing the landscape with a grizzly. Bringing a visionary's vision to the screen is a tall task. I'm honored Doug has trusted me and thinks I'm up to the mission. Doug and I share a deep bond. Doug's memoir *Grizzly Years* recounted his return from Vietnam with PTSD so profound he could not talk to his mother. Doug came out here to Yellowstone to lose, then find, himself in the wilderness. My own story—the story of losing, then finding, Marley—follows a similar path.

"If we lose both the grizzlies and the wild . . . ," Doug says, taking a breath and letting the ominous thought hover unfinished. I check the angles again, hoping we're getting all the inserts and cutaways we will need in postproduction to edit the film. I slowly lean forward to look over our DP's shoulder and then step back one last time to get a sense of the big picture.

That's when it happens. I do what I told myself I would not do on this film. I start to cry. I instantly think of Marley and collect myself. Thinking of Marley used to be what made me cry; now it's how I center myself. I force the tears back and look around to see if anyone noticed. As it transpires, other people are blinking and eye-wiping, too. A few crew members have tears streaming down their faces because they don't have a free hand to stop them. It's

touching. With the lights in their faces, Doug and Terry cannot see the profound effect their narrative is having on the crew—but I can. Then the scene ends. The audio engineer requests thirty seconds of quiet for a room tone.

And just like that, there is complete silence. Even Oliver the cat acknowledges the aberration, panning the room for some indication as to why everyone went silent and still. We all hold our breaths in benediction and glance around the room at each other with half smiles. There's a shared knowledge that we just got a good scene, organic and powerful.

"That's a wrap," I say to everyone, and there's a collective exhale.

As the crew starts to break down their camera equipment and tripods, I can feel Marley here with me in the Peacocks' living room. She's been with me the entire time. Even when I was lost in a wilderness of grief and sorrow without her—she was with me. I was just too trapped inside myself to see or feel her. I stand amongst the flurry of activity and give thanks to my baby girl and the two orphaned grizzly bear cubs who let the wild into my heart, where it still beats today.

THEN

1

A Grizzly Conferment

Once again, I woke up shirtless and shivering on a plastic-covered love seat in the garage. It was early May 2012, and overnight temperatures were still only in the upper twenties. The night before, I had washed down a near-lethal combination of antidepressants and cheap vodka, trying to outrun the torment. When the vodka palsy kicked in and the garage began to spin, I took my shirt off and passed out face-first. I welcomed the oblivion: anything to help me forget that our little girl went to my mother's house a healthy toddler and came home in an urn.

Like so many of these mornings over the past two years, as soon as I opened my bloodshot eyes, I was overcome with dread. My core body temperature was dangerously low, and I had another vicious hangover to complement my guilt. As awakenings went, it was even worse than usual, exacerbated by a dream I didn't want to leave. I was in Marley's room, rocking her back to sleep. The faint moonlight edged through the window, illuminating the corners while she wrapped her little body around mine. Her gentle crying subsided into slow, deep breaths. I could smell her. I breathed her in. Her

death didn't really happen. It was only a slow, torturous dream. My relief was a living thing. Palpable and boundless. Then I began to shiver: I was waking up, realizing that holding her again—soothing her—was the dream. My life the nightmare.

I heard the school bus leave, so I knew Stacey and her girls—my stepdaughters, Chloe and Mazzy—were gone for the day. I had done this so many times, I doubted that Stacey even looked for me before leaving. I could now shamelessly go inside the house to privately attend to my sour stomach, frowsy bowels, and rancid mood. The dogs didn't even acknowledge my presence as I stepped inside. Was I already a ghost?

Opening the refrigerator, I spied five beers left in a six-pack purchased by someone with more restraint than I had. I contemplated them, then chose an apple juice, which I immediately threw up. In the bathroom, gagging over the toilet, I eyed my prescription bottles on the counter. What was I doing to myself and my family? I reached into my pocket for the same pitiful suicide note I'd written dozens of times in case I actually did overdose. But this time, instead of throwing it in the trash, I read it. Dry heaving there on the bathroom floor, a sinking feeling pinned me down as I read the drunken scrawls of a very sad man.

I had to get out. I had to get out now. Outside of this house. Outside of myself. Away from the pills and booze. Away from the looping hell inside my head. I had to do something—whatever that was. I was sick of the crumpled suicide notes in the trash, of my wife and surviving daughters watching me slowly kill myself. It was a day for movement. I would embrace nature and see where it led me. I didn't know exactly where I was going, except it was away from here.

I dressed hastily and raced out the front door. My eyes nearly closed as I was pelted with heavy raindrops. Pulling on a hat, I noticed the menacing black cloud that hung over the high bridge toward Blacktail Plateau. I climbed in my truck and headed toward

the steam coming off the travertine terraces in Upper Mammoth and Yellowstone National Park headquarters. After passing the Mammoth Hot Springs Hotel, I stopped at a crosswalk to let a group of tourists pass. Smiling, they hurried across the road. Even in the cold rain, they seemed happy to be in Yellowstone. Meanwhile, my head pounded, and I grimaced at life.

As much as Yellowstone and the new friends I was making were steering me toward a brighter future, dark clouds continued to roll in behind the blue skies. If something was beautiful, it reminded me of Marley. If something was sad, it reminded me of Marley. If there was a baby in a store, it reminded me of Marley. If there was a lavender sunrise, it reminded me there would be no more sunrises with Marley. Everywhere I turned and everything I experienced reminded me of losing Marley. I couldn't escape the pain. I didn't even want to escape it. Pain was all I had left of her. Hurting was better than forgetting.

I passed the upper terraces above Mammoth Hot Springs, driving on toward Norris Geyser Basin. The Mammoth–Norris road had only been open for a few weeks since the seasonal winter closure, so this would be mostly new terrain for me. As the road climbed south out of Mammoth Hot Springs, the long uphill straightaway quickly gave way to a series of hairpin turns that intersected a giant boulder field called the Hoodoos. If the upper terraces of Mammoth looked like the surface of another planet, the Hoodoos looked like that planet exploded. My already-queasy stomach spasmed in the curves, and when I glanced down the drop-off to my left, I began to wonder if there was a bathroom close by.

The higher I drove up the winding road, the harder it began to rain, and the sky became a dark slate gray. It looked like the canyon up ahead was socked in with a thick fog as cars coming from that direction had their headlights on and windshield wipers going full blast. I was feeling more nauseated with every curve, and

by the time I hit the canyon, I was regretting this drive. I could feel my blood pressure rising and blood sugar dropping because of the previous night's binge. The combination produced a dizzying, disoriented effect with painful stomach cramps. Upon entering the canyon, I felt like I might need to pull over and pass out.

A cataclysmic, volcanic eruption had formed the Golden Gate of Yellowstone. When the superheated ash and pumice cooled, it formed a welded tuff of multicolored "golden" rocks. Driving up this treacherous stretch of road, now completely absorbed in a soupy fog with a pounding rain turning to what sounded like hail on the roof of my truck, I felt like something cataclysmic was about to happen right then.

Beyond the last curve of the tight, rocky pinch of the canyon, the road flattened out onto a broad valley floor. The new view was, by contrast, a wide-open glacially carved basin with dense, knee-high plant life and pockets of timber. Just a few hundred feet higher in elevation and the weather changed dramatically. The storm was now moving off to the east. Glancing to the west, I could see blue skies peeking out behind the docile, parting gray clouds. I didn't know where I was going, but it felt good to turn the windshield wipers off and crack the window as I peered out onto the misty wetlands of Swan Lake Flats.

The air coming in the window was heavy and wet with a boggy, earthen smell. Scanning to the left and to the right, I observed that the valley floor was a lush and silvery-green sage steppe. Rabbitbrush thrived between the mountain big sagebrush and ground cover. Solitary pockets of Idaho fescue rose like tufts of unruly hair. I passed Swan Lake, still mostly shrouded in misty remnants. Right above me and to the east, there were lightning strikes in the retreating storm and random rain squalls in the distance. The sun that I couldn't yet see was already high on the snowy peaks behind the façade of the valley. The view seemed strikingly different in

every direction the farther I drove. It seemed a cruel joke to be surrounded by all this awe-inspiring wilderness and be too goddamn defective to appreciate it.

A marsh hawk flew low and irregularly out the passenger's window, and my mind drifted back to the tragedy. Images of Marley flashed through my head. From her birth to her only birthday, and to her death. That image of her lying on the hospital bed, ashen, with all the blue gone from her eyes, looped over and over in my head. I knew I couldn't go on living every day like this. It had been almost two years since we lost Marley, but in the part of my soul where I held her, it was as fresh as the morning rain.

Right after Marley died, I could still smell her in her room and in her bedding. Then one day, I couldn't smell her anymore. For weeks after her funeral, I swore I could hear her around the house; then one day, I couldn't hear her anymore. Marley was a bluebird in my heart, and when she flew away, the pain was astounding. There was nothing left to grab hold of except sheets that didn't smell like her anymore and tiny socks in random loads of laundry. That was it. Our baby was gone from this world forever, robbed of her life. All we had left were too few memories, some photos, and the constant and never-ending sadness that comes from losing a child.

Our loss and grief were compounded by unanswered questions. Or one question, mostly. How did Marley die? We had given up on getting answers from my mom. She wouldn't or couldn't—we didn't know which—say what had happened. How had Marley gone to my mom's house on her first overnight visit and just died? While she told me nothing—literally nothing—she made up for it by telling the investigating detectives several versions of what happened to Marley, convoluting an already unfathomable and bizarre situation. We had originally hoped that the autopsy would tell us, but the results were inconclusive. Marley had been deceased for hours when paramedics arrived, yet *Mom didn't even explain that.* All we

wanted was the truth so we could somehow try to understand. Heal and move on. Or try to. The county decided to charge her with a series of misdemeanors, including lying to investigators. They also sought restitution for all the time they wasted running down her lies. She eventually took a plea deal to one count of filing a false police report, a class A misdemeanor.

We believed that because my stepdad was an officer of the court and my mother had retired from the county that was investigating her, inside efforts were being taken to protect her. It seemed the detectives were hitting internal walls that shouldn't be there if this was a tragic accident. If this was indeed an accident, why all the secrecy, hiding behind an attorney and refusing to speak to Stacey or me? *Was* this an accident? The place in my heart that hurt for my mother was bleeding out. I lost not only my daughter but my mother that dreadful afternoon. Just when I thought I could finally have a mother.

Mom had been physically and psychologically abusive when I was young. But both my sister and I thought she had changed. She had made seemingly sincere efforts to be a loving mother-in-law to Stacey and a loving grandmother to Chloe and Mazzy, and then to Marley when she was born. I finally had a family, the kind I had always wanted. I loved my mom, but my misplaced trust and naiveté cost Marley her life, caused my wife—the woman I loved and who loved me back in the most profound way—immeasurable pain, hurt her girls—our girls—and hurt Stacey's extended family.

Inconceivably, Mom never reached out to me to say how sorry she was, to tell me that she loved Marley and was heartbroken: that she loved me and was so sorry to be the source of my pain. She didn't tell me what happened when I saw her at the hospital. She didn't tell me what happened when I called her in the days after Marley died. Finally, she wouldn't take my calls.

I had trusted her, so I was responsible.

These were the demons I fought with alcohol at first, then with alcohol and prescription drugs, and eventually with alcohol, drugs, and detailed fantasies of suicide. I did my very best to drown every part of me that felt anything. A pending insurance claim to cover our mounting medical bills was a constant reminder that Stacey and I would have to relive this terror several more times. This was like some unbelievable crime show I might have watched before bed without thinking about twice. Now, that unreal show was my life, and there was no turning it off.

The grief was stifling, but at least it connected me to Marley. My growing anger and guilt connected me to nothing except more anger and more guilt. I felt pushed into a void. The best moments would find me in a dark and dreary forest of uncertain doom where I knew my death was imminent. But if I was going out, I was going to take the person I felt was responsible for Marley's death, too: my mother.

That's what I had come to, plotting to kill my mother, then myself.

Some days, plotting this sinister mission was the only thing that kept me going. If I could only sober up for a few days, then I could exact retribution.

I planned to go to Indiana, confront my mother, and play it from there. That is where the plan clouded up. What would I do? Kill us both right there on her porch? And how? Every time I tried to imagine it, I wondered what the hell was wrong with me. How was this my life? I felt possessed, and then I drank more. Deep down, I think I knew that it was deranged to spend untold hours plotting to kill my mother to avenge my daughter's death, but to my drugged, drunk, and post-traumatic-stress-disordered psyche, it seemed a reasonable path, a good solution.

On a dark and rainy night, the mixture of cheap vodka and benzodiazepines started to blur my vision, and I felt like I was going to

pass out. I headed for the recesses of the basement, nauseated and hoping to never wake up. I fell, missing the mattress, landing on the concrete floor and hitting my head and shoulder. As the darkness appeared at the edges of my vision, vomit filled my mouth and my eyes closed.

This sure path to destruction—self or other—was halted, however, the day Stacey found one of my suicide notes and called 911. The paramedics and police arrived at the house and tried to take me in for "observation." I absolutely refused, explaining that I had been very drunk and upset but that now I was only slightly drunk and making better decisions.

The police said that if I didn't go willingly, they would place me in custody, charge me, and then take me to the psychiatric ward in handcuffs. In the garage, with the police giving me a choice between a rock and a hard place, I scanned for a possible weapon I could use to make my last stand. Semi-drunkenly attacking two trained, athletic police officers with a green plastic leaf rake seemed a poor choice and maybe a great way to get my ass kicked before going to jail. So I acquiesced and allowed them to escort me to the hospital.

I ended up under suicide watch in Holland Hospital. In truth, my desire to die was complicated, and I had plenty of time to think about it in the psych ward. First, it was in direct opposition to my belief that I *deserved* an earthly life, chafed by a bloody hair shirt, however much I wanted to escape it. Second, my suicide fantasies all ended up with finding Marley. And had I ever been certain that death would take me to her, I would have been on my way.

I spent most of a week there being monitored, given new antidepressants, and participating in group therapy—which, on a psychiatric ward, seemed to be neither group nor therapy since everyone was heavily sedated. One day, I was in the lounge and snack area,

numb from the drugs, eating crackers with cheese and mustard, while Chopin played in the background.

"If everyone is ready, we can start our session," declared a bespectacled nurse as he entered the room unannounced. Apart from me, "everyone" included Samantha, a despondent woman of seventy, clad in a well-worn red robe, a girl in her midtwenties, hiding under a black hoodie, and an exceptionally skinny kid, maybe sixteen years old. He sat in a lounge chair with his legs tucked under him like a bird, nervously tapping his fingers on the arm of the chair. No one acknowledged the nurse.

"If everyone could gather around the table where Brad and Samantha are seated, that would be great." No one moved. Not a muscle. Not an inch, except for the kid and his incessant tapping.

"I think they're as ready as they're going to get," I said with a mouthful of crackers.

"Okay," the nurse said with a deep breath, "let's try this again, and everyone can just stay where they're at." Once again, no one besides me even acknowledged he was in the room. I didn't know if this was them sedated or this was them needing medication. All I knew was the pharmaceutical concoction they were giving *me* made me feel like my head was a distant array of tiny bubbles, and my stomach was a ravenous pit.

The nurse asked us to color a picture of our feelings. Samantha eyed the Crayola box, but no one made a move for the crayons or paper, so I decided to replenish my empty plate of snacks. The nurse eventually left the room, throwing his hands up as he walked into the hallway. Samantha knocked the crayons and paper off the table with one swipe while the girl stared out the window, the kid fidgeted, and I munched, nodding along to the Chopin coming from the overhead speakers.

I continued going through the motions at the hospital. I knew

there were things I was supposed to say while under their care, then the doctors would say what they had to, then we would part ways and both pretend like I wasn't going to jump off a bridge someday. I think the lead psychiatrist may have sensed my defiance, my refusal to be helped, but he couldn't be tough with me. He cried when I told him the story. Just like every counselor and therapist I had seen up to that point, and in the years to come.

But I didn't want their sympathy—I wanted answers. The fact that each of them cried reinforced for me that I was fucked. I think they cried because it was so tremendously sad but also because they had an inkling of what the rest of my life looked like, and they knew the prognosis was not good. I played along, said I would go to AA, said I would continue getting help, promised to take my medication, blah blah blah. I wanted out of this annoying distraction so I could focus on finding out what happened to Marley or taking matters into my own hands. I talked my way off the mental ward with some new pills and the wherewithal to tighten up my game.

My drinking did not slow, nor did my game tighten. After leaving the psychiatric ward and one hundred days from the date of Marley's death, I received my first-ever DUI. Now I had lost my license, what was left of my pride, and any tiny hope that things would ever get better. No license meant no work—not that I had much. I was trying to maintain my small house-painting business, but work was scarce. That meant more time to drink during an already depressing midwestern winter. I was at least being preemptive with my new court case. I consulted an attorney, went to AA meetings, and made sure to grudgingly get my paper signed as proof I was there. I also checked out some rehab facilities online and did my best to show I was serious, but on the inside, I was a trauma hostage.

There were days and even multiple days in a row when I wouldn't get shit-faced drunk, but eventually, the longer the sobriety, the harder the binge when I relapsed. I tried to hide the relapses from

my family and only drink in the garage or in the basement, but they knew. My lack of presence at the dinner table, decreased family time, and slurred speech when I surfaced told the tale.

We both knew we had to leave Holland, Michigan, but it was Stacey who found a potential job in Yellowstone. We had come before as a family. When Marley was four months old, we took a road trip to Montana to pick up the girls from their dad's house, where they had been on summer vacation. We drove north through the Upper Peninsula of Michigan and then west along Highway 2, a.k.a. the Fudge Highway. At one time, the Upper Peninsula was so famous for its fudge that people would load up before they departed. As a result, the immediate stretch of Highway 2 heading west from the UP would be scattered with fudge wrappers. Leaving Michigan behind, we grabbed the high line and headed for Montana.

We went to Glacier National Park and tent camped near Lake McDonald in late August. Upon waking the next morning, I went to urinate a few feet into the woods behind our tent and found a fresh pile of grizzly bear scat full of seeds. We hiked to Bowman Lake with little Marley in her BabyBjörn, and she watched everything as always. Later, at the top of Logan Pass, I heard two elderly ladies ask someone if they had seen that beautiful little baby bear by the parking lot. I ran in that direction with my camera expecting to see a grizzly cub and instead found Stacey holding Marley in her bear onesie surrounded by admirers.

The girls joined us in Missoula, and our family of five headed south toward Yellowstone National Park. We entered through West Yellowstone, Montana, and made our way to Bridge Bay Campground. It was early September, but the cold, uninviting gray sky over Yellowstone Lake and our campsite felt more like early November. It was great to spread out, set up our tent, start a fire, and see Chloe and Mazzy give Marley center stage. Both girls wanted to hold, feed, love, take pictures with, and attend to Marley's every

whim at our little campsite under the thunderheads. We grilled hamburgers, happy to all be together again before a cold rain at dusk drove us into the tent.

That night in the tent as the cold rain turned to sleet, Stacey had to sleep with Marley's bottle in their sleeping bag to keep it from freezing. We began our August vacation with the heat and bugs of the Upper Peninsula and ended with frosty nights at 7,800 feet in Wyoming. Marley's first road trip at four months old had covered ten states, two national parks, and nearly 2,500 miles. The girls needed to get back for school, so on a chilly, gray morning, we packed it all up and headed home for Michigan.

I was finally back in Yellowstone—but without Marley.

The memories tightened my chest and shallowed my breaths so much, I started to hyperventilate. The edges of my vision blurred when I noticed a raven sitting in a tree near a pullout ahead. The raven glanced my way and flew off as I pulled my truck into the lot and killed the engine. Closing my eyes, I tried to focus on my breathing and calm myself back down. I should have brought my prescriptions that supposedly helped with anxiety and panic attacks, although I was so sick to my stomach, I doubted I could keep anything down.

When I opened my eyes, I saw a mountain bluebird sitting on a freshly mounded pile of bison shit. When the bluebird flew off, my gaze followed him a bit, then branched off to the sweeping sea of wet, greening sagebrush along the valley floor that sloped up to a sparsely wooded ridgeline spotted with elk. The layout was a classically carved U shape that boasted of receding glaciers. I wondered how far it was as the crow flies over those snowy peaks in the distance and to the next parallel road. How long would it take to walk there from here? Hours? Days? Weeks? I had no concept of where

I was or how far it could be to civilization if I just started walking toward those sunlit spots on the far-off mountains.

Stepping from my truck, I shivered and looked around. The temperature at seven thousand feet above sea level was much cooler than even in Lower Mammoth. I could see my breath as I panned around in every direction, trying to get my bearings. The cool, marshy air started creeping in around my neck and ankles and up my back. As I started to shiver from the cold, I became acutely aware of my hangover. I'd rushed out of the house so abruptly that I'd neglected to grab extra clothing or supplies. I might have bottled water somewhere in the truck, but what I really wanted was some food for my stomach or a beer for my nerves.

It was then, without plan or provision, I started walking into the verdure, toward the ridgeline in front of me and the snowcapped peaks behind it. There was no trail underfoot, and I had no particular destination in mind. Just a compelling urge to start walking toward the sunlight with the foul ferment of last night's storm receding behind me. My legs seemed to move of their own accord, powered by something not of me. Stepping into the sage, it was as if muscle memory had been turned on and the rest of me was just along for the ride.

A few swift strides into the meadow and my pants were soaked from the knees down. Another hundred feet in and the glistening sagebrush became waist high, making the going much more difficult. I could feel my bootlaces snagging on low branches and coming untied as I stumbled along. Now I was wet and cold from the waist down and breathing hard. My pants were so heavy with rainwater, I had to use one hand to hold them up while I picked my way through the rugged maze.

Even though I was soaked, chilled, and peaked, the morning sun was pleasant on my shoulders as I closed the distance to the first ridgeline. I paused to retie my boots and cinch my belt when

I noticed something brownish move through the lush sage in the distance. A contour that didn't fit the landscape. I caught only a fleeting glimpse of it across the varied terrain, but with elk on the slope directly above me, I figured it must be part of the larger herd.

My tongue felt like an anaphylactic caterpillar, so I tried slurping water off the sage sprigs that drooped with golden dew in the morning light. The moisture was immediately absorbed into my dehydrated mouth tissue. It left a pleasant taste that seemed like a natural antiseptic. Immediate needs met, I took a deep breath and started bushwhacking my way toward the upcoming incline.

After another few hundred yards of struggling through the miniature forest of sage, my mind, as always, boomeranged back to the tragedy. I couldn't break the cycle. No matter where I was or what I was doing, for the past two years, this had been my life. The moment anything gave me a budding joy or distraction, the guilt would creep in and scorch the new growth. Maybe I would get lucky and die back here, I thought. The birds and the bears could consume me and shit me out somewhere beautiful. It all seemed so poetic and fitting.

Then it lifted its head. That brownish thing in the distance I thought was an elk was now much, much closer with its head up, looking directly at me. *Oh shit, that's a bear,* I thought, stopping in my tracks. *Oh fuck, that's a grizzly bear!* My heart gave one hard, out-of-rhythm beat—momentarily forgetting what to do—then began pounding furiously as if to make up for it. The cardiac aberration caused me to gasp as I realized exactly what I had done.

In the throes of my woe-is-me pity party, I had accidentally wandered upon a grizzly bear doing whatever grizzly bears do at 9:00 a.m. on a Tuesday in May. We locked gazes. The bear turned sideways to me and let out a huff. I stood frozen in terror. I'd read all the books and even proclaimed to know something about grizzlies, from a safe distance. But this was very different. This bear was way

too close with nothing between us except sagebrush and destiny. It could be on me in seconds, yet it didn't seem alarmed. Nor did it seem interested in either my trivial book knowledge of grizzlies or my current predicament.

I had seen several grizzly bears hundreds of yards out while playing roadside expert to trusting tourists, but this was close. The bear's dark brown coat was completely soaked and matted from the night's steady rain. The hair on its forehead ran in wet channels, and there was mud all over the end of its snout. The bear raised its head and articulated its lips like it was tasting the air and stomped both of its back feet on the ground one after the other while exhaling. With its classic dish face and massive hump of muscle between its shoulders, there was no mistaking that this was a grizzly bear, and I had just invaded its space.

Then, unceremoniously, the grizzly lowered its head and proceeded in the same direction as when it first noticed me. Just like that, the bear disappeared back into the waist-high Wyoming big sage and out of view. I still couldn't move. The adrenaline dump into my system had ramped up my heart rate but made my legs feel like wet marshmallows. Staring off toward the swale where the grizzly disappeared, I could occasionally see the bear's great silvery-brown hump surface like a dorsal fin in a sea of glistening spring sagebrush. Then it was gone. No matter how hard I squinted, all I saw was the increasing waves of heat rising off the valley floor as the morning sun now broke over the remnants of the passing storm clouds.

Feeling like the immediate danger had passed, as long as I stood there for a little while, I started processing what had just happened. The sun was now burning off what was left of the morning fog, but all I could see was that bear's face. Then that bear's face juxtaposed over the image of Marley's face. I could actually feel the memory being created. The image I kept seeing of Marley's face in her bear

onesie was like a transparency over the face of the bear I just saw all too closely. Tears welled up in my eyes, and I felt nauseated again. My ears started buzzing like there were cicadas at dusk living in my head.

I began to emit a sound somewhere between a burp and a moan. Standing there soaked from the waist down and shivering in grizzly country, I laughed until tears streamed down my face. Maybe it was the inappropriate reaction to a dangerous situation by a shock victim or someone who didn't give a fuck anymore, but I laughed and cried until I made snot bubbles. That grizzly bear was so close I could see the whites of its eyes when it turned sideways, dropped its head, and looked right through me. Maybe I was too pathetic-looking to be a threat to the bear or it feared contracting some disease from me, but it simply walked away like our meeting was no big deal. The same would never be true for me.

Swooning and blubbering in the meadow, I realized two things: I never wanted to be that close to a grizzly bear again, and I definitely did not want to be consumed and shit out somewhere beautiful.

As my wild encounter sank in, a series of terrifying thoughts occurred to me. What if that bear was circling back for me? If there was one grizzly out here, couldn't there be two? Or more? What if there was something already dead out here in the swamp, and I was in the valley of the grizzlies? My forced death-march to the snowy peaks would have to wait until another day. Seeing anything discernible in the direction the bear disappeared was now nearly impossible with the sun fully up and unfettered by clouds. I felt very small and insignificant, yet strangely alive, surrounded by wilderness with a grizzly bear roaming nearby.

I turned around to look for my truck when I noticed the yarrow, biscuit-root, and what looked like sticky geraniums growing around me. On closer inspection, I realized there were shooting

stars, lupine, and larkspur all thriving in the shadow of the twisted sagebrush. I hadn't noticed any of these on the way out while I fussed with my boots and pants. I felt bad that I had probably trampled several wildflowers, being off-trail and clueless. My truck was a dot in the distance, and with the unfiltered sun now warming things up quickly, I decided to take my chances and walk the same course back. When I realized I'd missed not only wildflowers all around me but a grizzly bear rooting within a long stone's throw, I wondered what else I'd missed while trapped in my grief.

The sweat poured off me as I moved hurriedly to the road and my truck. The realization that I had absentmindedly walked into an area I *knew* to contain grizzly bears washed over me. This was wild country, and it didn't give two shits about my tragedy. I scanned in every direction as I hurried along. That feeling of being completely insignificant, and now exposed, welled up inside of me again as I hustled, panicked, to the safety of my truck.

The closer I got to the parking lot, the thinner and shorter the vegetation became until I was walking freely with nothing to impede my steps. Reaching my truck, I looked down to see both boots untied and my down jacket ripped in two places. I was soggy, covered in some kind of Velcro seedpods, and quivering, seriously booze-sick, but I also felt exhilarated and even a bit elated. Watching a mating pair of sandhill cranes fly over the marsh and call out like pterodactyls, I also realized how lucky I was the grizzly bear kept moving.

I found bottled water on the truck floor and drank it in one long gulp, hoping it would stay down. Staring out onto the flats, I tried to pinpoint exactly where my close encounter had happened, but the ubiquitous sagebrush maze all looked the same now. I started to cry again; there was no holding it back. The weight of what could have happened and the paralyzing fear I felt in the moment began to

register. I was embarrassed and ashamed that I'd let my still-drunk emotions get in the way of my better judgment. It could have cost me my life.

But wasn't that what I wanted? To walk off into the wilderness and lie down to die with my sadness? To be consumed and shit out somewhere beautiful in lieu of a tortured life? Here I was next to an apex predator that could easily oblige my deluded, suicidal fantasies, but when the opportunity presented itself, I'd cowered like a child.

My mind was now racing, trying to process what had happened out there on the flats as I headed south to Lower Mammoth and home. My head was spinning, heart pounding. My mind wanted to go to the tragedy, but another and seemingly more powerful part of my mental gadgetry couldn't shake the grizzly bear encounter. What the hell had just happened? I had been snapped out of my woe-is-me zombie shuffle with terrifying speed all by the presence of a grizzly bear that didn't give two shits about me. This was all so strange. There was only being present in the moment when sharing the landscape with a grizzly bear.

Something had just happened to me besides being scared shitless. An anoesis of sorts, the revelations of which were yet to be fully born. That was the closest I'd been to having something else decide my fate for me. On all my practice suicide runs, I was in control. Whether I jumped or pulled the trigger, it was up to me, on my terms. This time, the choice of life or death wasn't up to me. It was heart-stopping yet stimulating. That grizzly had sized me up and knew more about me in ten seconds than I knew in a lifetime. I felt lucky to be alive for the first time in two years.

I became hysterical once I hit the Hoodoos. Pulling over to wipe tears out of my eyes, I started to whimper, then full-on laughter erupted through the blubbering. It was the gut-wrenching reaction of someone coming apart. All the emotion I'd been holding inside

for years exploded at the same time. Grief, guilt, shame, terror, and a deep, pressurized sadness came pouring out like a seal had been broken.

I didn't want to die anymore.

I just didn't know how to live.

In that moment, facing the grizzly bear, I was paralyzed by fear like I had never experienced. It was the best thing that could have happened to me. Time froze, completely halting the merry-go-round of toxic sludge I'd been strapped to. From the time I had stopped in my tracks at the sight of the grizzly bear, through the entire speed walk back to the truck, I was fully present with no past or future. There was only right there and right then. No tragedy, no flashbacks. A wrinkle in the two-year-long misery du jour, concealed as a meadow in plain sight. I was dumbfounded. Visions of Marley flooded my mind as they had every day for the past two years, but now I was laughing. I wondered if she saw me. She must have been shaking her head in heaven over her dad being a moron. It felt so good to think of Marley and finally smile.

Maybe I had discovered a secret passage into a world where awe and ever-present danger offered me shelter long enough to get my legs back under me. I was in no way bewitched by the grizzly and was copacetic if I never saw one that close again, but what intrigued me was that span where time stood still. It was the sanctum I'd been seeking through booze and pills—an escape from my hell on earth. One thing was for sure in keeping with my ass-backward life: it made perfect sense that the safest place for me was in thick grizzly country.

I told no one of my experience. I didn't think I could explain it without sounding like some kind of anthropomorphizing, patchouli-soaked tree hugger. More importantly, I was afraid that if I talked about it, the magic of the encounter would vanish.

Howling Wolves

We had arrived in Yellowstone—as a still-grieving family—in January 2012, only five months before my grizzly encounter. As we made the short drive from the Roosevelt Arch to the guard shack and park entrance, I saw a small herd of pronghorn antelope on the barren flats. The day was monotone, gray, and cold, but the pronghorn, looking more like they should be in Africa than Montana, seemed content.

"Welcome to Yellowstone," the ranger at the guard shack said.

"Thanks." I smiled. "We're actually moving here."

"Well, that would explain the giant moving truck," he said flatly. "You're now part of the true one-percenters."

I gave him a confused look.

"Only one percent of the public will ever get to live in a national park, so now you're a true one-percenter."

I smiled and nodded. Stacey was disappearing around a curve, so I let off the brake, waved goodbye to the ranger, and eased the massive moving armada into Yellowstone. Within a few minutes, we were in a canyon with steep cliffs on one side and a river flowing through the middle. Coming around the curve near a bridge,

I saw cars stopped and people outside their vehicles. Several bighorn sheep rams were down below drinking out of the river. Was this seriously our new home? I could have no idea in that moment how many times I would utter that very statement in the weeks and months to come. We crossed the bridge only to find another bridge over the same river. Steam rose from the river corridor, and a sign said, "Boiling River." A long, icy, and curvy incline stripped away my wonderment as I felt something shift in the back of the truck again. Having a jam-packed, twenty-eight-foot truck was one thing, but hauling the flatbed trailer with a Volvo station wagon on it added another sometimes disjointed and articulated element to the drive. Muscles I didn't know I had flexed. Cresting the top of the hill, I noticed a campground and my first herd of elk lying on the hillside next to the road. Following Stacey, I turned onto a road with a sign that said, "Residential Housing. Residents Only." Ahhhh . . . I was finally with my people, us true one-percenters.

We pulled up to a very small, outdated house that looked like every other small, outdated house in the neighborhood. The upside was we were on the very back row, so our house had no neighbors behind it, only a sea of sage that went down to a river, then up a mountain on the other side. My eyes focused on elk bedded all through the vast sage.

"This must be it," I told Mazzy. "Our new home!"

As we exited the vehicles, there was a palpable excitement within our little family. We did a brief survey from the outside, then went inside, as of course the girls wanted to see their new bedrooms. The inside of the house had been recently remodeled, so everything was new. They had been very conscientious about using recycled building materials, and the thoughtful touches gave it a warm feel even though it was cold and empty. There was a gift basket of some fruit, coffee, a french press, and a can of bear spray. *Oh, yeah, grizzly bears,* I thought as I looked out into the new backyard. Stacey

and I had always gone back and forth in Michigan about what type of property we wanted. She liked a larger, nicer home, where I preferred more land when it came to where to spend our money.

"Looks like you won," Stacey said, giving me a hug and a smile.

"What do you mean?"

"We went from a four-thousand-square-foot home on a small lot to a twelve-hundred-square-foot house on two point two million acres!" She laughed. "You win!"

After Marley's death, we had slowly tried to put our lives back together. Not only did I try to restart the painting business, I kept up with a photography job doing freelance work for the *Holland Sentinel*. I also had hobbies that helped: baseball and fishing. To be specific, cheering on the Detroit Tigers and casting for salmon and steelhead off the pier at Holland State Park.

Fishing was a lifelong passion, and it was a perfect reprieve from the agony of missing Marley. It was also a reprieve from drinking. Because it's easy to get sloppy and miss strikes, getting drunk and fishing had never mixed for me. The pier at Holland State Park, only a mile from our house, jutted out into the expanse of Lake Michigan. On cold, autumn mornings, you could find 3:00 a.m. fishermen lining the pier, casting glow-in-the-dark spoons, until the luminous lures smashed the surface of Lake Michigan with a *kerplunk* and sank for the rocky bottom.

There was something about charging up the giant hunks of glowing metal with a headlamp, then quickly turning off your light and launching this night-glow, treble-hooked UFO at the twinkling stars over Lake Michigan. When the runs were good and the pier was packed with eager anglers, it looked like tracer rounds being fired at some unseen and unknowable enemy in the night. The goal was to get this incandescent, hooked teardrop in front of a short-

fused, pre-spawn steelhead or salmon and hang on! The process was rhythmic and soothing. Make a few casts, alter your drop time and retrieval rates, recharge the spoon, and repeat. I would get lulled into the night, drawn to the inky nocturnal sky of twinkling stars and open water. Some dark nights when a storm was blowing in and most anglers retreated closer to the shore, I would venture out to the end of the pier to embrace the storm, while casting a nine-foot carbon fiber rod at the lightning out over the lake.

After Marley died, I found ways of keeping my mind and body active, but there was never more than an hour or so the tragedy didn't seep into my thinking. Holland was a small town, and our story had been all over the news, reaching as far away as Australia. Many of my paint clients were aware of my circumstances, and a lot of my initial jobs were sympathy contracts. Several clients had awkwardly mentioned Marley. How do you express sympathy to someone whose baby girl died mysteriously under the most tragic of circumstances? They fumbled and stumbled, and I genuinely felt sorry for them. I knew this hit home with so many people and made every parent wonder what it would be like to lose their child. They offered condolences, sometimes gently probed (as it had been in the media that Mom was facing charges), but they mostly just cut me a wide berth when I needed a minute or still smelled like a tavern.

It really seemed like every time I even for an instant thought of something else, a tidal wave of emotion and depression would break over me. So I would take my prescribed pills and then become an automaton. A medicated dullard. I took the meds to numb the hurt parts, but it bludgeoned indiscriminately. Some days, it was mere biological existence on the most primordial level. A red plastic straw sticking up out of the sand probably appreciated the breeze off the lake more than I did. I felt nothing. I knew nothing. I was nothing. Life had become a tedious routine of work, drink, take medicine, pass out, feel like shit, repeat.

One day, I was in a customer's bathroom, the paint drying on my brush, lost in a suicide fantasy.

It's December, and the weather has changed for the worse since my last visit. Temperatures are well below freezing, and the pier is covered in several inches of frozen lake spray, making it extremely slick and dangerous in spots. There are still steelhead and salmon lurking in the depths of icy water, but I'm here for another reason.

I've trudged in tennis shoes the mile or so from my house to Lake Michigan with two twenty-five-pound weights in a backpack. I walk out onto the icy, early-morning pier, now devoid of anglers. A nasty storm rages, blowing freezing lake water on everything it encounters. There is an icy sheen building on the flat surfaces in the gray light at the end of the pier. That's where I'm headed. I'm not sure I want to do this. In fact, I'm sure I don't want to do this, but I don't see any other way. I left the house on foot so no one will know where I've gone. Stepping off the pier with a weighted backpack in a violent winter storm on Lake Michigan, I should go straight to the frigid bottom, possibly getting slammed against the pier by a rogue wave if I time it right. I imagine the initial shock of the cold water, but I will go down fast. There's no turning back. The pack is too heavy. Bubbles from my last breath will brush against my face on the way to the surface, my breath and my body going in two different directions. I won't fight it. No more struggling to survive. I will exhale completely and inhale cold lake water. I will let go into the darkness.

I came to and wondered how long I'd been standing there, daydreaming of death while my wet edge dried on the wall. It was troubling, this inability to focus on anything besides the tragedy and fallout, when all the while I was supposed to carry on, buck up, and act like a man.

These suicide fantasies were something of a sanctuary from the

horror of reliving Marley's death, my mom's role, and how I could have prevented it. Plotting my own death gave me some control over emotions I seemed to have no control over. I believed that running through suicide scenarios was more productive than getting drunk, though, unfortunately, one thing would often lead to the other.

Around this time, Stacey had been trying to figure out what her next career move was. I was personally hoping she would find something in northern Michigan so we could move up around Traverse City. Everything there reminded me of Marley, and that was exactly what I wanted. If we got a little away from the bigger cities, we could still find a nice home with lots of land, lakes, and woodlands.

I was pushing for the Upper Peninsula, but it seemed a little remote for the girls, and schools would be an issue. North had been my land of exploration before the tragedy and a stronghold of solace in the months immediately after. The peninsula seemed vast enough to fulfill my need to get away from the city and back to nature. Camera and fly rod in hand, I had visions of raising our girls in the north woods, where I sojourned and wrote stories while Stacey worked at her own endeavors, and we ran a photography business together. It was pure fantasy, I thought, but it gave me something to look forward to.

"What do you think about moving to Yellowstone?" Stacey asked one day.

"I don't think about it," I replied, somewhat annoyed at more fantasy.

"There's a job opening I'm qualified for at Yellowstone Association in Gardiner, Montana. It would be working for the educational nonprofit partner to the park, and we would be living in Yellowstone," Stacey continued. "Do you care if I apply?"

"No, go ahead," I said offhandedly, not really giving it much thought.

Stacey wanted to move away from the disease-related nonprofit

sector and more into connecting people with the outdoors and outdoor activities. Especially with our loss, working with ALS patients had become too painful for Stacey. She was actively seeking career opportunities in northern Michigan with just a few feelers out west.

Initially, I had wanted to get back out west as soon as possible and raise Marley in the mountains with her sisters. Since losing Marley, however, I now wanted to stay in Michigan and go north. North was full of woods and that inland sea, Lake Superior. North was where I went looking for Marley's spirit. Any deviations from that were tough for me to get my brain around, especially given the myriad of pharmaceuticals I was taking.

The weeks ticked by, and the lakeshore grew cold and windy. It had been just over a year since we lost Marley, and so much had happened. It was gray and rainy that fall of 2011, which matched how I was feeling. I'd sit at the beach where we had Marley's funeral when it was warm and still summer with beachgoers. Now there was no one. Covered in a frozen mist, the channel markers defied everything Lake Michigan could throw at them. I'd walk the deserted, frigid beach finding remnants of summer partially buried in the sand. A turquoise flip-flop or Popsicle stick peeking out of the sand, exposed by the wind ripping off the big lake.

I was flooded with memories of a warmer, happier time when my family was complete. When all my girls were at the beach with baby Marley, fat and happy, playing in the sand. It seemed so idle and wonderfully ordinary. Now, as the wind drove tears against my face, I would have done anything to have those commonplace days. I just didn't understand how any of us would ever truly be happy again.

"They want to fly me out to Yellowstone for a site visit and interview," Stacey told me one day as I walked in from work.

"Wow, that's really cool!" I said, somewhat surprised at myself. "You should go." It was the most excited I'd seen her in what seemed like forever.

That was all it took for Stacey to lock in the interview. A few weeks later as the holiday season approached, Stacey flew into Bozeman and was escorted down to the headquarters in Gardiner. Gardiner was the original entrance and only year-round access to America's first national park, Yellowstone. She visited with staff, interviewed with the CEO, and toured what would be our employee housing in Yellowstone. Stacey texted me pictures the whole time until she had a chance to call and say she thought they were going to make her an offer. We discussed what we would like as far as salary and benefits as well as relocation expenses and decided if they came close to what we needed, she had my buy-in. The following day, she called me to tell me we were moving to Yellowstone.

What the hell had just happened? This had gone from a mildly annoying distraction to a life-changing decision in what seemed like the course of a week. We were excited for the opportunity but were both worried about what I would be doing. I was still on shaky ground and just starting to get some legs under me. Too much idle time was not good for me, and we worried that in a resort town, I'd be going back to a ten-dollar-an-hour job. Stacey expressed this to the CEO, and he understood completely, as they tend to lose good people if both partners aren't happy. He asked me if I wanted to come photograph and possibly teach photography for them in Yellowstone. Well, I'd have to think about that and . . . okay . . . YES!

This was huge. This was *beyond* huge. Our lives were about to change in a very wild way. They wanted Stacey to start by the first of the year, so we had three weeks to sell or give away everything we couldn't fit into a moving truck, celebrate Christmas with friends and family, and leave Michigan behind us.

Personally, I had a lot of loose ends to wrap up. I needed to close the painting business and let my editor at the paper know I was leaving. When I told him I would be living and photographing in Yellowstone, effective immediately, he thought I was making it up.

And who could blame him? I'd had some front-page shots while working at the *Sentinel,* but going from covering the Tulip Festival and Veterans Day at the elementary school to photographing full-time in Yellowstone was quite a leap.

I considered myself a bit of an outdoorsman with a little knowledge of animals, mainly just from being a kid who always preferred to play outside. Atari and computer games were only starting to get big when I was young. I never had any video games as a kid, mainly because it involved being in our house—within the rageful grasp of our dictatorial mother. I preferred to be outside and away from home's violent fits, so I learned a few things along the way about nature.

From there, I read adventure and survival stories, found myself homeless in New Jersey one winter and survived, embarked on numerous extended (homeless) camping trips in Colorado, and had been turned around too many times mushroom hunting in northern Michigan to remember, yet had always kept my wits and gotten out.

I jeered at survival shows where hosts had backpacks full of foam to make them look laden and were still clean-shaven after five days. Once, I even took a class taught by a guy who graduated from a Tom Brown course. I promptly went out that same day and got horribly lost at dark in the Garden of the Gods less than a quarter mile from the parking lot. I was starting to make a juniper poncho and fashion weaponry when a couple in their eighties wearing matching white pants hiked by. They seem startled when I gasped, "Where's the parking lot?" out of breath and tucked beneath a juniper. They just pointed and continued their stroll.

When I finally got back to my truck, I noticed the dried blood on my face and dirt stuck to me everywhere juniper sap touched me. No wonder that elderly couple seemed a little unnerved when their nightly evening walk revealed a woodsy self-POW possibly denning

up 150 feet from the main parking lot. I'm lucky I didn't get shot or pepper sprayed crouching in the scrub brush like a madman. I'm sure they had a story to tell their friends around cocktails that night.

A bit of bumbling aside, I was kind of proud of myself for being mostly calm and knowing enough to prepare shelter to spend the night out in freezing temperatures. I thought these experiences had been at least rudimentary training for our move to grizzly country. But like all dipshits who die in the Greater Yellowstone Ecosystem every year, my self-assured hubris was enough to get me killed. Knowing just enough to get in trouble was potentially worse than knowing nothing, as I was about to discover.

Our goal was to leave by January 1 or shortly thereafter. For several weeks, we pared down our belongings in preparation for moving into a drastically smaller house. Plus, we were limited by the size of the largest moving truck. Craigslist became our best friend for selling stuff we couldn't or didn't want to take while raising some road trip funds.

My wife sold our superfluous possessions like a pro. I responded by hiding shit like a pro. I saw her eyeing my ice-fishing gear, an inflatable pontoon, and the five-dollar roll of chicken wire I bought at a garage sale in Detroit. When she went inside for more coffee, I stashed it deep in the moving truck. While I hid things, Stacey sniffed them out, and next thing you know, someone from Craigslist was standing in our garage negotiating with her. To be fair, she sold everyone's stuff with a gusto that could have earned her a reality show. It was good to see her working and having fun. She was in her element, getting things done, making it happen. I stuffed items into buyers' vehicles, muttering, "Pay the lady," pointing to Stacey when they tried to hand me the cash.

It was just stuff. But when something of Marley's sold, then it was irreplaceable. It hurt like a son of a bitch to watch a trivial item

made untrivial by Marley go into a bag, into someone else's car, and out of my life forever. Little pieces were all I had left, and I wondered if those people leaving our garage appreciated the priceless fragments of a happier time that they were driving away with. How trivial and yet how irreplaceable they seemed.

I tried to gauge how the girls were doing and kept the moving process as light and fun as possible. Since we were selling or packing everything, including the kitchen, there were lots of pizza deliveries and dining out. I think we were all quietly feeling the significance of leaving the place we'd shared with Marley. Marley's room had been empty now for longer than she was alive, but it was still Marley's room.

There were visits to her room by everyone during the last few days of packing. I'd come up the stairs to grab another box and see one of the girls coming out of Marley's room with heartbreaking tears rolling down her cheeks. I didn't know how to help them and felt irrevocably responsible for their suffering.

I had one last moment alone in Marley's room. Walking the perimeter and running my hand across the wall feeling for imperfections, I remembered prepping these walls for a fresh coat of honeydew-colored paint. The joyful anticipation the room had brought us poured over me.

Occasionally, I would still get a whiff of Marley in her room. I don't know how to explain it. Knowing this was my last time ever in that room, I inhaled deeply, trying over and over to smell her one last time, but it only smelled like a room. Then I remembered that I never smelled her when I tried. Instead, it was ethereal, arriving on the end of an inhale like a mist. I slowed my breathing and closed my eyes in hopes for one last inhale of Marley, but it didn't happen.

Sitting on the floor of her now completely bare room, I remembered one of the last times I held her there. One night when it was my turn to get up, Marley cried out, and I jumped up and ran into

her nursery. She seemed like something had just startled her. A bad dream? I picked her up and sat down in the rocker with her, and she wrapped her little body around me so tight, she was like a little monkey. I felt her tiny heartbeat slow as she let out a big sigh, and we melted into each other. It was one of those rare flashes I knew to hold on to. This was the good stuff: one of those moments that make an ordinary dad feel like a superhero. I never thought that it would be one of the last. After sitting on the floor for some time pretending I was sitting in the rocker again, pretending to hold her close to my chest once again, I rose, said goodbye, inhaled vainly and closed the door forever.

As I moved from playing *Tetris* with couches, coffee tables, box springs, and heavy moving boxes into packing my personal things, the past few years began to catch up with me. Mementos I'd stashed in coffee cans, boxes, desk drawers, everything seemed to have meaning, and while I was supposed to be culling my collection, it was hard to throw away anything that reminded me of Marley. A receipt for ice cream from the beach became the closest thing to a day at the beach with Marley I would ever have again. How could I throw that away? I realized how much our lives had changed with the addition of Marley into our world and how drastically different our worlds were with her gone. Like standard time is measured in B.C. and A.D., our time was now With Marley and Without Marley. There was the cozy, happy time W.M. and the hell that followed W/O.M. Every shoebox and coffee can I sifted through seemed like manifestations from one of those time periods.

The fact that I had doubled up on my medication made me feel like I was walking through some milky goo already, and making any decisions on what went and what didn't was beyond me, so it all went in totes to be sorted out later, somewhere far west of the Mississippi

River, when I was hopefully feeling more clearheaded. One thing that was not hard to throw away was my hidden collection of empty vodka bottles, and they were *everywhere*. I'd pull a basket off the shelf in the garage from one of the kids' outgrown bikes, and there would be dried flowers, candy wrappers, things a six-year-old girl puts in baskets, and several empty pints of cheap vodka. Nearly every box or tote I pulled out had empty bottles stuffed down in them or tossed haphazardly behind them. Had I really consumed that many bottles of rotgut vodka over the past year and a half? Jesus! And those were just the bottles I thought I was cleverly disposing of. Drunks always think they are wily about covering their tracks while falling on their faces.

While packing my personal items into totes to be sorted later, I had a revelation. This move was my opportunity to put all the drunken, vengeful, sorrowful, suicidal rage and self-loathing behind me. It occurred to me whatever I was packing in Michigan I would be unpacking in Yellowstone, and I should pack wisely. Anything to do with drinking—coasters, bottle openers, beer-sponsored coolers, hats, shirts, mugs, all drinking memorabilia—went in the trash. That went double for tobacco products. Over the past year and a half, I'd switched from a take-it-or-leave-it smoker who only puffed when drinking to a full-time coffee-and-cigarette-first-thing-in-the-morning guy. I was finding numerous empty cigarette packs stuffed in with the empty vodka bottles. As long as I hid the evidence, it was like it never happened. Now I was finding the proof of dozens of polluted nights, which all seemed to come back to me in one clouded, convoluted vision. A vague recollection of stumbling around the garage late at night, completely wasted, talking on the phone or contemplating my murder/suicide plot began to wash over me. I couldn't isolate one thought or one night in particular, but it all seemed like one nearly two-year-long blur and here were the artifacts. I vowed that night to use this move to put all unhealthy

living and thinking behind me. This opportunity in Yellowstone was a gift, and I was determined to turn things around.

The following day, as we loaded the last bits and pieces in the bitter cold, I realized I had a rising fever. I was trying to bulldog a queen-size mattress against the mass of belongings—including a piano—so I could pull the back door of the moving truck closed. There wasn't a square inch of space to be had in our caravan, and the plan was to pull out of Holland and make it somewhere past Chicago the first night. Last-minute details were taking forever, and my fever worsened. Plus, my joints and bones ached. We only managed to get our entourage across town to a hotel room since we had to be out of our house that day. It seemed very anticlimactic for the first leg of a multiday trip. After Stacey and the girls went out to eat, I passed out on the bathroom floor, crawling back to bed when I came to.

My exterior was freezing while my brain was burning. Dreams, visions, delusions came in waves. Images of Marley in her pool, the woods, the beach, moving boxes, and clouds flooded my mind. Shivering and sweating at the same time, I couldn't tell where I was when I peered out from under the hotel blanket. Was I in the hospital again? Treatment? Where was Stacey? I heard voices outside the door, but they didn't sound familiar. At some point, Stacey came back with some food, medicine, and ice for me. I vaguely remembered thinking there was no way I would be in any condition to drive cross-country the next day without an IV and an astronaut diaper.

The next morning, I woke feeling utterly depleted but oddly good. I gingerly drank some tea and snacked in the hotel room to make sure whatever I ingested stayed down. After a continental breakfast in the hotel lobby, we headed out into the cold, gray Midwest winter morning and started the engines. We had been experiencing some trouble with the rental moving truck. It had not started in the

driveway one morning and had to be towed away, packed with our belongings, to be repaired and returned. By this point, when the truck started, we felt like we were already miles down the highway.

Mazzy rode in the truck to keep me company and awake, and we towed Stacey's car on a flatbed trailer. Stacey had Chloe, both dogs, both birds, and all the things we would need on the road crammed into our Suburban. Since she knew her way around Chicago, she would lead. We pulled out of Holland, Michigan, with a stiff, cold wind coming off the lake. There was a palpable melancholy in both vehicles, a sadness in leaving I'd never experienced before.

We easily navigated Chicago, arriving at dusk as the buildings began to light up downtown. We got our second hotel in two days with a total of about 250 miles under our belt. We weren't setting any speed records, but considering all the rental truck problems we had starting out, we decided not to push our luck in the dark on an icy interstate. We ordered some food, and the girls went straight for the swimming pool. Kicking back in a hotel room and feeling the freedom being on the road brings, it seemed that the hardest part was behind us. All I had to do was get us to Yellowstone in one piece.

The next morning after just enough cheap hotel coffee and rubber eggs, I snagged a muffin, a banana, and one more cup of that robust roast for the road and went to start the vehicles. It was still in the single digits, so I wanted to get the vehicles nice and warm for the girls and our big day ahead. We hoped to get to Sturgis, South Dakota, that day so we still had thirteen hours of driving through a winter storm, but I was ready. I crawled into the cab, turned the key, and heard nothing.

"Sonofamotherfuckingpieceofgoddamnshit!" I yelled as I beat my fists on the steering wheel.

I turned it all the way, and still nothing. Dead. This piece-of-shit U-Haul was doing the same thing it had in my driveway four days

ago when they towed it away and "fixed" it. I listened for the fuel pump, because I remember the mechanic saying:

"Listen for that fuel pump to kick on. If it does this again—"

"What do you mean if it does this again?" I'd asked.

"No, it's fixed." He'd squirmed as I stared at him standing in my driveway.

Now five days later, I was freezing my ass off. I hadn't worn a coat or gloves, as I was just going to go start the vehicles we could see from the room. The only thing keeping me warm was pounding on everything my fists encountered and screaming some choice words and phrases that would get me kicked out of hell. Sitting there freezing and fuming, I finally laughed. This was my life—fucked up and ridiculous. This was a test. My rage switched to problem-solving mode. I would get on the phone with U-Haul and then see if the hotel could hold our room for another night. We were being tested to see if we had any guts and determination left like the Montana-bound emigrants that preceded us.

There was nothing the mobile mechanic could do in the parking lot of the hotel. The fuel pump was out. He offered to tow us fully loaded to another subcontractor and exchange trucks.

"Fine," I said, picturing workers who would help us repack the new truck.

"Repack!" Stacey exclaimed when I told her the news.

The U-Haul "facility" was more of a truck stop–mechanic shop in a sketchy area right off the interstate in Rockford, Illinois. There was a guy behind the counter, an office behind him, and a bunch of guys in leather jackets milling around smoking and drinking coffee.

"Here's the keys," the counter guy said, handing me a ring.

"Okay. Where are the movers?"

"We ain't got no movers."

"What am I supposed to do now? Unload everything from one truck to the other by myself because your truck is a piece of shit?"

"It's not *my* truck," he said in a thick Chicago accent, flushing with anger.

"Sorry, man," I said as the other guys there started to take notice and move closer. "I'm moving my whole family cross-country, and this is the second time this truck has left us stranded. I know it's not your fault."

Just then, a guy in his midfifties with slicked-back hair and a black leather jacket walked out of the office and asked what was going on. It was clear this guy was the boss.

"I'm sorry to bother you guys," I said, looking him directly in the eye. "I'm moving my wife and daughters across country to Yellowstone, and this is the second time this truck has left us stranded. We have our whole lives in that truck, and my daughters are terrified." I hoped that even if this character had done time for cutting off someone's fingers and mailing them to their relatives, he could still take pity on a Clark Griswold–looking dude with a carful of scared females. He listened to my spiel, then turned to the fellows behind him.

"Get your boots and gloves or whatever, and get your asses out there and help."

He looked right at me as he said it and never broke the steely stare on his tough face. Once he gave the order, these guys jumped and got their mobbed-up asses out to our truck.

We backed the new truck straight up to the broken-down truck. The first problem was even getting the roll-up door open because all the furniture had slid against it during the towing. Once we had the door up, we connected the two trucks with an aluminum ramp and started an assembly line. The second problem was that we had carefully packed heavier items like a piano toward the front of the truck and close to the axle. Now as a result of our process, it was going to be in the exact opposite order. Stacey couldn't even watch. Everything was getting stuffed and slammed into place, but I just

kept laughing to myself that this looked like we were shooting a *Sopranos* episode—Chicago-style. I jumped in and tried to direct traffic a bit, but they acted like I wasn't even there. And they didn't seem to care about the sofa getting dirty anyway.

When we finally got back on 90 West, we wondered what exactly was crashing around in the back of the truck. Something slammed the side at the apex of the merge curve, and all Mazzy and I could do was look at each other and laugh. Over the next two days, we drove through South Dakota and Wyoming, through rolling prairies, with a vision of bluffs and buttes in the distance. We cheered driving along Highway 212 when we saw the "Welcome to Montana" sign. Eventually, the road narrowed approaching Lame Deer as we made our way down a hill and then through some curves. Beyond was a long, steep incline that appeared to be covered in ice. I had no momentum after coming out of those curves in a twenty-eight-foot truck towing a station wagon on a flatbed. I downshifted and punched it, hoping Stacey would notice the urgency in front of me and do the same while trying to not let on to Mazzy this might get weird. Two-thirds of the way up the incline, Mazzy looked at me, and I knew the question she was going to ask.

"Do you smell something burning?"

"What? Maybe," I said. "Probably just burning off some of the buildup from doing the same speed on the interstate." Whatever the hell that meant.

"Oh, yeah, right."

Then we began to noticeably lose speed as the engine continued to rev. I thought I could see the top of the hill, so I held the pedal to the floor while the smell of whatever was burning began to fill the cab.

"Dad, are we going to be okay?"

"Well, we're about to find out," I said, trying the watch both the road and the gauges. I looked over and saw her eyes welling up with tears.

"Oh, hey! We're going to be fine."

"Okay," Mazzy said, not sounding completely convinced. But then, I wasn't convinced either.

The top of the hill was finally in sight. Unless something exploded, sending the driveshaft right up my ass, rocketing me through the roof, we were going to make it. As we crested the top, and I let off the accelerator, we both gave out a sigh and half-heartedly laughed.

"Phew, that was close," I now admitted.

"Yeah, I didn't think we were going to make it," Mazzy said. "I was starting to cry a little bit."

"Me, too," I said, smiling at her. She smiled back, and we both unclenched.

We arrived at Exit 333 for Livingston, Montana, and Yellowstone around 8:00 p.m. We were only an hour away from Yellowstone and our new home, but it had been a long day, and the new house was empty with a big truck to be unpacked. Instead, we decided to get one last hotel room and a good night's rest, so we were sturdy for the final push and unloading of everything the next day.

We awoke to a dismal, gray morning among ghosted mountain peaks shrouded in low-hanging clouds and mist and covered in snow. The mountains looked ominous. Stepping from the warm hotel into the parking lot without a coat, I was smacked breathless by fifty-mile-per-hour winds and a cold that made Lake Michigan winter feel warm.

The drive through Paradise Valley was dull, as everything was socked in on both sides of the road. There seemed to be plenty of snow on the mountains while the valley floor had scant covering. The highway continued to parallel the Yellowstone River, and my heart got excited recalling that it ran right through Gardiner, Montana. I pictured myself fly-fishing on lunch breaks. The very limited views coupled with the anxiousness of getting to our destination,

and being done with trucker school, had me eager to push directly there.

"Welcome to Gardiner, MT," the sign with an elk antler on it said as we pulled into town. Gardiner was more like a village huddled together along a river on the edge of something large and mysteriously wild. Driving in on a Sunday in the winter, it seemed like any other off-season mountain resort town I'd been to, except for the 2.2 million acres of some of the wildest country in the world. I noticed the market was also the state liquor store. This was good to know as I got my bearings where the bank, post office, local tacos, and dive bars were. I got my first view of the Roosevelt Arch, and the reality that we were getting ready to cross the threshold and become residents of Yellowstone really started to hit me. I stared at the guard shack, and at Stacey in the Suburban in front of me already zooming toward it.

"Here we go!" I announced to Mazzy as we drove under the arch and entered our new home in Yellowstone as a pack, much like the Canadian wolves who were introduced to the park in 1995—minus the fanfare, of course.

The kids and dogs ran around our new yard with a sense of freedom as a truck pulled up slowly. Two guys got out.

"Stacey?" a bearded guy in his fifties asked, looking over at us.

"Yes," she replied.

"I'm Tom, and this is Larry." He pointed to the other guy. "We're the movers."

"How'd you find us?" I asked, looking at the caravan that appeared large on the interstate but now seemed freakishly out of place in this little neighborhood of tiny houses.

Everyone chuckled as we shook hands and sized up the task at

hand. It was already getting late in the day, so we decided the best thing to do was to quickly unload. It was going to be *Tetris* in, *Tetris* out. We dropped the ramp, opened the roll-up door on the big truck, and got started. Larry stopped in his tracks halfway down the ramp, straining under a massive box labeled "Kitchen," and cocked his head to one side like a bird. He had the weirdest almost-smile as he cocked his head a few more times like a robin eyeing the ground, but he was looking straight ahead into the distance.

"Did you hear that?" he asked.

Oh, great, they have meth here, too! I thought, but said nothing.

"Did you hear *that*?" Larry asked again with a widening smile.

"No," I said, continuing with my box labeled "Mazzy's Room."

"The elk heard it," Larry said, nodding.

All the elk sporting their thick winter coats that had been spread out were now standing in a tight circle, butts facing in and heads looking out, with frantic expressions on their faces. I stopped where I stood, mesmerized. The elk had gone from relaxed to insanely nervous, scanning the horizon and snorting. A few pawed the ground. What had them so spooked?

Then I heard it. Ever so subtly on the southbound breeze, I heard wild wolves howling—for the first time in my life. I noticed I had inadvertently cocked my head to one side like Larry, and if I held this position, it seemed to amplify the howls ever so slightly. As I turned to Larry, I noted that everyone else had tilted their heads, too.

"Wolves," Larry said enthusiastically as he now had all our attention. "You guys are the luckiest people alive today. You just moved into one of the wildest places in the world, and it's all out your back door now. You can expect to see anything and everything go down right in your yard. Before they closed the school up here, one day the bus pulled up and the wolves were disemboweling an elk right against the front door."

"Cool," I said, feeling a little squeamish and concerned for the dogs and the girls.

I couldn't believe that somewhere out there, not far away yet not visible, in the rolling hills of sage and snow, a wolf pack was getting tuned up in our new backyard. I imagined them all coming together for a group howl complete with lots of jowl licking and kisses for each other, then they would all bound off on a dusky hunt in an established order through the fresh snow just like the wolves on the Blue Buffalo dog food commercials. They would all be gray, groomed, and smiling with healthy teeth and gums as they rocketed over downed timber with sapphire eyes. This vision of "wild" wolves was not reconciling with the gory details Larry was giving me as we passed on the ramp, laden with boxes.

I was no doofus. I knew that nature was brutal, honest, and didn't seem to care about the status quo. I knew those dog food wolves had probably never been wild nor ever had to take down anything other than frozen roadkill tossed into their pens, but the thought of a pack of wolves eating the bloody guts out of a still-kicking elk just a few blocks away from our new home was a fine "How do ya do, and welcome to Yellowstone!"

"No letting the dogs out after dark without lighting up the backyard, and we have to go out with them," I said to Stacey with the "hey, I'm serious" look as we now passed smaller boxes like an assembly line. She smiled and nodded, but I don't think she realized the full extent of where we were yet either. The thought of what a sassy, deep-fried-Twinkie-looking golden retriever must look like to a hungry, territorial wolf unnerved me as we coaxed the oak dresser through the narrow doorway.

We were now living in this experiment called a national park. I couldn't get those wolf howls out of my head and strained every time I went outside to hear them again. The elk had moved off but were bedded once again, so I assumed the wolves had just moved

along. Having spent most of my youth along the rivers and woods of northern Indiana and my twenties in Colorado, I felt comfortable in the out-of-doors, and I knew what to do in the case of run-ins with animals, especially predators. Not that I had any real experience, mind you, but I had watched all the TV shows growing up and read a few books. The closest I'd probably come to any predators was the guy standing in the dark bushes next to the bathrooms at a rest area on the drive out. As I scanned the terrain, it became gloriously and overwhelmingly clear where we stood. We were in the wildlife's yard, not the other way around. I was way out of my league.

3

Centripetal

If I go off the road here—I'm dead, I thought as I drove the icy slope near Undine Falls not long after we'd moved to Yellowstone. The back tires of the truck broke loose on the ice as I eased the gas pedal just enough to make it up the incline. To my left, the gorge dropped hundreds of feet into Lava Creek, though it was still too dark to see anything but my headlights bouncing off the glistening sheen.

I had finally worked up the nerve and sobriety to drive fully into Yellowstone, in the still-dark hours with the digital thermometer on my rearview mirror hovering right around minus thirteen degrees Fahrenheit. With the first treacherous stretch between the high bridge in Mammoth and Undine Falls behind me, I peered into life at the edge of my headlights as the wind began to pick up on Blacktail Plateau. This might have been stupid. I was driving out in the dark, not to mention the ice and snow, without another soul around if I got in trouble. I had stayed sober the night before so I could be awake and handle the drive to the fabled Lamar Valley that everyone raved about. Up ahead, I thought I saw the faint red flicker of taillights through the blowing snow. The fact I wasn't the

only fool out in the blustery darkness brought some comfort, and I sped up slightly. I wanted to catch those lights. Following the intermittent red dots, then hot brake lights, then red dots, I weaved my way past Tower Junction and Slough Creek and into a tight canyon. Coming out the other end of the canyon, I saw a brief glimpse of a sign I thought said, "Lamar Valley."

The car in front of me was still there. To the east, the faint glow of dawn emerged on the horizon as I passed some buildings and a sign that said, "Yellowstone Institute." The white Prius I was following stopped in the road a few hundred yards ahead of me. I wondered if it had mechanical problems or if the road was drifted over. The temperature now read minus twenty-one as I crept up behind.

A shadow crossed the road in front of me. Two more shadows stood right next to my truck, barely fifty feet away. I blinked. Wolves. They were wolves! As my eyes adjusted to the faint light, I could see wolves all around, and they were walking right across the road in front of the car I'd been following, their shadowy figures illuminated as they moved into and out of the headlights. The wind swirled snow squalls around their feet and blew the scruffy hair on the backs of their necks to and fro. The gray wolf and two darker wolves that were next to my truck moved up the hill to the north, and the rest of the pack fell in line, stopping occasionally to smell the ground in front of them. The gray wolf in the lead stopped and looked down on the procession. Within minutes, they all vanished over a ridge with mini–snow tornadoes sweeping upslope behind them. For an instant, they were there, and in an instant, they were gone.

I was shaken and spellbound and didn't want to leave, but the car in front of me had left, and there were approaching headlights behind. I eased my foot off the brake and onto the accelerator, but, though the engine revved, the truck wouldn't move. I hit the gas again, and the same thing happened. As I started to panic, I realized

the truck was in park. I shifted into drive, and off I went with a lurch, still shaking from the adrenaline and awe. The car I had been following was in a plowed pullout with several other cars a few hundred yards up the road. Pulling into the last spot available, I could see a dozen or so people out of their vehicles, dressed like they were going to summit Everest and looking with binoculars and scopes toward the predawn hills where the wolves had disappeared.

Exiting the vehicle, I heard people buzzing about the wolves and radios crackling. They bandied about numbers: 832 and then 755 and 754. I checked my phone. It was 7:32 a.m. Were they talking about time? I drifted toward the edge of the group to eavesdrop.

"I bet you got a pretty good look at 832 and 755," an older guy in an orange parka said to me, barely looking up from his scope.

"Yeah." I nodded, having no idea what he was talking about.

"She was standing not twenty feet from your truck," he continued, shaking his head with satisfaction. "832F—she was right next to your truck!" He looked up from his spotting scope to smile and make eye contact with me.

"Mm-hmm." I nodded again like this was old news and of no particular interest.

"That's the Lamar Canyon pack." He smiled, nodding toward the hills across the road where they disappeared. "That was the alpha female, the '06 female, that was next to your truck. They took down an elk north of the Trash Can pull off last night and are now heading up to bed down." He finished and went back to his one-eyed world of a spotting scope. I nodded like, "Yeah, that's pretty much what I figured, too," but I had no clue what he was talking about. Then I remembered the radio collars. The numbers were the radio collar numbers for the individual wolves!

"So that's the alpha," I said, pretending to scan into the distance even though it was still dark, and I didn't have any binoculars.

"Yep," he said.

"Yep," I replied.

These people were serious about wolves and knew what they were doing. I had no clue. My Ozark Trail hiking boots, bought just for Yellowstone on sale for twenty bucks, and thrift store ice-fishing coat weren't going to cut it in the Lamar Valley. The cold took advantage of my half-hearted attempt at layers before I had even closed my truck door behind me. I felt not the cold of mild distraction but the dangerous cold of death if something should go wrong.

"I'm going to warm up a bit!" I shouted over the wind. "How long will you stay out here?" I asked, pushing my hands deep into my coat pockets.

"All day," he said, barely audible. "They have a carcass behind you and to the left so they could come back down in the daylight to feed again." He never looked up from his scope.

"Okay! Well, good luck," I said and turned around with the wind at my back as I headed for my truck, wondering what would possess a person to do such a thing.

Back in the warmth of my truck, I wondered about people who would stand in subzero temperatures all day for the chance to see a wolf. I didn't know then that soon I'd join them or that '06 was the most famous wolf in the world. I was still oblivious, still locked in grief, not yet tuned in to this glorious place, Yellowstone. The truck's heat felt good and thawed the frozen snot and condensation in my mustache. I eased back on the road and headed for home, giving the line of identical—but for their parkas—watchers a quick wave as I passed in front of their line of scopes. I left them staring in the distance, where the wolves had disappeared.

I'd been close to wolves before with the canyon pack hanging around our house in Mammoth, but something about predawn Lamar Valley with wolves literally in every direction—while the bitter wind whipped spindrifts across the headlights—was different. For

one, most of my time with the canyon pack had been either alone or with a couple of friends. I'd never been with active wolf-watchers or tour groups. I had assumed that I and the car I was following were the only lunatics brave, or stupid, enough to be driving through Yellowstone on such a dangerous morning. Lo and behold, there seemed to be a whole subculture hell-bent on spending as much time viewing wolves as humanly possible, whatever the weather and no matter the hour.

Then there was this wolf pack: it had a different feel from the canyon pack I could hear from our house and sometimes glimpsed. The Lamar pack leaders moved with a sense of confidence as if the cars and people were a minor nuisance. The gray with the collar had walked a few steps up the ridgeline, then slowed, stopped, and turned to survey the entire scene while the darker wolves following did the same. There was a poise even as the swirling wind whipped their fur in competing directions and pelted their faces with sideways snow. From that vantage point, the pack leaders could see all the subordinate stragglers crossing the road and falling in line until the pack began to move as one. Once the last, smaller dark wolf cleared the road, the gray on the ridge in the lead turned her gaze upward to the timber, moved in that direction, and never looked back. There was an air of dignity—even royalty—to their organized retreat.

Because the canyon pack had to surreptitiously navigate populated areas, most of what I had seen of them was either on the move or bedded at a distance. The Lamars, in contrast, seemed to own their landscape. In the Mammoth area, you were likely to come upon a tour group or ranger-led presentation. In the Lamar Valley, if you walked far enough in any direction, you'd be lucky to find your way back. There was something out there that felt wild and dangerous.

I began to venture out to the Lamar Valley with my camera more

often throughout February. There was something about the vastness and remoteness of the landscape that made me feel as wild and free as the animals I was trying to find. Plus, every death-defying drive out in the dark cold and blowing snow of Yellowstone made me feel more alive. I began spending time with some of the wolf-watchers and gleaned a wealth of information from their kindness and willingness to educate a newbie. It turned out that the gray wolf that had been just feet from my truck was the alpha female of the Lamar pack. The alpha female, 832, was also referred to as "the '06 female" as she was born of royal bloodlines in 2006. The wolf-watchers were clearly enamored with her. She was a masterful hunter, caring mother, and strong pack leader.

It was the canyon pack and their white alpha female that showed up within range of our house. On moonless evenings, I would step outside half-drunk to smoke and hear the canyon pack howling from the rolling hills of sagebrush and snow. The white alpha female came from royal bloodlines herself, and the alpha male was a big, black Mollie's wolf, a pack from the southern Pelican Valley area that hunted bison. Some of their offspring had the most incredible gray coats with distinguishable saddles of rust and slate. One daughter had a unique mottled coat with a blaze of white on her chest and was never far from her father, the alpha male 712M. I'd heard people refer to her as "Daddy's Girl," but I could never quite make myself say it comfortably. I had seen her quite close several times in our neighborhood from my car and on foot. It was an intense experience to round a rise in the rolling hills and come upon a black wolf.

These wild moments were the first spans of measurable time that I wasn't mired in misery and despair. I was still a few months away from my grizzly encounter, the one that would set me on a journey. Seeing wild wolves just being wild wolves enabled me to think of Marley without pain. I thought about how delighted she would

have been to be seeing this with me. But then my thoughts would whiplash to the pain of losing her, our staggering loss, and my fatal mistake of trusting my mother. As I felt joy watching wolves, I also felt guilty.

Most nights, by the time I got home from sojourns into the Lamar Valley, I had already grabbed some booze and had my night etched out. I would do my best to drink slowly and be a family man during dinner, but eventually, I would isolate in the garage, where I'd drink, smoke, and indulge in self-pity. I tried to numb myself beyond feeling, beyond thinking, but occasionally I would ponder some hard truths. Stacey and I had stopped comforting each other, and I began to wonder if we ever had. The hole left by a dead child *cannot be filled*. Deep down, I realized we had parted ways on some level, and each of us had entered a solitary journey. Stacey threw herself into her work, and I threw myself into self-medicating, with brief reprieves out in the wild. Prescription drugs and alcohol pushed me beyond help. It made me ugly. So I hid out in the garage. I had been doing it in Michigan, and now I was doing it in Yellowstone. Even though I was surrounded by beauty and wild on the outside—on the inside, every day was hideous. I woke up every morning swearing off alcohol, and I did try to take some positive steps.

Because of Stacey's job at Yellowstone Association (YA), spouses were allowed to take one free institute class a year, so I signed up for a three-week Certified Interpretive Guide course that offered a full immersion into Yellowstone. I was starting to get to know some of the YA staff as I had covered a three-day coyote/raven course at the Lamar Buffalo Ranch and had been to a few work events with Stacey.

The class gave me something to look forward to, and since I had no job yet, I needed the structure and training. Reading had always been an escape for me, but after Marley died, I couldn't concentrate enough to get through even one page of reading or writing. That

began to change, and I read everything I could get my hands on about Yellowstone, from the thermal features to the human history and to all the critters that called this ecosystem home.

With spring approaching, the animal I found myself reading the most about was the grizzly bear. My wife's boss had been horribly mauled by a grizzly bear in Glacier National Park and was lucky to be alive. He showed me the scars on his arm as he told me the story. I knew that bear attacks were rare. His story showed how horribly gnarly they were. From what I read, if you survived, you were in for a long, painful haul of sutures, surgeries, and excruciating physical therapy for months, and that was just to get you well enough to wipe your own ass. The psychological injuries might never heal. Some people are done hiking in grizzly country after even hearing of such an incident. Grizzlies flat-out scared the shit out of me, and I knew absolutely nothing about them. So I read everything I could get my hands on and listened intently to anyone who had a grizzly bear encounter story to share. Oddly, I was never afraid of the wolves, even in proximity. I treated them with the same respect I would any pack of feral dogs I might come upon. I never let my guard down around wolves, but they had also never given me much cause for alarm. Mountain lions didn't scare me, because I thought the odds were so incredibly marginal of ever seeing one—like being struck by lightning. Besides, there are no books full of mountain lion or wolf attack stories like there are grizzly bear attack stories.

The mere thought of having anything happen even remotely like the horror stories I'd been reading about grizzly bear attacks left me squeamish and nervous about walking out to the car at night. Neighbors said once the grizzlies started waking up from their winter nap that it wasn't uncommon for them to wander the neighborhood at night and sometimes even during the day. My mind conjured herds of grizzly bears owning the night! We definitely weren't in Kansas anymore.

The three-week CIG course was nothing short of a full immersion into Yellowstone. Five days a week, we met for classes, with more time in the field as the course progressed. We learned history, characters, first peoples in Yellowstone, edibles, flowers, tree identification, supervolcanoes, and, most popularly, the animals that call Yellowstone home. We learned how to guide visitors safely through Yellowstone while protecting the resources, the people, and the experience. We were taught the value of a shared responsibility for stewardship and the importance of fostering that attitude in others. We learned as much about ourselves and each other through the program and formed fast friendships that spilled into our free time. I was feeling better than I had in almost two years.

"Hey, do you know where a few of those recent wolf kills are behind your housing?" George Bumann, a new friend and Yellowstone Association instructor, asked me from behind his rimless glasses. We were wrapping up class for the day.

"Sure, I've been out to all of them."

"Great. I'd like to take the class out there Monday if you can help."

I was beside myself. George was one of the top instructors, and everyone loved him. The previous day, he had us all spread out along the Gardner River, sitting quietly wherever we wanted. The goal was no phones, no watches, only to sit silently, turn off the internal dialogue, and "feel" the earth all around us for twenty minutes. The experience had a profound effect on the class.

"I'd love to help! I'll go scout them all again this weekend. I've also got photos of the canyon pack at those kills."

"Perfect," George replied, adjusting his glasses. "Bring them with you."

The following Monday, our class of a dozen students with colorful backpacks, binoculars, and water bottles marched into the sage below our house at Lower Mammoth. George and I led the way to

the first wolf-killed cow elk. Even though it had only been a few weeks since the kill, all that remained were bones, some hide, and the undigested contents of the rumen sack. Picking up the lower mandible of the cow elk, George began to explain.

"If you guys will notice," George said as everyone leaned in, "this cow elk's teeth are almost completely ground down. Old age and poor health may have been why the wolf pack singled her out. Wolves typically prey on the old, weak, and sick, which can help keep a herd healthy."

"From which way did the chase occur?" a blue-eyed girl with a matching backpack asked.

"That's a good question," said George, nodding over his glasses and picking up a wolf turd full of elk hair while everyone leaned in even closer to examine it. "Let's ask Brad! He was the first on the scene."

George and the class turned to me.

"They ran her uphill from the river corridor, separating her from the herd. She stumbled when she hit the rolling hills, and it was over. When I woke up at dawn, the pack had pretty much consumed her and were all spread out on the adjacent hills sleeping off a good meat drunk. Coyotes were circling. Before the sun was up, ravens had found it and were giving out their 'there's food over here' call to each other." The words came spilling out of me. "I have photos."

"Ladies and gentlemen, Brad will teach the rest of this class." George laughed and winked at me in approval.

"You could easily teach these courses, Brad," one of my classmates said.

"Someone should snatch him up as a guide," our senior resident instructor, Julianne, added. It was a humbling and proud moment. I was acknowledged as a quick study with good instincts for putting myself out there in the wild—day after day. Maybe I was finding myself and the next chapter of my life in Yellowstone.

I excelled at the course, impressed my instructors, and was offered a job guiding for them before I had completed the course. The position paid well, I would get to be in Yellowstone a lot, and I at last had a job with purpose to look forward to. My concerned friends were relieved that I had moved away from house painting and would be guiding in Yellowstone and continuing my photography. Our little broken family celebrated. Everyone was making friends, we each had new endeavors that excited us, and my drinking slowed a little. I was stoked to tell anyone who would listen that I was a guide in Yellowstone and embraced the rest of my training with the hearty vigor and guarded optimism of a farmer in June.

Less than a week after being offered the job, I was informed that my DUI back in Michigan one hundred days after Marley died precluded me from guiding. They were genuinely sorry to have to rescind the offer, but they had no choice. We told them the backstory, but it didn't change the fact I couldn't work for them. My hopes of a fresh start tanked when I felt the whole community looking at me differently. I explained to my classmates why I couldn't take the role as a naturalist guide after all. There was no point in lying, as the entire community knew the sad truth. I was devastated that my traumatic past could not be transcended. I decided, however, to finish the course. The structure and learning were good for me, even if only in the short term.

The class took us to the Brink of the Lower Falls of the Grand Canyon of Yellowstone on a visit to understand how the falls were created and the canyon thermally altered. We parked and made the short walk to the overlook while our instructors explained the features to us. Standing as far out as I could get and looking directly down the three-hundred-foot waterfall, I felt like I was being pulled over. Like there was a force compelling me to go slack and end everything. I was mesmerized watching the bubbles as they spilled over the brink and turned into rainbow spray on their way down.

All I had to do was unburden my tired legs and fall forward. Even with all these people around, by the time they realized what had happened, it would be too late. But I could not do that to myself in front of people who had become my friends, so I instead made a mental note of the location, and while our instructor lectured on the history of the canyon, I devised another suicide plan.

I had seen foreign work program kids hitchhiking around Yellowstone. If I could leave my truck at a trailhead along the northern range, then hitchhike to the canyon, I could then walk to the brink and mill around until everyone left. Once I was sure everyone was gone for the evening, I could step up on the rock wall, take one last breath from this world, and go find Marley. My body would be pulverized by the rocks at the bottom of the falls and surely vanish. The trout and suckers could feed on the remnants of me. Searchers would look for me in the northern range while my body was feeding the rivers.

"So that's how the Grand Canyon of Yellowstone is like a baked potato," I heard our instructor say as the class filed up the stairs back to the parking lot. I had no idea nor any interest in the baked potato analogy. My focus was on the perfect suicide plan, where I would disappear from the face of the earth on a starry, romantic spring night in the Grand Canyon of Yellowstone. It was comforting to find such an ideal location to end it—a much better option than the high bridge in Mammoth or the bridge over the Yellowstone River in Gardiner. A moonlit nosedive from the Brink of the Lower Falls would not disappoint.

One of the people I'd connected with in the CIG course was a wiry, rugged-looking guy in his sixties. It turned out he was a retired Ph.D. entomologist who worked on the decline of white bark pine (a prime food source for grizzlies), a lifelong fly fisherman, and a serious backcountry skier as well as sage. Jesse Logan and I

became fast friends, and he was one of the few people I felt comfortable revealing more of our story to than the *Reader's Digest* version I'd been forced to share with the rest of the class. Jesse, like most people, was moved to tears and gave me a heartfelt hug. He insisted that some fishing would help. He also recommended I read *Grizzly Years: In Search of the American Wilderness* by Doug Peacock, a personal friend of Jesse's. He was the second person to suggest the book, and he wouldn't be the last.

It was around this time that my prescriptions were running low, so I called the local clinic to get a refill. When I told the nurse what medications I was on, she explained that I would have to see the doctor first. By now, I was completely hooked on benzodiazepines. The thought of not having them handy freaked me out. I needed the Xanax, Ativan, and trazodone just to get through the day, and at night, I needed Ambien, with copious amounts of alcohol, to sleep dreamlessly.

I met the doctor and gave him my history. I expected that he would cry, like all the other professionals, and quickly refill the prescriptions. Instead, he informed me that he would be taking me off all the addictive and mind-altering medications. He would pare down dosages over the next few months until I was off them completely. I pleaded but to no avail. Like every addict, I immediately formulated a plan to find another doctor, even as he prescribed sunshine and fresh air in lieu of pills and hiding in the garage. Since I'd mentioned a renewed ability to read, he recommended *Grizzly Years* by Doug Peacock and asked if I'd heard of it. I had looked it up by now. It was a well-known book about Vietnam, PTSD, and how living in the wild with grizzly bears healed a Green Beret medic. I had planned to read it to learn about grizzly habits because Doug Peacock was a grizzly guru but had not considered it as some sort of self-help book. Doug Peacock's experiences and mine were night

and day, although both terrifying. I didn't see how something that happened to a Green Beret medic my dad's age, thousands of miles from here and decades ago, applied to my situation.

Since the trail was beginning to really fall away under my feet, I thought it might be a good idea to talk to a mental health professional. The drug and alcohol consumption had been going on too long. "Success" had become not pouring a drink until 5:00 p.m. I made an appointment with a psychoanalyst in Livingston.

After I told him my story, he told me I had PTSD and that my self-medicating had left me unable to focus on anything except Marley's death, even though I *took* the drugs and alcohol to forget. Then we began the long work of "uncovering multiple layers of trauma" starting back in my childhood in northern Indiana.

I was born in March of 1970, the same year Jimi Hendrix and Janis Joplin died, the Beatles broke up, and Jim Morrison of the Doors went on trial for allegedly exposing himself at a concert in Florida. Nixon invaded Cambodia, expanding the war in Vietnam, while posing for photos with Elvis at the White House, and four students were shot and killed at nearby Kent State University by the Ohio National Guard. Peace and love had hit their high-water mark, as Hunter Thompson had suggested, and receded into an era of televised hostages, shag carpet, and punk rock.

I grew up surrounded by cornfields and Amish buggies. My father was a Vietnam veteran and semitruck mechanic who drank Folgers black and smoked Marlboro red. My mom stayed at home doing crossword puzzles or working odd factory jobs. With my younger sister, we lived in a little pink house in Goshen, Indiana, long before John Mellencamp memorialized them.

As a child of the '70s, my heroes were Evel Knievel, Muhammad Ali, Gene Simmons, and Bruce Lee. At night, while eating hot

dogs and government cheese, we watched the Iran hostage crisis unfold between episodes of *The Muppet Show* and *Charlie's Angels* on the console TV. During the day, life was all about riding bikes and running wild with friends. We drank Kool-Aid with twice the sugar and lived on tubs of generic peanut butter. When both of my parents worked, my younger sister and I spent a lot of our preschool years at various babysitters. That was fine with me, as there were new neighborhoods to explore and much less risk of being beaten at a babysitter's house.

In 1980, we moved from our pink house on Riverside Avenue into a brand-new home in a more affluent suburb. The housing development was located at the edge of a large, privately owned orchard. It seemed like a huge jump from our modest pink house. Even at the age of ten, the move didn't quite make sense to me. My dad was a truck mechanic, and my mom bounced from job to job; plus, I liked where we were. I was in the fifth grade listening to albums and trying to convince my parents to let me join the KISS Army when I learned we were moving. My sister and I would be starting at a new school after Christmas break. So, with "God of Thunder" playing on my portable record player and Farrah Fawcett staring down at me in that red swimsuit poster, we packed up and headed for a new trilevel house on the edge of an apple orchard.

Although I was torn away from my friends, the new countrified lifestyle ended up suiting me just fine. We were surrounded by orchards, cornfields, woods, and the nearby Elkhart River. I made new friends who opened my eyes to the vast expanse around me. My old stomping grounds afforded only small parks and undeveloped lots for recreation, but the new homestead offered wilderness in every direction. For a ten-year-old boy with an unhappy homelife, this new boon of open-air country offered an endless refuge: an escape from my mother's emotional and physical abuse. My mother had a quick temper and a gift for ranting. When that didn't suffice or if

there was any back talk, she liked to let her fists do the talking. She could lecture for literally hours, high on caffeine, Dexatrim, and nicotine. She loved to say that getting pregnant with me had ruined her life. When enraged, she'd grab for anything within arm's reach, usually a yardstick, a wooden spoon, or the occasional vacuum extension and swing with wild accuracy at whoever was pissing her off. And I was always pissing her off.

"Brad, did you take the garbage out?" she called down the stairs one Saturday morning as I was about to go play with friends.

I could only hear her, but I knew the long pause at the end of the question was when she took a gulp of her coffee, then a long drag off her cigarette.

"No, I forgot," was the only offering I could think of. I knew what was coming next.

"Get your ass up here now!"

She made a fresh pot of coffee to mix with Dexatrim while I sat at the kitchen table, back to the wall—my usual spot. She paced and raged amid gray clouds of cigarette smoke and the aroma of brewing Folgers. She started with the garbage and quickly moved to what a failure I was. I was so used to her rancid blathering that I spaced out and imagined I was at the river, going through fishermen's trash looking for forgotten pike lures.

Two hours passed. The nicotine, caffeine, and diet pills gave her focus and endurance as she paced like a tiger. My body may have been pinned there—but my spirit was back along the muddy banks.

"Did you hear that?" she asked, banging the table and bringing me back to the kitchen. I took a shot on one of her favorite topics.

"How you had to quit college and ruin your life because you were pregnant with me?" This was a standard part of Mom's story, and not something I ever wanted to pursue. I did wonder why she married so young if she didn't want kids.

She glared at me, the cigarette dangling from her pursed lips.

"Did you even hear a goddamn thing I've been saying, or am I wasting my breath on you, like usual?" Her anger was rising, and she began to twitch.

"You know," I said quietly and evenly, "all this time you've been rambling about responsibility and sucking down cigarettes—you could have just taken the trash out yourself."

Her head snapped around. I was an expert at reading her body language, something that would assist me later in life filming apex predators, so I knew my next move was key. I lowered my head—not in submission but in something else. Something changed in me that morning, and I suddenly felt liberated. I just didn't care anymore. I didn't care if she hit me a thousand more times—I was all scar tissue anyway.

She couldn't snatch the awkwardly long wooden spoon out of the drawer quickly enough, so instead grabbed the wire-handled lime-green fly swatter on the counter. I ran for the door, and though she clocked me a few times in the back of the head while I fumbled with the handle, several seconds later, I was jumping off the porch, heading for the blooming Honeycrisp and Golden Delicious apple trees, out of earshot and away from the violence. I knew she wouldn't pursue me outside in front of our new neighbors.

The orchard and surrounding open country became my go-to place for recreation and sanctuary from tensions at home. Plus, there were lots of cute girls around the orchard and ample smallmouth bass in the Elkhart River. Most summer days when my chores were done, I'd skip the girls and head to the river with friends. We would explore, fish, swim, sunbathe, talk about girls, and try to dunk each other—typical teenage-boy stuff. I felt like Huck Finn.

Some of the older kids who frequented the river smoked pot and drank beer. When they offered me a burning joint, while standing knee-deep in the river, I declined. I had signed a code of conduct pledge as part of playing football that prohibited drugs, alcohol, or

tobacco. The guy holding the joint exhaled while laughing and told me that most of them were starting football players and instructed me to take a hit anyway. It was true, no one was under the code of conduct agreement implicitly during summer break. But I believed everything I'd heard in church about the evils of drugs and alcohol. I'd hoped my continued refusal to smoke pot would impress them as dedication to the upcoming football season, but I was mostly the butt of jokes as my other friends began to partake while I continued to refuse. Back then, I could have never suspected that one day drugs and alcohol would consume me.

I was facing typical adolescent issues while trying to cement my recent emotional separation from my mom. I truly believed that she couldn't hurt me anymore, couldn't take anything integral from me. But I was wrong.

One day, I came home to find that my dad had packed his Ford pickup with most of his belongings. A canvas tarp covered the contents of the bed. The passenger seat was packed full. He was tightening black rubber bungee cords that held the tarp down when he saw me. There were tears in his eyes. It was only the second time I had seen him cry. The other time was after a rare too many beers when the Vietnam War photos came out.

He told me that he couldn't endure it anymore, that he had to go, he couldn't live with her. I told him that I understood. And I did. Mom was always moody and resentful. Plus, she was sneaking around behind his back. Between that and the anger, I don't know why he stayed as long as he did. Secretly, I wanted to go with him.

My dad was a mostly quiet man who reminded me of the *Dirty Harry* movies we watched together. I could imagine Dad, clad in his greasy, green mechanic's uniform also squinting at the bad guys with a .44 Magnum in one hand and a hot dog in the other. I was at the age when I was beginning to wonder what he was like as a

teenager, before he and a few buddies took an unexpected vacation to Southeast Asia.

He and two of his childhood friends had patriotically signed up for the "conflict" in Vietnam. They enlisted together so they could stay together, while serving their country in the motor pool. One of their tasks was to go in ahead of the troops to establish base camps, which left them in a precarious spot, with little protection from the Viet Cong. One evening in the Binh Duong Province, while they were eating dinner and playing cards in their tent, Dad went to see if there were any seconds in the mess hall. They came under mortar attack while Dad was en route, and he jumped into the first place he could find cover, the latrine. When the shelling stopped, he saw that his tent had taken a direct hit: his friends were all dead. His first visit upon returning home in one piece, physically anyway, was to apologize to his dead friend's widow and child for ever encouraging her husband to go fight for his country in some godforsaken, hot jungle thousands of miles away from northern Indiana. He brought the tail fin of that fatal mortar round home with him and kept it in the medicine cabinet for years.

There was a golden, Indiana naiveté in him that turned to burnished rust in the jungles of Vietnam. That day while surveying the carnage of war under the stench of diesel fumes and smoldering flesh, both his youth and his belief in what they were doing were stolen from him. Returning from Vietnam, he drank ouzo, fought anyone who looked at returning GIs sideways, and got kicked out of every bar in town before finally destroying his beloved, souped-up Chevy after he went off the road drunk, hitting hundreds of sapling trees and eventually a pregnant cow. And with that final act of self-destruction, he quit drinking and settled into a backbreaking career as a semitruck mechanic.

Along came my young mom, with big dreams for her future.

She met the tall, quiet, shy truck mechanic with a steady job and even demeanor and, as I imagined it, fell in love. Mom thought she wanted the security that marriage with a stoic, even-keeled man could bring her, and they tried to make it work. The longer they were together, however, the more their differences began to grate on each other. Though she had dreamed of a glamorous future far from the mock metropolis of Des Moines and surrounding cornfields, her reality was much the same. Her big move in life had been from Iowa to Indiana, where she was still surrounded by cornfields. Instead of being a starlet in the Hollywood Hills, she was a factory worker living in a pink aluminum-sided house with her perpetually greasy-fingered mechanic husband and two rug rats.

My parents were never in sync.

"Let's go out and try that new Chinese place, Pagoda Inn," Mom suggested to Dad one night while I watched *Gilligan's Island* in the living room.

"I had enough rice when I was in Vietnam."

He was just getting home from work, clad in his filthy, green pants and matching long-sleeve mechanic's shirt. There was a company logo patch above the right pocket and a red patch that read JOHN above his left pocket in case any of the seven people he worked with for the last ten years forgot his name.

"You never want to do anything!"

I considered slinking away to my room, but I was watching Gilligan lure in hostile natives from a neighboring island with his drumming.

"I'm tired and I gotta mow the yard." The words trailed off, and Dad set his lunchbox and thermos down on the counter. Moments later, the lawn mower was humming, and my dad was in his happy place. This was how every argument ended: with Dad mowing the lawn. We had the best lawn in Goshen. I knew he watered and fer-

tilized our modestly sized yard vigorously, so he had a place to escape whenever he needed it. The more my parents argued, the more mowing he did. "I gotta mow" was his mantra. Mom stepped out; Dad mowed. Mom raged at us; Dad mowed. It got so all anyone had to do was say, "We're out of milk," and my dad would rise from quietly reading the newspaper and stride out the screen door, muttering, "I gotta mow."

So it wasn't a surprise when he left. Dad said he would be staying temporarily at Grandpa's house, and once he got his own place, I could come live with him. I think he sensed my dread at being left alone in that house as I investigated the cab, wondering if I could lie on top of the boxes and go, too. I waited for that "you're the man of the house now" routine I'd seen on TV, but it never happened. With both of us crying in the driveway, he got in his three-on-the-tree Ford, backed out, hit the gas pedal, and waved goodbye.

With Dad gone, my mom's new boyfriend was always at our house. Once, while Mom and I were having yet another argument at the breakfast table, he walked up behind me and smashed my face into a bowl of cereal. We immediately went to the tiled kitchen floor in a wrestling match with the spilled milk and Cap'n Crunch all around us. The fight ended in a stalemate, with both of us letting go of the other and going to opposite corners of the kitchen. It was then I told my mom that I wanted to go live with Dad. I fully expected to be hit again, this time by my mom. Instead, she found another, more brutal, way to be mean. The ace she'd been holding all these years.

"You wanna go live with your dad?" she asked, dragging on her cigarette until the end glowed orange. "Well, for your information, he's not even your father."

I heard her words, but they made no sense. I laughed a bit and asked what she was talking about. There was a deafening silence

while she stared at me and then abruptly left the room. Moments later, she returned with a folded piece of paper. It was a birth certificate from Polk County, Iowa, with the name *Charles Bradley Jones* and my birth date on it.

I stared at that piece of paper, my mind almost blank.

"You're welcome to go live with John, but I thought you should know he's not your real dad. John Orsted is actually the second cousin of your biological father, Chuck Jones."

I rubbed my trembling fingers over the raised seal on the document. How could this be true? My dad and I looked alike, and he'd been my dad for as long as I could remember. We went to drag races at U.S. 131 Motorsports Park, watched the Chicago Bears play football, and built pinewood derby cars for Cub Scouts together. *There was no way this could be true.*

Mom smirked.

Or could it? And who was this Chuck Jones I'd never heard about? Was it the guy whose name I saw on all the *Looney Tunes* credits, maybe? How could Chuck Jones and John Orsted be related?

If so, what else about my life was a lie? In a fury, I turned to the boyfriend.

"Don't get too comfortable sleeping here," I said. He carried a gun, and I was normally afraid of him, but at that moment, I just didn't care. Then I fled out the back door to the orchards.

Deep in the endless rolling hills of linear apple trees, I found a large, wooden crate the migrant workers filled with harvested apples for transport back to the orchard's processing plant. Someone had stenciled KERCHER'S SUNRISE ORCHARD with orange spray paint over rusty staples on each of its four water-stained sides. I hopped up and took a seat, staring at the closest apple tree. The tree had either been hit by a tractor or suffered some disease when it was young. The gray-black bark covered most of the scar, but its scraggly branches and scant fruit made it stand out among the

healthy trees. I felt like that tree. Scarred. Hit by a tractor or struck by lightning.

I picked at the graying dead top layer of the wooden crate. With the wind climbing up my back, I started to cry. I was fifteen and alone. I didn't even know who I was; my name and my father weren't real. I knew I had nowhere else to go but back to the house that was once my home but was now my mom and her boyfriend's love den. I knew I would find her seated on the couch, watching TV with the remote in her hand and a smug, recently crowned look on her face. Her tough-guy boyfriend who liked to beat up on teenagers would be sitting in my dad's recliner, reading gun magazines. An updraft of cold wind blew dirt into my mouth and eyes, and I used the inside of my T-shirt to clean myself. I walked home in the rain with white funnel clouds building against a gray sky.

Six months into psychoanalysis, all I felt was terrible. I would revisit incredibly traumatizing memories lurking behind the closed doors of my psyche and leave without the tools to deal with them. Sprawled on a mahogany faux leather couch with lights flickering overhead and the path to my pain laid bare, I would try to field—or just survive—my therapist's questions.

"Are you still dreaming nightly about Marley?" he asked, peering over his designer eyeglass frames.

"Yes," I said. "Except for the nights I drink myself to sleep—and even then, sometimes . . ." I trailed off, knowing I would be drinking that night.

"Do you still feel guilty—like you played a dangerous game of trust with your mother—delivering Marley to her death?" he probed, pen and legal pad in his lap. I mean, what kind of fucking question is that even? I stared at the wooden globe in the one well-lit corner of his office, wishing I were anywhere else in the world but

there. Wishing I had taken a late-night nosedive off the high bridge. Wishing I could blow my brains out right there in his office.

Every time I left therapy on my way back to Gardiner, I stopped at the first gas station to chug a beer before I drove the rest of the way home. It was the only thing that calmed me down enough to take the back roads home. I really wasn't sure therapy was working for me. The constant rehashing of Marley's death was something I just couldn't do. I couldn't see the end of it. I couldn't see how it was healing. I was growing bitter about how the two things that were supposed to help me, pharmaceuticals and psychoanalysis, pushed me closer to the edge. I tried one more visit, though, already dreading the inevitable therapy-induced binge that would follow the session.

"Last time you were in," the doctor said, flipping back a few pages and studying his notes, "you said your life felt like a Greek tragedy. Do you still feel that way?"

I squirmed a bit and wished I had taken *two* Xanax before my appointment. He made some notes while I pondered my answer and wondered how many times we could go over the same things.

"How long do you think I will have to be in therapy?" I asked. The sandalwood candle on the coffee table gave off a sickeningly fake smell, and I noticed how slowly the ceiling fan was turning. I didn't know there was a setting that low.

"Honestly, Brad," he began, setting down his pen and taking off his glasses, "I have lifelong clients who have been through much, much less than you. I think you should plan on being in intensive therapy the rest of your life." Now I wished I taken *three* Xanax. And that damn candle was making me sick to my stomach.

"Do any of those people ever get better?" I asked hopefully.

"Define 'better,' Brad. They are coping."

"But they have to come see you every week just to cope?"

"It's better than the alternative."

"Maybe," I said, staring out at the alpenglow on the Crazy Mountains.

"Look, if you want any hope of whatever 'normal' will be for you—you should actually be coming twice a week instead of just once." I thought about the thousands of out-of-pocket dollars I had already spent going to see therapists.

"How much do I owe you?" I asked.

He put his glasses back on and shifted his weight. "Why, Brad? Are you ending our professional relationship?" But he smiled as he checked his notes. I think we both knew I didn't have the constitution for a life of biweekly, intensive therapy.

"The only place I feel good is out in the wild—away from all of this," I said, waving my arm around his well-furnished flat while contemplating a one-way trip into the backcountry.

"What about your suicidal fantasies of jumping at night from the Brink of the Lower Falls in Yellowstone?"

"I don't have those anymore," I lied.

"Mm-hmm." He nodded in disbelief. "Brad, going on your own from here is a very dangerous decision. You are broken and very fragile right now—prone to emotional responses and quick to anger." The statement really pissed me off, an irony that wasn't lost on me.

"Well, my only other option is a life of therapy and a constantly evolving myriad of prescriptions, right?"

"It's called *coping*, Brad."

"I'd rather be dead than resign myself to that existence. How much is my balance including today?"

"There's no charge, Brad," he said, taking his glasses off again and shifting in his leather seat. "Somewhere else you'd rather be?" he joked, catching me staring at the globe.

"Anywhere." I smiled, shook his hand, and thanked him for doing all he could. I left convinced, or at least hoping against hope, that I could find salvation in Yellowstone.

Salvation came in the form of a guiding job with another company, and just in time. Losing the guiding job at Yellowstone Association had been devastating, as had been some of the social issues that came with it. Word had traveled around the Yellowstone Association, and even though everyone was incredibly considerate, I was embarrassed and ashamed. I'd overheard a few resident instructors talking in the gear room, "Jesus, his mom killed his daughter. No wonder the guy has a drinking problem." So much for being a discreet alcoholic. Now I was that sad, broken guy everyone felt sorry for again.

When I left the psychotherapist's, I spent several days binge drinking: passing out whenever or wherever the pills kicked in. Then one day, I wandered into town for tacos. A new friend who had also just moved his family to Gardiner was munching on the deck.

"Hey, man," Steve Bierle said. "Get your food and come sit with me."

Fuck. The last thing I wanted to do was talk to anyone in the community. There was a reason I was wearing all black and hiding behind sunglasses.

"Okay," I said, nodding and waving back. I knew Steve and his family were already active in the local church as well as adventure outfitters. We had spoken several times, and I liked Steve—I just didn't like myself right then.

"How's things?" Steve asked, wiping lettuce and shredded cheese from his face with a napkin. Seated next to him at a café table with my own red basket of tacos, I felt anxious and trapped, even on the patio. I grabbed a taco to prevent an anxiety attack and avoid the question.

"Could be better. How about you? How's business so far?"

"Business is great! Our first year is shaping up really well."

"That's awesome." I reached for the hot sauce.

"Hey, I heard a little bit about everything," Steve said.

Here we go, I thought. I'm getting invited to church. I should have just eaten canned soup at home.

"So what are you going to do?" he asked.

"Eat tacos," I said, taking another bite.

Steve leaned back laughing and threw his wadded-up napkin in his basket. "Look, if you want to guide for us—I spoke to my wife, and we'd love to have you."

"What about my DUI?"

"YA has much more stringent guiding policies than a private enterprise. Since they are the official educational nonprofit partner to the park, they must go over and above. How long ago was your DUI?"

"A year and a half ago. I completed everything the court asked. The judge even acknowledged this was a complete aberration in my behavior and took leniency on me. It was exactly one hundred days after my daughter's death, and I'd never even had a speeding ticket before that." The explanation came pouring out of me.

"We're good, dude!" Steve announced confidently. "I may have to pay a higher premium on my insurance for you—but I've seen your photography, your passion for wildlife and the park, and I know you had a pretty rough break, so we want to help."

I teared up; then Steve did, too. Two grown men eating tacos and crying on the deck in front of tourists.

"Are you serious, Steve?"

"Yup!" He smiled. "Welcome aboard! I'll have Sandy send you everything we need to get you a guide card and on our insurance. Can you start Friday?" And like that—I was a guide in Yellowstone again.

Spring arrived with my first official sightings of a mountain bluebird and a western meadowlark. Both species migrated for the winter, so when they arrived back in Yellowstone as messengers of warmer

days, every guide in the park trained their scope on these colorful birds for eager clients. The western meadowlarks were heard first with their melodious greeting. The male mountain bluebird was a cobalt-blue dart against a backdrop of greening Wyoming big sagebrush. A new chorus of birdsongs seemed to fill the air every day, along with the exhaust of a steady stream of tour buses bound for Old Faithful and huckleberry ice cream.

I'd seen these birds before, but after a monthlong naturalist course and a few weeks guiding in Yellowstone, the complete immersion made me feel like we were more connected, like neighbors. It was almost as if the wildlife and I were coworkers, both there to enhance the visitor experience.

One cold, wet morning in the Lamar Valley, my clients were admiring newborn bison calves called *red dogs* because they are born with shaggy red coats. The bison herd was close to the road and lazily grazing while the days-old calves chased each other and played. While the family laughed and photographed the red dogs running and kicking in every direction, I turned to get coffee and snacks out for everyone.

Across the lush valley, on the slopes of a massive, verdant bench was another herd of bison, but this herd was running uphill bunched together. I'd seen a lot of bison herds, and this was unusual behavior. Spring was a time of fattening up on all the new green shoots of vegetation popping up, recovering from winter, and giving birth. Why would they suddenly start sprinting uphill? My training taught me that these nearly one-ton animals don't usually stampede without a reason. Was there something chasing them, or were they just feeling frisky?

Raising my binoculars and looking toward the back of the herd, I hoped to be the first guide to spot wolves that morning. At the back of the herd, I saw one small bison that was way behind but

catching up fast, although its gait seemed different. *Wait . . . that's no bison,* I realized, *that's a grizzly bear!*

What I saw was less than ten seconds of a giant, dark grizzly bear closing the gap on some newborn bison calves at the back of the herd as they crested the top of the slope and galloped over the other side. The last image I saw through my binoculars was the grizzly making a hard charge at a bison calf toward the top of the hill at a terrifying speed, the sagebrush exploding around him. Then they were gone. I didn't even have time to alert my clients. I slowly lowered my binoculars, gulped, and finished making their snacks. I was, like everyone in Yellowstone, awed by the grizzlies: by their power, their ferocity, their speed. They were the park's apex predator extraordinaire, and though I didn't know it yet, my very life force would become linked to theirs.

4

The Crow Sweat Hot

The Crow sweat hot!" Sweeney said, highballing down the dusty gravel road. It was August 2012, three and a half months since my face-to-face encounter with a grizzly: the beginning of my long journey to recovery. I was going to my first sweat lodge, where a respected Crow elder would be "pouring" or leading the ceremony, so it was important I understood the etiquette. I already knew that I could never divulge specific details of the sacred and secret ceremony; they were a gift to me and not mine to share.

"Once you are in the sweat lodge and the flap is closed, there is no leaving," Sweeney continued. "If you pass out, try not to fall into the glowing, red-hot rocks in the center, and we will drag you out." He was very matter-of-fact. I was getting nervous about my request to share in this centuries-old ritual as we motored past painted hills and timeless bluffs, heading deeper into the Crow Agency Reservation. I looked back to see if I could get my bearings, but all I could see was the wall of dust we were leaving and I-90 disappearing somewhere in the past.

"The Crow sweat naked, too," he said. "So you'll be in a hot,

confined, dark, tight space with a bunch of naked Indians." He laughed and offered me a cigarette. I think he sensed my nervousness and tried to lighten the mood. "Just focus on why you are in there. Think about your daughter and your sacrifice. You are going into a sacred ceremony to give of yourself and seek healing for you and your family. Listen to the words. Even though they will be in the Crow language, and you won't understand them, the words are sacred and powerful." He looked directly at me while pulling on his generic cigarette. I smoked, too, but nervously, while staring out the window as we swerved along deeper into the reservation.

I had spent time on several occasions with Loren Black Elk on the Pine Ridge Reservation in the '90s, and after losing Marley, I sought sanctuary in Michigan's Upper Peninsula among the Ojibwa and their tiny, cedar house cemetery with "spirit houses" marking the graves. I hoped through this ancient ceremony of purification I might find some lasting healing, peace, and understanding after the death of Marley.

The old Forest Service–green Suburban began to slow as our own road dust caught up and engulfed us. We turned down a long, dirt driveway headed toward a creek bottom lined with cottonwoods and mineral-stained, chalky bluffs in the distance. Nearing the small house and cottonwoods, I noticed a Crow-style tipi and, among the several vehicles parked there, the truck of the tall Native man Sweeney had asked in private back at Crow Agency if I could attend. Tim was his name, I learned, and he exclaimed, "A 'ho!" as we pulled the dusty, hot truck under the cottonwoods.

"A 'ho," Sweeney said as we stepped from the truck and made our way over to him.

"You guys ready for this?" Tim nodded, projecting his words and pointing toward a partially hidden structure with his mouth. He was dressed in jeans, a white snap shirt, and cowboy hat and

boots, with long black braids running down his chest. His question was in our general direction, but it seemed his words and crazy-ass stare were directed at me.

"C'mon." Tim motioned, turning toward the back of an out-building. "The rocks are hot, and it's a good day for a first sweat!" Tim gave me a look of reassurance, but I was in a daze.

I had read about this ceremony many times and felt like I understood the literal and symbolic meaning, but as Sweeney and Tim walked and made small talk, I felt like an outsider. What the hell was I doing? This wasn't reading *Black Elk Speaks* on the front steps of the library in Boulder, Colorado . . . this was for real and about to happen. I was headed way outside my comfort zone. This might have been another of my overly romanticized notions. The gravity of what I was about to do made me feel like I was moving underwater. *These are not my people,* I thought. *I don't even have fucking people.*

In all my readings and visits to Pine Ridge, had I neglected to remember the murderous history between Euro-Americans and Indigenous cultures? Did I seriously think this healer who came down from the hills especially for this, who communed with nature and lived in sacred, ancient ways was going to buy any of my bull-shit? A guy who could probably sense my arrival before he knew I existed. He probably knew my trepidation as well and reveled in the fact I was psychologically squirming in my Chaco sandals. The very shoe that says *white tourist.* What if I did pass out face-first onto the bone-searing hot rocks? What if I had a bad experience? What if the spirits called me out as a phony and undeserving? What if I shit my pants? I couldn't even do that, as I would be naked. This might be a huge mistake. Then I remembered what Sweeney said: "Think about your daughter." My head immediately cleared. I was here to pray for Marley and my other girls. I was here to find peace and healing for loved ones—and myself.

It was then I got my first close look at the sweat lodge and an

older Native man standing near it. He was shirtless with short hair and a towel around his waist. The lodge was under a three-sided stall with the opening facing east. The lodge itself was a combination of bent branches formed in a circle and an assortment of blankets and tarps draped over it to seal out light. I saw the firepit outside the lodge with about a dozen similarly shaped and sized rocks sitting on the glowing embers. There was a pitchfork, a metal bucket full of water, and a metal dipper inside the bucket next to the lodge. This was all happening too fast.

There were some brief introductions, words said in Crow, laughing and embraces between Sweeney, Tim, and the old man.

"This is Mr. Old Horn," Sweeney said. "He will be pouring for your first sweat lodge."

"Hi, Mr. Old Horn," I stammered, extending my hand. "Thank you for the opportunity."

"Where are you from?" Old Horn asked, shaking my hand and walking right through my thank-you.

"Yellowstone," I replied. "We live in Yellowstone."

"Oh, you live in our home," Old Horn said flatly.

I had been so proud that we lived in Yellowstone. Whenever I announced it, I waited for the wide-eyed oohs, aahs. People were fascinated at our good fortune to reside in the world's first national park. Not so much this time. I looked down at my feet and noticed how pale they were next to Old Horn's. I was tense, but my companions seemed light and jovial, joking in Crow. Probably about my nervousness and possibly where they would ditch my body after I crapped myself and passed out on the glowing rocks. I tried to laugh, too.

As they spoke, I looked around. I wondered how many ceremonies had been conducted in this sweat lodge I was about to enter. I was told back at camp that Sitting Bull and his band of Hunkpapa had sweat nearby before the Battle of the Little Bighorn. Outside the

lodge, this looked like any other reservation homestead. A modest house, a few outbuildings, numerous cars and trucks in various states of decline, and, of course, horses. The Crow always have horses. I then noticed a bat hanging upside down on the rafters right above the sweat lodge.

"Hey, you see dakáakbaleleepe hanging above the sweat lodge?" Tim asked me, pointing to the bat with his face. I nodded. "He oversees our ceremonies," Tim said and let out a whoop and boisterous laugh. His eyes looked deep and vacant, like river-polished black stones. He nodded to me, laughing enthusiastically.

"Remember why you are in there when the heat becomes intense," Old Horn said to no one in particular. "Focus on my words," he added, now staring at me.

His gaze was fixed and as expressionless as the stand of dead cottonwoods that lined the creek bottom. He looked right through me, like he was studying something on the horizon. I felt a jolt of adrenaline. While the other two joked, Old Horn was all business. There was an air about him—a calm power. Old Horn leaned down, picking up a handful of prairie dirt, cleared his throat, and began to speak.

"We enter the same way as the sun," Old Horn started while the dirt slipped through his opening fingers, falling back to the ground. I saw Sweeney and Tim step over to a coffee can on the ground that had smoldering sage smoke rising from it. I watched them cup the smoke and then move their hands over their bodies as if rubbing the smoke all over themselves from head to toe. They did this several times and nodded for me to do the same. I followed suit, and then Old Horn spoke again.

"You like baseball?" he asked me, dusting off his hands, then cupping the smoke himself.

"I used to."

"Are you familiar with the hot corner?"

"You mean third base?" I asked.

"Yes." He smiled. "Since you are the guest, you will enter first and be in the hot corner." He motioned to me as he opened the flap to the lodge.

"We enter naked on our hands and knees."

We all disrobed, and I got down on all fours, crawling through the dirt at the lodge entrance. Old Horn lifted the flap opening, and I entered the womb of the lodge as naked as the day I was born. It was dark, but I made my way around the small pit of hot rocks in a clockwise direction until I came almost full circle. When I stopped, Sweeney and Tim entered in the same fashion and took their places. Old Horn said something in Crow and then entered, leaving the flap open. It was dark with the only light coming from the small opening, and my eyes struggled to make out my tiny surroundings. It was then that claustrophobia began to creep in. I realized that although I was close to the opening, there was a pit of hot rocks between me and the door. *Remember why you are here. Remember why you are here,* I kept repeating in my mind.

"Once I begin and close the flap," Old Horn began, "no one can leave until the flap is opened again." He then said something in Crow, and I thought I felt a small tremor underneath the lodge. I looked to Sweeney, but he had his eyes closed and was nodding like he was entranced.

"Try to stay upright when the flap is closed and beat your back with the chokecherry branches," Old Horn said, handing me a small bundle of branches. I looked at Sweeney and Tim, and they were both holding bundles of branches, too. Old Horn said something in Crow and closed the flap. Although it was the middle of a bright, hot day in August, the world went dark.

Old Horn began praying in Crow. I assumed it was a prayer, because of the cadence, and I occasionally heard the names *Mike, Tim,* and *Brad.* It was remarkable how dark it was in that confined space.

You couldn't see your hand in front of your face. Hell, you couldn't see your hand *on* your face! The complete visual deprivation heightened my sense of smell and hearing, which made it easier to breathe in the burning sage and sweetgrass while focusing on Old Horn's words, even though I didn't know the Crow language. I did know that what he was saying was holy, and I tried to listen hard to how each word sounded. The cadence was rhythmic, pounding at times like buffalo hooves on the prairie. Then other times soft and almost inaudible like a whisper. There were whoops and punctuating yells from Sweeney and Tim as I sat there sweating in the stillness.

Then came the heat. Creeping across me at first and nowhere near the intensity I had imagined. It was about the same temperature as a hot sauna and felt good on my muscles and in my lungs. I did my best to breathe it in—stunted gasps at first until I could get the moist, warm air to the bottom of my lungs. Focusing on Old Horn's words, I felt the pregame jitters lift as I took my place in the sweat lodge. Maybe I did belong in here today and wasn't so far out of my element. Weren't all people born to touch the earth?

Water spilled from the dipper over the deep-heated rocks and hissed, announcing a new concentrated wave of heat. I instantly bent toward the ground but remembered Old Horn's advice and righted myself. I remembered that I was supposed to smack myself with the chokecherry branches, but I'd lost them in the darkness and could barely function. I thought about Marley in an abstract way and focused all my attention on remaining upright. I wasn't going to be the guy facedown in the dirt when the flap opened. Suddenly, a blinding light poured into the lodge along with the most welcome breeze I ever had the pleasure of meeting. I looked over, and both Sweeney and Tim were flat on their stomachs but crawling up to meet the light. Old Horn looked at me and nodded saying something in Crow.

"Hey, all right, you stayed up," he offered in the same cadence he

had been praying in. I nodded back, unable to speak. "I guess next round we'll have to *really* make it hot!" Old Horn said sternly with a nod, looking at no one.

Wait, wasn't that really hot? I thought, drinking a small amount of water from the metal dipper.

We joked and laughed, lying in the lodge with the light and breeze pouring in. The conversation was mellow, and Old Horn was incredibly funny when he wasn't so dead serious. He was easygoing and easy to talk with, and he made sure to include me in the dialogue. It seemed a bit odd to chitchat during a centuries-old purification ceremony. Maybe I expected a reverence from start to finish, like in a Catholic mass. But we were just four guys on break telling jokes and busting on each other like we hadn't a care in the world. Suddenly, Old Horn's demeanor changed as he said something in Crow. Sweeney and Tim both acknowledged what Old Horn said with an *mmmmm* sound.

"We ready?" Old Horn asked. "The flap is closing. Let's get this one good and hot."

Once again, total darkness prevailed. I heard the dipper clang the metal water bucket while Old Horn prayed and now knew that meant a pour was coming and it was about to get very hot. How hot I could not have imagined. I don't think the thermophiles living in Yellowstone could have anticipated the degree of heat encapsulated around us that day. Whereas before there was an ever-so-slight lag between the hiss of the steam on the rocks and the overtaking heat, this time it was simultaneous. Previously, the heat hit and swirled, leaving cooler spots at the back, near my feet. This time, the inferno smashed into my face, stealing my breath, while completely engulfing me until the soles of my feet felt like they were blistering. I knew another pour was coming. The hiss cued a heat no human who hasn't been in a sweat lodge could ever prepare for. It took me straight to the ground.

Now I was flat like a bull snake trying to get under a rock. My face went directly into the crook of my bent arm, but there was no cool air to be found. I tried to get every square inch of my strained body against the dirt floor. My skin felt like someone had soaked a blanket in napalm, lit it, and wrapped it around me. My shallow breaths found only more hot air, and I started to panic. I had to get out! To compound the unhinging hysteria, I was sure I could feel blisters starting to form on my back now. This was bad and had gone too far. Then I heard the ladle again and braced myself.

This time, I was ready and in position for another wave of purifying heat. I had no shame left. Like a naked, dirty earth child being born into a strangely new, dark world, I was in a forward-facing fetal position in one of the oldest ceremonial structures on the planet. The heat slammed into my head and cascaded over my body, like boiling butter. I timed my last deep breath of cool air before the penetrating heat invaded my little buffer. When I tried to breathe again, I couldn't. The air was so hot my windpipe closed and wouldn't let any air through. I kicked myself for not asking to leave at halftime when the flap was open. I twitched and spasmed. Old Horn's voice sounded like it was coming from inside my head, like it was coming from the same place internal dialogue does. I focused hard on his sacred words, doing my best to endure and, above all, to remember why I was there.

I was there for Marley.

On the evening of April 22, 2009, Marley Anne Orsted came into our world. She was our Earth Day baby, and Charles Mingus was playing in the background. She came into our lives beautifully and easily, with no complications except that I nearly passed out. The ob-gyn looked at me just before delivery and asked if I needed a chair. I said no, but someone wisely put one behind me anyway.

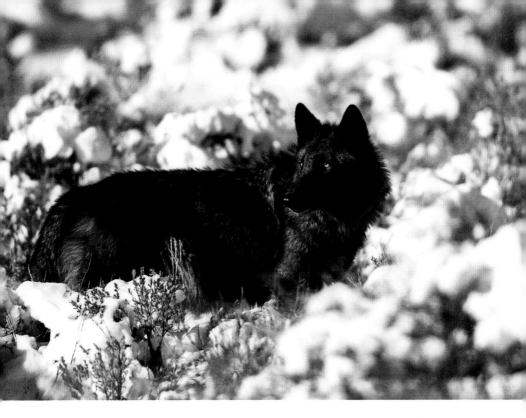

(Above) 926F before she was collared and the alpha female (Yellowstone 2013)

The white alpha female of the Wapiti Lake Pack howls to a rival pack. (Yellowstone 2020)

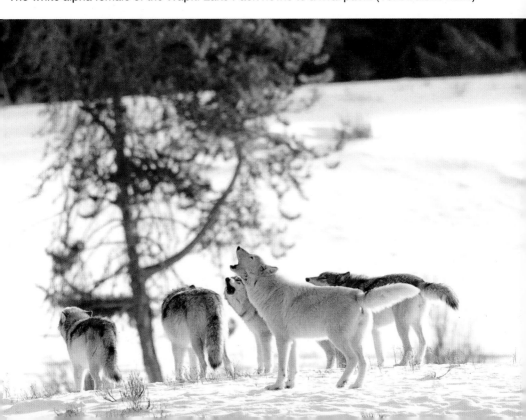

Mountain lions are masters of using the natural resources as camouflage. (Yellowstone 2018)

Me and Casey Anderson filming mountain lions (Montana 2015; credit: Travis Gillett)

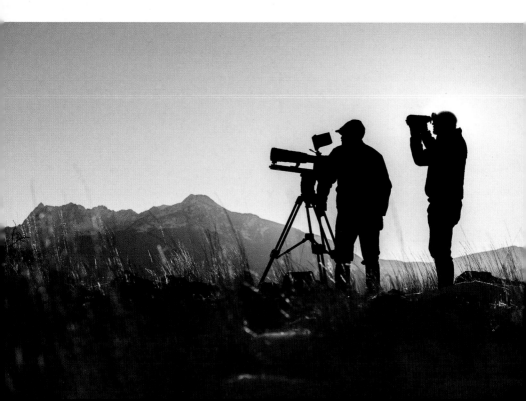

(Above) Me and Doug Peacock attend an event at Patagonia. (Dillon, MT, 2019)

At my new job guiding in Yellowstone (2012)

(Above) Photographing in
Monument Valley (2019)

Working on *Through the
Wilderness* (Emigrant, MT,
2021)

(Below) Photographing
grizzlies on Swan Lake
Flats (Yellowstone 2018)

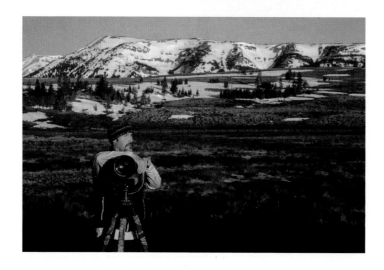

My biological father, Chuck Jones

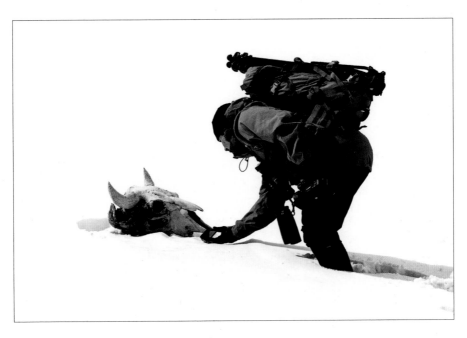

Photographing Casey in Yellowstone (2014)

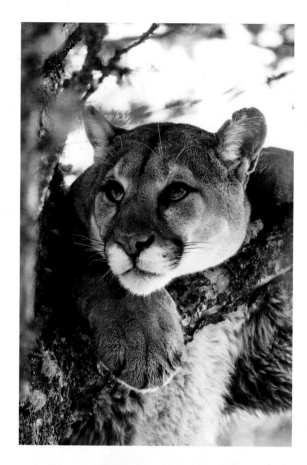

The first big male
mountain lion I ever
photographed (2013)

(Below) Crow tipis
at Crow Fair (Crow
Agency Reservation,
MT, 2012)

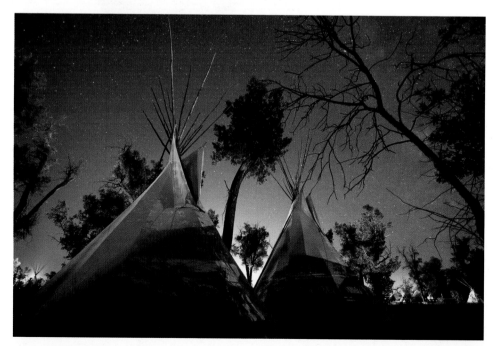

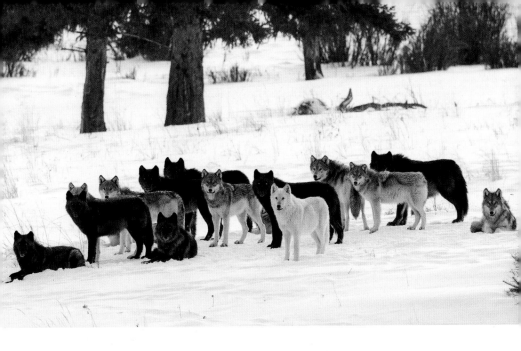

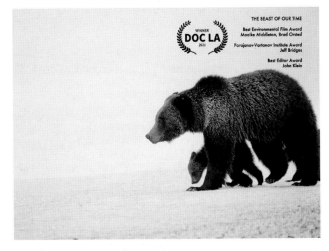

(Above) Family affair—the Wapiti Lake Wolf Pack in Yellowstone (2020)

Film award with Jeff Bridges

THE BEAST OF OUR TIME

Best Environmental Film Award
Maaike Middleton, Brad Orsted

Parajanov-Vartanov Institute Award
Jeff Bridges

Best Editor Award
John Klein

WINNER
DOC LA
2021

The fox is one of my spirit animals.

Great horned owl on a crucifix at dusk (Emigrant, MT, 2020)

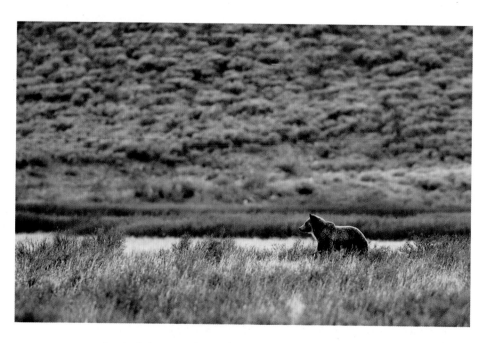

A grizzly bear on Swan Lake Flats (Yellowstone 2013)

The music is intertwined with my memories of the birth. The tambourine jangling like rain on a metal roof, the *ba boom boom boom* of Mingus's upright bass. Cymbals crashed. No one touched the volume, but the music pulsed louder and louder in my ears, in my head, spilling into my veins, as Stacey pushed, moaned, and ratcheted up her grip on my hand.

The first thing I saw of Marley was her dark head of hair easing into the ob-gyn's waiting hands, and then I was cutting Marley's umbilical cord, with tears rolling down my face. The nurses cleaned Marley and wrapped her in a warm blanket before handing her to Stacey.

That was my first image of her. Safe in her mother's arms.

This was my last. She was sound asleep with her middle two fingers in her mouth and the fan gently blowing her bangs. She was peaceful, happily napping in the balmy stillness of a summer afternoon, safe at her grandmother's house. It was July 14, 2010, and I got in my truck and drove away.

Barely a day has gone by since that I haven't tried to understand what happened before and what happened after.

The "before" began with a visit from my mom in June. She and Marc, my stepdad, drove up from Indiana. Things had been rough between us in my adolescence, but that was nearly thirty years in the past. Over the years, she had mellowed into an eager grandmother in practice as she babysat many of my friends' kids. Since I had moved to Michigan and started a family, Mom had made numerous efforts to be a part of our lives and make up for lost ground.

We sat on the deck, surrounded by blooming forsythia and rhododendrons, and watched Marley play in her pool. Marley splashed and laughed, turning to make sure everyone was looking before resuming her antics. Mom seemed as happy and lighthearted as I'd ever seen her.

"Isn't she adorable?" Mom asked Stacey.

"Yes, that's her routine. I'm not sure who enjoys it more, her or us," Stacey joked, taking a sip of her salt-rimmed margarita.

"You're such a big girl," Mom said to Marley. "Do you want to come have an overnight visit at Nana's house? Just us girls?"

I knew where she was going with this. She had been asking to have Marley for an overnight visit ever since hearing that Marley had stayed with Stacey's mom. My mom was certainly doting over Marley, and a part of me was jealous. She sure as hell wasn't that loving, attentive, and patient when I was a kid. If Marley was in the room, it was difficult to even have a conversation with Mom, as she was so baby focused. Stacey and I were happy with her sincere desire to be a part of our family. We had considered her request to have Marley overnight but weren't ready to make a commitment right then.

"Well, what do you think?" Mom asked, squinting and laughing through the pool spray. "Is she big enough to have her first over-night visit to Nana's?"

"We'll see. Stacey and I have been talking about it. There would of course be some ground rules," I said.

"I've been babysitting more since I retired and even lost some weight trying to keep up with the kids." It was true, my mom did look like she had slimmed down and even had a healthy glow. "Next month is Marc's birthday, so maybe you could bring her down then, and we can bring her back up on his birthday."

"We'll talk about it, then," I said.

Stacey nodded, sipping her margarita, not willing to commit.

"I'll follow whatever ground rules you want, Stacey," Mom said.

"What about your epilepsy?" Stacey asked. My mom had been diagnosed with epilepsy as a child, but with proper care and med-ication, it was completely manageable. "That's honestly one of my main concerns."

"Since I retired a year and a half ago, I haven't had any issues. I

think it was the stress from the job that brought on episodes," Mom assured Stacey.

"Have you ever had a seizure while caring for any of the kids you babysit?" Stacey asked bluntly.

"Oh no, of course not, or I would never offer to babysit."

"What about your heart and general health?" Stacey added.

"I meet with my doctor regularly, and he's very happy with how my health has improved since I quit that damn job with the county," Mom said, laughing.

Stacey and Mom smiled at each other, and both took a sip of their drinks. It made me happy to see my mom address Stacey as Marley's mom and show her respect. Maybe there was hope for our insanely blended family to all come together. As Marley giggled, turning to a prune in her pool under a sapphire-blue sun hat, I wondered if she would unknowingly be the glue that finally brought our broken family back together.

Even my sister, who had grown cynical and weary of our mom's antics while still in college, was amazed at her newfound less obtrusive and passive ways. Mom had been making efforts to be a part of both of our lives, also making frequent visits to Kalamazoo where my sister worked as a microbiologist. Neither one of us were ready to jump in with both feet yet, but it was encouraging. We were both tired of being from a broken family. When Mom left that night, I told her we'd think about a visit.

On July 4, we went to the beach with Marley. Mazzy and Chloe were in Montana with their father. People stopped to admire Marley in her little blue sun hat, digging in the sand at the water's edge. We decided to drive into Grand Rapids and take Marley to the zoo. It was her first time, and she was enthralled with the river otters. She was so tiny and precious, watching them through the underwater windows. Marley giggled wildly when they swam by in what seemed to be a play session just for her. The otters were as intrigued with Marley

as she was with them, and they delighted in each other's presence, drawing a smiling crowd of fellow zoo-goers.

As I watched Marley giggle and point at the river otters, I knew this was one of those moments that would transcend into a treasured memory. There are certain moments in life that you mark. I marked it. I smiled at Stacey because I was just so damn happy. So much had changed in my life in such a short time. I had gone from a careless drifter to a family man. Right then, with my wife crouching next to our baby girl at the otter exhibit, I felt like the luckiest man alive.

When we got home, I phoned my mom to tell her about the day. She laughed as I described Marley and the otters. She asked, again, if she could have Marley for a few days. With Marc's birthday around the corner, it seemed like a good time. Marley was fifteen months old, standing on her own, and starting to talk. Marley had spent the night at her maternal grandmother's house, so after making Mom promise to follow our instructions, we agreed to an overnight visit to Grandma's house. I would take Marley to Goshen on a Wednesday, and my mom and my stepdad would bring her back home to Holland on Saturday for a cookout to celebrate his birthday.

Wednesday morning, Marley and I set out for Indiana. Even though she'd had breakfast, she was getting fidgety, and I thought we could both use a second breakfast. I grabbed some breakfast potato bites from Burger King, which we ate in the parking lot. I faced forward and watched her through the rearview mirror as I handed her a potato bite. I would say, "Hot," and hand one to her even though they weren't, and she would grab it, blow on it, and say, "Hot," and we'd both laugh. She was so darling sitting up like such a big girl in her car seat. The wind from Lake Michigan was blowing her fresh-cut bangs around in her face. She was a little beach baby with summer shining all around her.

When we arrived at Mom's house, Marley was getting tired, so

I set up the pack and play in the guest bedroom and laid Marley down for a nap. My mom and I spoke for a while about random things and her plans over the next few days. I wanted her to take it easy and enjoy her time with Marley. I knew she was anxious to parade her all over town, but I didn't like my daughter being in cars if she didn't have to be. My mom's friends could come to her house to visit with Marley. I reiterated everything Stacey asked me to, and Mom told me that they would be fine, she'd watched dozens of kids. I added one last point: that she call me before bed that night and the following morning when they woke up.

She called that night, saying they'd spent the day at home watching the Cartoon Network and playing in the sprinkler. Mom had a doctor's appointment the next morning, and I asked her to call me as soon as they got back. When I didn't hear from her, I called and left a message. I began to reconsider the length of the visit. One night might be plenty. Marley was cutting some new teeth. She might get homesick. I would leave for Indiana immediately if Marley was out of sorts. Mom finally called before noon to say that they were at home and had stopped to do some shopping after her appointment. They were about to eat lunch and take a nap. Everything was going great. I rehashed the instructions.

"Marley sleeps in the pack and play, right?"

"Yes, Brad. She slept in it last night and will sleep in it today."

"It's not 1975 anymore—no co-sleeping with babies or co-smoking Marlboros in the car with the windows up."

She chuckled.

After lunch and a run to the pier, I took a nap myself. It felt odd not to have the baby monitor on for Marley's room. This was usually the time of day she would nap, and I would try to get caught up on work. But I got a kick picturing Marley running—or toddling—through a sprinkler. I reflected on how nice it was that my new and improved mother was part of her life. I closed my eyes with a feeling

of well-being and, despite the muggy summer day, was asleep in seconds.

The phone rang from the nightstand next to me, waking me instantly. It was Mom.

"Hey, how's things going down there?" I struggled to sound alert as I wiped the drool from my cheek. There was silence on the other end. "Mom?"

"Brad?"

"Yeah, what's going on?" The breeze coming off the lake kicked up into our open bedroom windows. I struggled into a sitting position so it could cool down my face.

"Brad?" Mom asked again, repeating herself. She sounded confused.

"*Yes?*" I got up and out of bed, a knot of anxiety forming in my gut.

"Marley isn't breathing."

I couldn't process the words. I could barely *hear* them.

"What?"

"She isn't breathing," Mom said, sounding spacey.

"Call 911 now!" The room began to spin and close in at the same time.

"I did," she said. "They're on their way."

"Start CPR!" I still couldn't process it. Of course she was breathing. When I left her, she was breathing. Children don't just stop breathing. It was a mistake. A terrible mistake. Maybe she was crying and couldn't get her breath, that thing Marley did that always gave me a mini–heart attack. "Mom!" I yelled. "Are you doing CPR?"

But I knew she wasn't. She was there on the phone, breathing heavily into it.

"Start CPR!" I was out of my fucking mind, screaming, but there was no response. Noise was rising, exploding, inside of me. "Mom, are you there?" I grabbed the doorjamb to steady myself.

"Oh, Brad."

Oh, Brad? Why did she sound so disoriented and aloof? Suddenly, it occurred to me that she'd been poisoned. Maybe they both had.

"*Hang up the phone and start CPR,*" my voice said without me, because I had gone somewhere else, scattering and flailing out of body.

"Oh, Brad," was all she could say.

"Is she blue?" I asked, desperate for something. Some help from my mom. Information, if nothing else. "*Is. She. Blue?*" I yelled into the phone, enunciating every word, wishing I could reach through the cord and throttle her.

"Yes," she said.

That took a moment to sink in. Marley was blue. So really truly, she wasn't breathing. Marley was blue. *My little Marley.* I had left her at my mom's yesterday for a sleepover, and now she was blue.

"What the fuck did you do?"

"The ambulance is here. I gotta go." She hung up.

"*Nooooo!*" I screamed, stumbling into the wall, blind with fear and rage.

I prayed like I had never prayed before, lying there in the Crow dirt with Old Horn now chanting loudly. I heard Old Horn say my name with the others, and it spurred us on. I felt honored to be there and so glad I had Marley to focus on. When it got unbearable, I thought of Marley. Yips and yells followed with another pour. The hiss, the flesh-burning steam engulfing my body as I inhaled my last cool breath. The earth dropped away, and I entered a void. There was no room for questions without answers. Only the hiss of heat—and the here and now.

It was then I found what I was praying for. When the searing

heat was at its apex, and I prayed for it to end, at that moment, it happened. In that otherworld, I found Marley. I could see her sweet blue eyes, talk to her, and finally smell her again.

I didn't want it to end, but now it was time to go.

Old Horn said several words in Crow, and the flap was thrown open again. Squinting into the light, I could see both Tim and Sweeney flat-faced on the floor, too. We were all drenched in sweat and covered with dirt.

"A 'ho!" Tim shouted.

"A 'ho!" replied Old Horn and Sweeney.

"A 'ho!" I threw in for good measure as we crawled out of the sweat lodge in the reverse order we had entered.

"Did you see dakáakbaleleepe?" Tim asked as we began to wrap towels around our waists.

Old Horn and Sweeney both smiled and nodded.

"The bat!" Tim said to me while pointing to the bat still hanging upside down above the lodge. "Did you see him flying around inside the lodge and making the ground shake?"

"That's what that was?" I said, puzzled. "I felt something but wondered if I was imagining it."

"You weren't imagining it, bro," Tim said. "I told you he presides over our sweats."

This got everyone laughing a bit. We washed off before dressing, the sage still smoldering in the coffee can. It felt cool in the hundred-degree shade. As I dressed, I felt clean, even though I'd only rinsed off with creek water after the most intense sweat I've ever experienced. The mood was casual, and everyone told stories as they made plans to get back to Crow Agency for the night's powwow and afternoon horse races. I threw in some comments, since I felt like I was part of the group now, but quickly realized both Old Horn and Tim had that same reserved distance with me they'd had before the

sweat. I immediately understood, and I remembered to listen more than speak. I was an outsider. Which was as it should be.

And with that, Old Horn said a few words in Crow and walked slowly back toward the sweat lodge. I stood there—stunned momentarily—as Sweeney said his goodbyes.

I took a long look around, hoping to make a mental map of where I had just been, but it was no use. Everything looked the same as everything else around it. I wanted a place I could pinpoint from the I-90 and say, "There! Something happened *there*." But we were deep in Crow country, where time wasn't linear and everything was more than it seemed.

After getting into Sweeney's truck, I looked back, trying one more time, but distinguishing my "there" was like picking out a tiny pebble in a handful of falling dirt as it spilled through Old Horn's fingers—returning to earth. Like trying to separate the clouds from the western sky. All I knew was I felt centered and protected, somewhere along the chalky bluffs of eastern Montana—a few miles away from the Little Bighorn River, as the crow flies.

5

The Long Walk Back

One snowy, cold November night in Montana in 2014, I was lucky enough to be driving around with Casey Anderson—filmmaker, wildlife naturalist, host of Nat Geo, and fifth-generation Montanan. We were looking for fresh mountain lion tracks in the new snow.

I had met him two years back, shortly before the Crow sweat, when I suggested Stacey contact him as someone who could help her Yellowstone Association. The future of the park lay with the youth, and it was imperative the YA changed the demographic on programs or soon there would be no organization or park stewards left. Casey was a living legend. If anybody could bring in a young, cool crowd, it was Casey.

I didn't know him, but I reached out anyway, and he agreed to meet us. Stacey and I went together on a Sunday. We drove north past Dome Mountain and through Yankee Jim Canyon to Paradise Valley and our destination: Chico Hot Springs. Steve McQueen used to ride wheelies on his motorcycle here and soak in the natural hot springs. The Chico Saloon is a favorite watering hole of locals and celebrities

alike. The bar entrance opened to a rustic wood interior with a window overlooking the hot pool and soakers. We found Casey sitting at a table with a beer and dozens of hats hanging from the ceiling above him. He was wearing his classic black beanie and sporting a goatee.

Eric Clapton belted out "Lay Down Sally" from the overhead speakers, and someone made a hard break on the pool table. Stacey and I introduced ourselves, and we all ordered beer. I was surprised that Casey knew who I was and that he claimed to admire my wildlife photos. Needless to say, I admired him. The beer kept flowing, and Casey and I connected, each of us showing videos we'd taken of wildlife and trying to outdo each other with wildlife encounter stories. (Casey left me in the dust.) I realized a little late that I had totally hijacked Stacey's meeting. Eventually, she made plans to meet with Casey when there wasn't beer on the table and I wasn't there to fanboy him.

I left thinking Casey was a pretty cool dude. I hoped we would stay in touch and that he would make good on his promise to show me a mountain lion in the wild. And he did. We became fast friends, but I was still taken aback with the life raft he threw me one early morning in the fall of 2014.

It was 6:00 a.m., and first light was starting to creep from the east and Blacktail Plateau. Several cars raced by the high bridge, beating a path toward Lamar to look for wolves when there was a pack cleaning up a fresh kill in the predawn light two hundred yards off the road to their right.

I was watching the canyon wolf pack devour an elk in Lower Mammoth. A text came in, and the notification boomed at such a startling volume in the still truck cab that I smacked myself in the face with my binoculars. It was from Casey.

Quit your job. Be at my house tomorrow at 10 am.

What does that mean? I texted back.

Quit your job. Be at my house tomorrow at 10 am.

I was used to his cryptic texts by now, but this one really perplexed me. What the hell did he mean quit my job? I didn't even *have* a job. My guiding season had just wrapped up, and I was thinking to pick up some bartending shifts at the Two-Bit Saloon for the winter. But come morning, I hopped in my truck and went north toward Casey's ranch.

I took the long way—winding along the Yellowstone River through Paradise Valley, Montana. The valley hosts such town names as Pray, Chico, and Emigrant, where a tidal wave of writers and artists landed in the '70s after they regained feeling in their faces from debauchery of biblical proportion in Key West, Florida. Jim Harrison, Tom McGuane, Richard Brautigan, Russell Chatham, Sam Peckinpah, and Ernest Hemingway I'm sure have all driven East River Road by Pine Creek Lodge and nearly veered off the road as I did—mesmerized by the towering Absaroka-Beartooth Wilderness area that expands all the way to Wyoming.

Casey lived around the corner from legendary author Jim Harrison in a natural wildlife funnel between two onetime pristine valleys. Bison by the hundreds of thousand would have used this thoroughfare between Paradise and Gallatin Valleys while expertly mounted Crow horsemen pushed the herds down drive lines to their slaughter. With Antelope Butte watching it all, you could almost see the smoke rising from tipi camps of full bellies. Neighbors excavate ancient bison skulls exposed in the creek bed after severe runoff years. The history and magic of this land are still in the bones and arrowheads lying just below the surface.

I walked into Casey's geodesic home and found him and another friend already seated at his kitchen table. Casey was biting

his fingernails and gave me a sideways ornery grin I would come to associate with sore knees and incredible wildlife adventures. Marci, who had been Casey's personal assistant for years, sat with a fresh yellow legal pad and a cup of tea. I hadn't seen her since . . .

"Hi, Brad," Marci said, warmly smiling. "Long time, huh?"

"Yes, it has been," I replied, wiping my feet and closing the front door.

Natural light flooded the living room, and the house smelled like woodsmoke from the fire in the stove. Casey, dressed in his black beanie and matching hard fleece, paused from biting his fingernails at the kitchen table.

"Well, get your ass in here so we can get this over with." Casey was staring at me uncomfortably. Why did I feel like I was in trouble?

"I don't know what *this* is." I walked in, smiling at Marci for answers.

Marci was unable to control her excitement and returned a genuine broad smile, then started laughing. But one look at Casey, and he was still dead serious as he cleared his throat.

"You know I've been talking to you, Brad, about some vague future plans I wanted to bring you in on, right?"

"Yes," I said, pouring a cup of coffee. I sat down at the antique kitchen table, and things became very serious. Even Marci was in business mode now, and I could see she had a page worth of notes in front of her.

"The reason you two are here," Casey began, "is I'm starting a production company, and I want you two as my core members." He said it like it was a bad thing—then just stared at Marci and me. *Classic Casey pranking,* I thought.

"Brad—I want you to be my right-hand man. I'm going to teach you how to film wildlife instead of photographing it. I'll show you how to build sequences and all the supporting shots we need for an assembly. I need you to help me purchase all the equipment this

is going to require. I basically need you to do a lot, and in return, we are going to film some of the most incredible wildlife moments people will ever see." Now Casey couldn't contain his excitement anymore, but it didn't matter—he had already sprung his trap. He laughed his crazy laugh, and Marci joined in while I sat there a bit shell-shocked.

"Were you in on this?" I asked Marci, starting to laugh myself now.

"I found out just before you did!"

I was in complete disbelief. Casey was a Nat Geo host and producer. His show *America the Wild* was incredibly successful, and now he wanted to teach *me* the ropes of wildlife cinematography? Since our meeting at Chico Hot Springs two years prior, Casey and I had embarked on a number of crazy adventures and pushed each other for more and more. We had sat in a blind at night drinking Jack Daniel's at a horse carcass with grizzlies circling and Montana stars all around us. We'd followed a big tom mountain lion to the top of the wineglass and photographed him before walking away. But this was work beyond my pay grade. I was a picture boy—not a filmmaker.

"Why me, though?" I asked amid the excitement. "I mean, you have an army of natural history filmmakers up the road in Bozeman at MSU with way more experience than I have."

"Because of that. Because of that question," Casey fired back.

I sat there quietly.

"Yes, I have several close friends who would jump at this opportunity, but I see something in you. Your humility, your passion, your drive, your dedication to getting incredible shots in Yellowstone. I know the work that takes, and if you don't love what you do—that grueling schedule will break you. We've spent the past two years together chasing wildlife, and you've never once questioned me when I said go up or go over a mountain, and you've always had my back. The rest I can teach you. Passion and loyalty, I can't." I

looked at Marci, and we all three had tears in our eyes. "Marci has always had my back, too, and that's why she will run the business."

My mind was racing with the possibilities. I had grown up watching Marty Stouffer, Jim Fowler, and Marlin Perkins, and more recently Bob Landis in Yellowstone, but this had never even been in the realm of possibility for me. As Casey spoke of gyro-stabilized, 6k Red Dragons with cinema lenses mounted to a four-wheel-drive truck, my mind was already racing across Alaska, Africa, and the grizzlies of Kamchatka we'd vowed to go film. Was this really happening? The idea of filming wolves in Yellowstone next to Bob Landis made my head fizzy.

"Who's ready for a beer to celebrate?" Casey announced, holding his hands in the air and bringing me back from my Lamar Valley reverie. And like that, VisionHawk was created around a kitchen table on a sunny November afternoon in the heart of Crow country.

It was only a few days later that we spent hours looking for mountain lion tracks in Yellowstone in vain. Finally, we gave up, and Casey dropped me off at midnight before starting the forty-five-minute drive to his place. As I was dozing off, I received a text from him. Fearing he might have had car problems or hit one of the dozens of six-hundred-pound elk sharing the road that time of year, I checked his message immediately. What I saw was an image of incredibly fresh, female mountain lion tracks in the undisturbed snow across Casey's bridge.

Neither of us could have predicted where that single set of tracks would lead us.

We eventually discovered that the set of tracks belonged to a female lion, a mother with three kittens who also called the butte home. She had chosen to make her living in part around the sparse homes where not coincidentally the deer came to graze and bed at night. This cat was killing deer literally right under people's bedroom windows without waking them up and dragging the carcasses

under a moon-laden juniper with the homeowners none the wiser. We were hot on her trail day and night. There was no playbook for how to follow a mountain lion family and try to film them. Neither was there a "Filming Mountain Lions" section in Barnes & Noble, so we had to get creative trying to build the right gear.

It was one of the most amazing times of my life. We were setting eyes on a mountain lion family regularly, getting extraordinary trail cam behavior, hiking our asses off in the brutal cold, and drinking Japanese whiskey at night as we gathered around an old toilet bowl that served as our workstation to smoke American Spirits and watch our footage from the day.

We felt like small gods. We drank and smoked all night, laughing and plotting while charging camera batteries and off-loading media. We rose early and sore, before most people had opened their eyes, and hit the icy trail with hot breath and headlamps in search of fresh lion tracks. The process of layering up—boots, gaiters, gloves, binoculars, hats, scarves, coats, and heavy packs full of gear—felt like suiting up for a football game, and there was always that same *Friday Night Lights* electricity in the air, too. We were like Transformers. We could out-drink, out-smoke, and out-hike 99 percent of our peers (carrying ninety-pound packs) with less sleep and see more beautiful amazingness in one day than they would in their whole lives. We were incredibly lucky to have a lion working the graveyard shift in the same wild neighborhood, and we got after it day after day for months at a time, no matter the hangovers, injuries, weather, or pissed-off family members. We were full-blown cat addicts and began to act like mountain lions. Everything became cat-centric, in our personal lives, too: we were cagey, and when the lion family disappeared for days, it was like having a loved one missing. We hiked harder, extending the boundaries of our search desperately seeking any sign of them. Along the way, we learned as much about ourselves as the habits of mountain lions.

The pain that came with some of those days and nights tracking lions across frozen, wind-carved, rugged, gnarly terrain reminded me of the sacrifices that came in the sweat lodge ceremony. It taught me to work through physical pain with a strong mind and will. Physical toughness started with mental fortitude. A desire and will to complete the mission. A reason to live. Some days, one excruciating side-hill step after the other was all I could muster for miles. My knees hurt so badly from side hilling with heavy packs on unstable terrain that two thousand milligrams of ibuprofen a day did little except dull the ache. There were lessons in the wild, but the good ones didn't come easy.

One day, we covered nearly the entire butte, checking camera traps and looking for a lioness we named Mama Mo. She had three small kittens to feed, but we were yet to set eyes on her brood. Arriving back at Casey's house after a cold, exposed December day in the mountains, we gathered around our makeshift toilet desk and proceeded to drink Hibiki and 7UP while we reviewed the trail cam footage on Casey's laptop. There were videos of Mama Mo returning to old, dried-up kills to check on them—but no kittens to put with the three little sets of tracks we had found recently near a day bed.

Having celebrated our footage with more Japanese whiskey, I arrived home late and decided to make a fire in the cabin and have a few more. Now it was dark, the fire was out, and I had no concept of time except for the damn cell phone that kept beckoning from the pitch-blackness. I saw the phone light up on my desk, and I sat up quickly—too quickly for my still-drunk head. My tongue stuck to the roof of my mouth as I sat upright and licked my lips—then, quickly laid back down. *Buzz, buzz, buzz* . . . the phone wouldn't stop vibrating on the desk.

I noticed that it was already getting light out. This had to be Casey texting.

Reaching for my phone with a divine fury, for being awoken, I was

surprised to see thirteen text messages from him, starting with *I think Mama Mo has a kill right by my house* and ending with *She definitely has a kill close by, the magpies have already found it, get your ass here NOW!*

Besides being still drunk, I had passed out fully clothed down to my Outdoor Research Gore-Tex gaiters and Schnee's hunting boots, which made a quick departure easy. The fire in the stove had been out for hours, so no need to worry about that. All I had to do was sneak in the house, brush my teeth, make a cat tracker coffee—which consisted of strong coffee with butter, coconut oil, and hemp oil, along with two thousand milligrams of ibuprofen in anticipation of a lot of side-hill hiking with heavy packs on unstable volcanic till (a recipe for incredibly sore knees and backs), then slink away before the Steller's jays woke up.

With a cat tracker in my to-go coffee cup and a banana for some quick sugar, I was on the predawn drive right back to where I had come from just hours before. I felt guilty hoping Casey was wrong about a kill close by. If he was wrong, I could be back home and properly in bed by nightfall—like normal people. But if he was right, our lives would be solely focused on a mountain lion kill for the next several days, putting sleep, food, family, and common sense on the shelf. We had to become mountain lions, the goal being to capture as much raw mountain lion footage as possible while we had them in a predictable location. That meant eating gas station burritos and sleeping in Casey's garage—the little we *would* sleep. However, to spend time with a mountain lion family, on their terms, made it all worthwhile. But just the same—a hot meal and about ten hours of rack time sounded pretty good, too.

I arrived at Casey's with the warm sun still hiding behind the Absarokas—it was clear Casey was ready to go. He was fully geared up with cold-weather clothes and his classic sand-colored Mystery Ranch backpack. As I crossed the snow-covered bridge where this

whole adventure had started just months before with one lone set of lion tracks, I saw Casey pacing between the juniper and cedar, biting his fingernails. The crystalized sweat on his beanie told me he had already been on a brisk walk in the frigid morning. Glancing at the digital thermometer on my rearview mirror, I saw that the temperature read minus nine degrees.

Casey raised his index finger to his mouth to give me the *Shhh!* signal. This meant the kill was close and Mama Mo might be on it. Before his finger left his face, I heard the squawky carcass talk of the magpies. It was just getting light out, and the magpies were announcing their first meal of the day to anyone who would listen. This usually meant the killer of the carcass was away, but may be close, lying above on a rock ledge, surveying the situation. There would be no chitchat this morning except for the frozen crunch of fresh snow underfoot as we moved in a hush toward the chattering magpies.

The magpies let out the intruder alert as Casey and I approached single file. When the dozen or so flew off in flashes of white, blue, and black, it became obvious where Mama Mo had tried to hide her fresh kill. It was cached in a slight depression under a fifteen-foot-tall juniper bush at the base of Death Canyon. Before the last of the now-irritated magpies had fled the scene, Casey stopped in his tracks—and looked down at the fresh snow. Kitten tracks! We were within one hundred feet of the kill site, and there were tracks zigzagging everywhere. Casey turned with steam rising from his beanie and snot freezing in his mustache with the biggest smile I'd ever seen on him.

"These are super fresh," he whispered. "They were just here."

As we scanned around, we realized we were standing in a maze of plum-size kitten tracks. We had been watching the magpies fly off, and when Casey looked down again, we were in the middle of the kittens' playground. There were hundreds of miniature lion tracks all around us. We stood there in awe—like we had found a lost city of gold.

The sun finally rose high enough over the peaks for the much-welcomed golden light to reach into the mouth of Death Canyon. I instinctively turned my frozen cheeks to the warmth; the extreme cold had turned any moisture in the air into twinkling stars with intermittent, fleeting frost rainbows. I smacked Casey on the shoulder, snapping him out of his adoration and pointed back to the east.

"Diamond dust," I said, smiling and nodding from behind my frozen breath.

Casey smiled in awe. "This may be the first kill she's brought the kids to," he said, resurveying the scene now that there was a little light on it.

At approximately three months old, they weren't much larger than big domestic cats. Their diet had consisted primarily of mother's milk. This may have been one of their first experiences eating meat directly from one of their mom's kills. Right then, a magpie let out an alert call from around the corner and did a dipping flight pattern that look like an origami bird on a string. It was alerting and cocking its head, looking straight down.

"That's her!" Casey shout-whispered. "She was coming back and heard us. She hates magpies, and the feeling is mutual—they take every opportunity to heckle her from above!"

The magpie made a hard plunge and seemed to be cussing at something below while following it. Before I could retrieve my phone from deep in my layers for a quick pic of the kitten tracks, Casey was gone around the corner—in pursuit of a squawking magpie and mountain lion family. One thing I knew about Casey, it was keep up or die, a motto he had been raised on. Much the same way Mama Mo raised her kittens.

I was mesmerized by all the kitten tracks in the twinkling diamonds of snow all around me. I couldn't help but step on kitten tracks as I set out to catch Casey. You could see where they had chased and caught one another, exploring the outer reaches of their

mom's protection. One set of tracks was slightly larger and belonged to the more adventurous sibling.

Nearing the kill site and drag, you could see in the melted snow where Mama Mo and all three of the kittens had lay down next to each other under a juniper with full bellies. Then I saw Mama Mo's adult tracks in the snow with three little sets trailing hers and Casey's boot track right behind them on the trail heading up. In the distance, a magpie was still jeering at the lions as they made a hasty retreat, and I was almost to Casey and chuckled wondering what he must be seeing.

I trotted through the dense underbrush with a heavy pack to catch up, the bitterly cold air reaching the depths of my lungs. My hangover couldn't keep up that morning as the rich, oxygenated blood began coursing through my veins—bringing me back to life. Adrenaline kicked in, and I thought about all the people still in bed, dreading going outside in the cold to see if their cars would start, while we were hot on a fresh set of mountain lion tracks with sweat pouring down our necks. Chance certainly favors a prepared mind, and while kitchen lights turned on in the neighborhood and coffee makers gurgled to life, we were already following Mama Mo and her kittens up the side of a mountain.

Sometimes I had to just stop and shake my head in awe at how much my life had changed.

Awkwardly sprinting across a sliding lichen-encrusted talus slope, I felt like a guy out with a new pair of legs. After falling several times, I caught my first glimpse of Casey kneeling below a natural bench and giving me the hand sign to hurry up but be quiet about it. Clearing the talus, I knelt breathless in the scrub brush and crept toward Casey on all fours. Heart racing and nose running, I committed a hunter's cardinal sin: sniffing and clearing my throat. Casey's head snapped around, and he shot me a disappointed glance, then closed his eyes and hung his head. The top of his black beanie

was completely white with frozen sweat now that he had stopped moving. I heard rocks break loose above Casey and start tumbling down the side of the mountain. I hadn't grown up hunting in the mountains like Casey had and still made rookie mistakes like making clearly human noises while on a stalk. My faux pas in the wild had possibly blown our cover, and now Mama Mo had taken the kittens and really made tracks getting out of there. A montage of me sniffing in the wild and Casey shooting me that same look ran through my head. I'd blown it. Now my hangover was back, and I felt the acrid stomach acid of a cat tracker coffee wearing off. So much for seeing the kittens. I had another sick feeling—that this was probably the last time Casey would invite me along. I vowed to never sniff or cough again as the snot ran freely from my nose and froze in my mustache.

Casey opened his eyes with the sun finally hitting deep in Death Canyon, and he slowly raised his binoculars to his eyes with one hand. His other hand reached out to touch the rock wall and steady himself as he rose to peer over it. I could barely hear the magpies that had all now gleefully reconvened on the neatly cached carcass with both man and predator gone. Casey's binoculars had just cleared the rocky outcrop, and he shot back down.

"They're still there!" he whispered, all smiles.

Thank God. I wiped my nose on my sleeve and crawled toward him. Careful not to displace even a pebble en route—fighting the urge to clear my throat. When I got next to Casey, we both started to quietly laugh at the mixture of condensation and nasal drippings freezing on each other's faces.

"Go very slowly with your binos and peek up over this ledge. They are in that rock cavity by the gnarly juniper that hangs out."

When the last supervolcano went off in Yellowstone some 640,000 years ago, ejecta landed everywhere, and volcanic lava flows took *everything* with them, including massive redwoods and sequoias.

When the volcanic till cooled, the organic matter rotted away, leaving perfectly rounded caves for mountain lions and pack rats, and before them, possibly dire wolves and saber-toothed tigers.

As my Vortex binoculars crested the brittle outcrop, I saw, full frame, a seated mother mountain lion with three small kittens gathered next to her. While the mom sat very still, glaring down at me from less than a few hundred feet, her kittens bobbed and weaved their curious little heads like prizefighters, trying to figure out what I was. I could see their black spots just under their tawny full-winter coats. Their tiny noses were pink like bubble gum. The two bigger siblings ran around to their mom's other side, leaving the runt all by herself. Only then did they stop moving their heads long enough for me to notice they had the same Cleopatra eyeliner as their mom.

Seeing the runt, it struck me how blue her eyes were. I checked the other two kittens—they had equally blue eyes. They were Marley's jeweled eyes—the same shade of blue. My binoculars began to fill with tears, and I crouched back down next to Casey.

"I know," he whispered. "Aren't they beautiful?" He could have had no idea why tears were freezing to my face. Casey propped himself back up for another look, and I heard him giggle. When Casey slid back down, I went up for another look.

Weeks later, it was a blue dusk, and I was kneeling at the bloody, partially consumed remnants of a female mule deer in Death Canyon. Another Mama Mo kill. The snow all around was imprinted with kitten pads, and those delicate tracks pulled me into another world.

"What's taking so long up there?" a male's voice said from somewhere in the cold. I barely registered it.

I could see where the kittens had eaten, played, and chased each other before finally settling in to sleep next to their mother. Each one of their tiny tracks was about the same size as Marley's hand

when she left this world. I could picture the kittens' blue eyes, then suddenly I saw Marley's.

"Brad, it's Casey. Do you copy?" The voice came from my backpack leaned against a juniper. But I was remembering Marley's only birthday: she was dressed up in blue to match her eyes—the deepest shade of blue I had ever seen.

"Brad! *Do you copy?*" The intensity of his voice finally grabbed my attention. Shivering from the cold, I ran over to my pack and radio.

"Hey, sorry about that; my radio was in my pack," I said, out of breath. "I'm trying to get all the cameras reset and get out of here. What's up?"

"Just hurry up," Casey said flatly.

"Why? What's up?" I asked, surveying the kill site.

"You got company."

"Company?"

"I'm down below looking up at you with the FLIR camera."

"Yeah, so what?"

"There are four mountain lions on the ridge above you trying to figure out what you're doing with their dinner."

"Fuck off. Whatever, dude," I said sniffing, with my breath and free-flowing snot freezing to my beard. "Must be nice to sit in a heated camera truck and prank the guy at the carcass."

"No joke, dude," Casey said. "Mamo Mo's standing right above you with all the kiddies, watching you fuck with their dinner."

I could tell by Casey's tone he was serious. I also knew this was completely feasible, as we had gleaned from remote footage that this lioness often came back to her kills before it was even dark. Feeding herself and three kittens in the depths of winter in the northern Rockies is serious business to a female mountain lion. It was to me, too.

"Dude! Shit! Am I okay?" I looked around, but the encroaching darkness made it difficult to see anything except growing shadows.

"Just hurry up and finish. Make sure all the cameras are set prop-

erly. I have a good feeling they're coming back. And when you leave, don't hurry, but don't lag. I'll watch from down here—you keep your eyes open."

"Copy," was all I had left to say.

I turned the red light of my headlamp on and got to work changing out AA batteries and SD cards with frozen hands. I was nervous and doing exactly what I was not supposed to do in cat country—crouching down, exposing my neck and back. I needed to hurry, but the cold and steam from my breath were making the simple task monumental. My hands fumbled and lost dexterity from being naked in the cold.

With my frozen breath obscuring the red light on my hands, I fumbled. I closed my eyes, shook my head to clear my mind of blue eyes and slow my breathing down so I could finish my work. Once everything was set to record upon any motion, I started my way down the mountain. One small, red light descending in the dark, down the frozen slopes of volcanic till while mountain lions with Marley-blue eyes watched. As I walked, I sank into the lonesome theater of child loss reverie until I found myself back in my bedroom in Holland, Michigan.

I was still holding the telephone after Mom had hung up. After telling me that Marley was blue.

I struggled and stumbled. I paced. Noises rose inside of me. I became sick and dizzy as I spun around the room—or was it spinning around me? I grabbed the doorjamb to steady myself. I screamed and cursed. I yelled, "*No!*" at the top of my lungs. I fought. Refused to believe. It could not be. *It could not be.*

Then I gathered myself.

I called Ed, my best friend in Goshen, and through choking tears asked him to go to the hospital to be my eyes and ears. Our

families had known each other for decades, and Mom had babysat Ed's daughter many times.

But what had happened? I kept asking this question. *What happened?* Healthy children don't just stop breathing and turn blue. Did Mom go against our orders and co-sleep with Marley? I had spoken to her only a few hours earlier, and everything was fine.

Then I remembered Stacey. My legs gave out, and I dropped to the floor when I realized what I needed to do next. I had to call her, but what in God's name would I say? I dialed, and she answered.

"Stacey, are you somewhere you can talk?"

"Well, I'm at work. What's up?"

"It's Marley."

"What's wrong? What's wrong? What's going on?" Her voice rose with each syllable.

"Meet me at the carpool lot; we need to go to Indiana."

"Brad. What is going on?"

"She's not breathing. We need to go to the hospital."

"I'm on my way . . ." She choked up, then hung up.

As I tore out of the house, our one-eyed German shepherd, Jack, couldn't get out of my way fast enough. I charged out to the driveway, confused. What happened to Marley? Did I have my wallet? Where were my keys? Where was my phone? *What happened to Marley?* I couldn't focus. Was this really happening? My mind was a short-circuiting pinball machine with all the lights and buzzers going off at once.

Darting back in the house, I found my phone on the kitchen table and Jack cowering underneath. I raced back out through the garage door. My keys were in the ignition. I started the truck before I had even closed the door. I checked the rearview mirror before backing up, and there was Marley's empty car seat, her sock monkey crumpled in it.

I had a moment, a very long moment, when I feared we wouldn't

be bringing Marley home. Then I squealed out of the driveway and down the street.

I tried to maintain the speed limits through our Waukazoo Woods neighborhood, but everything inside of me wanted to stand on the gas until I saw Stacey. I worried my stuttered exit would have her arriving at the carpool lot well before me. I couldn't bear that. Sitting at a red light, eyeing my phone for the call I was expecting from Stacey asking where the hell I was, I checked my rearview mirror again out of habit. And there it was again. Marley's car seat. It was more than I could bear. I quickly turned the rearview mirror straight up and contemplated throwing it in the cargo bed before the light turned green. But no, I didn't have time.

I had to get to Stacey.

Weaving through trucks pulling boats and campers, I tried to piece together the last few things Mom had said to me. Marley wasn't breathing, but the paramedics were there. She had also reluctantly answered yes when I asked her if Marley was blue. I knew once a person was blue, they were most likely deceased—I couldn't even think the word *dead*—but I held out hope. Maybe she was just brain damaged. That would have to be enough. I thought of Marley with round-the-clock home care, attending the girls' graduations ventilated in a wheelchair, head tipped back, trapped in herself, and that became my only hope. A brain-dead child. But how was I going to tell Stacey that? I silently practiced the words. *Maybe she's just brain-dead, and we will take care of her the rest of her life. That will be all right. Yes.*

Stacey's car was up ahead as I drove into the lot. I parked in the first available spot, next to a MacDonald's and a 7-Eleven. Dodging customers with their Big Gulps and Big Macs, I ran to my wife. She was barely holding it together, hiding behind her Ray-Bans and leaning against her black Volvo wagon, mascara tears leaking from underneath the lenses. She looked so incongruent, dressed in a wispy, light skirt and sleeveless top with careless summer all around

her. None of the beachgoers or tourists who were moving between us laughing and chattering the way you're supposed to in July saw the wilt in Stacey's long, dark hair. They didn't know her shoulders weren't supposed to droop and fold in like that. No one walking by knew that she didn't usually tremble and stare up into the sky in parking lots to keep the tears from streaking her face. They didn't know a part of her was dying right there on the sweltering black asphalt. But I did. What was I going to say when I got to her?

I wanted to ask her how she was doing, but it seemed banal, pointless, and cruel, so I straddled her and pulled her close. I could feel the sweat on her back. I readied myself for her to collapse into me, but she didn't. I waited for her to raise her arms and hug me back, but she didn't. She just leaned against her passenger door like a lump with her head in my chest and her arms dangling at her side.

"Let's go," she said. The words beat against my chest.

Once inside the Suburban, I tried to get a sense if she wanted to talk. Before pulling onto the road, I took an extra-long look in her direction like I was waiting on traffic, but I was actually watching her for a clue. She was leaning against the window with her hair now enshrouding her face and sunglasses. She looked over like she was going to say something, then Marley's car seat caught her attention. She reached back and grabbed Marley's slumped-over sock monkey and cradled it in her lap, rubbing her thumb across its red lips.

"What happened?" she asked me, never looking up.

"I don't know," I choked. "She wouldn't say." I took the truck up to ninety miles per hour and set the cruise control. Stacey was shaking her head with her hand up to her cheek on the window side.

"I wonder if she—" I started, but Stacey cut me off immediately.

"I just want to know what happened."

She didn't want to speculate, whereas I couldn't stop. Stacey didn't cry, so I wouldn't either. I needed to be as strong as she was and strong for her.

"I know, sweetheart. I love you."

"I love you, too," she cried.

I put my hand back on the steering wheel and navigated through the merging commuters. The silence between us was brutal. I turned on the CD player to fill the void. "Three Little Birds" by Bob Marley started playing, and both our heads snapped up. I turned the power off. Bob Marley was not only our daughter's namesake but also her favorite driving music—after Beyoncé. The first rhythmic backbeat would kick in, and Marley would start shaking her little shoulders in her car seat.

Now that backbeat was a dagger.

We were both in a state of shock as I sped down the interstate. The heart of Michigan's farmland zoomed by on either side of the road. Dutch-white barns and matching two-story houses with towering blue silos whizzed by as I zigzagged my way through unsuspecting traffic. There was a good chance I was going to get caught speeding by a state trooper, but I didn't care. They would have to chase me all the way to the hospital. I wanted to say something to Stacey, anything, but more importantly, I wanted her to say something—anything—to me.

"What's going on in that head of yours?" I asked her after a deep breath.

"I just want to see Marley," she whimpered, rearranging the sock monkey on her lap to make it more comfortable.

"Me, too."

"Any word on how your mom is?" Stacey asked, breaking the silence but never looking up.

"Something was wrong with her. She sounded . . ." I couldn't find the word. Or didn't want to. I had a bad feeling in my gut.

"How is she supposed to sound when there's obviously been some kind of horrible accident?"

"I don't know."

"I can't imagine what she's going through," Stacey sobbed, picking at imaginary lint on the sock monkey.

"I know," I said, bursting into tears. "I can only pray they will both be okay."

We neared the state line as I ran the dreadful conversation over and over in my head. It just didn't make sense. Why was Mom so aloof? How had things changed so quickly? They were going to both take a nap after lunch. What could have possibly happened during that time? I wanted to ask Stacey all these things, but I was afraid it would only add to her suffering.

My phone rang. I recognized the 574 Indiana area code.

"This is Brad."

"Hi, Brad," a calm, male voice on the other end said. "This is Nurse Yoder at Goshen General Hospital. Are you and your wife on your way?"

"How is Marley?" I asked. Stacey looked up at me, clutching Marley's doll.

"Mr. Orsted, I'd like to have you speak to Chaplain Mot, please." There was a pause.

"Mr. Orsted, this is Chaplain Mot at Goshen General Hospital. Are you and your wife almost here?"

"How is Marley?" My voice was flat.

"Mr. Orsted, I am so sorry to be the one to have to inform you, but Marley has passed away."

A guttural groan escaped me, and Stacey immediately knew. She pulled her legs up, smashing the sock monkey against her chest. She cried from somewhere deep, like a wounded animal. She *was* a wounded animal.

"Mr. Orsted, the police are already here, as is your mother. She's okay, and I need you to drive very carefully the rest of the way. I'll meet you at the emergency room entrance when you get here. I'm so sorry for your loss, Mr. Orsted."

I dropped the phone and lost control. I yelled. I swore. I punched the windshield so hard it spider-webbed. Stacey buried her head in her knees, wailed, and rocked back and forth.

Marley was dead. Just like that, our sweet little baby girl was dead. A white-hot pain was burning its way through me. It was the genesis of a hell that would torment me for thousands of days and nights to come. I wanted to rip a hole through the sky—to snarl and scream out at God. I wanted to dismantle the world. Then suddenly I thought of Mazzy and Chloe and the trauma that awaited them while they naively enjoyed their idyllic summer vacation in Montana, and I thought I might have to pull over. My hands and feet were going numb. An uproar was building deep in my solar plexus. Mazzy's and Chloe's childhoods had just ended, too. I knew all too well they would never be the same. Stacey rocked in her seat and let out a primal cry, and I knew she was thinking of Mazzy and Chloe, too. What had Marley done to deserve this? What had our family done to deserve this? How would we ever be the same?

What the hell happened in those few hours between phone calls with Mom?

Somewhere around the state line, the rural countryside became expansive Amish farms. We were off the interstate and rambling along between the lush green knee-high corn and soybean fields of Middlebury, Indiana. Black Amish buggies stuffed with kids wearing solid-colored clothing wobbled along the same county road, giving the landscape a dreamy, ageless feel, as if the state border were a time machine. Slowing to pass a rusty green farm tractor moving from one field to another, Stacey and I both looked at the Amish children gathered around a trampoline. The handful of preteen boys, all dressed in homemade high-water jeans, matching bowl haircuts, pastel-colored short-sleeve shirts and suspenders, were barefoot and jumping on the trampoline. The little girls, dressed in full-length

light pink and yellow dresses and sporting white bonnets chased one another around the yard and laughed with the boys' antics.

Stacey was still balled up, knees to her chest with the sock monkey pressed against her breast. But like me, she was gazing out the window, viewing the same tranquil scene. I wondered if she was also thinking what I was. That we should live the same way. We could carve out a simple, homegrown, God-fearing life of hard work and family dinners. To have our children, and someday their children, running around our trampoline in the summer heat while Stacey and I admired our good fortune and the cooling strawberry pies on the porch. Then I remembered Marley was dead. We could never carve out a simple life anymore.

While stopping to let a rickety tractor navigate the uneven county road, Stacey gasped. Two little Amish girls, standing under a cottonwood tree in matching dark blue dresses, were holding hands and looking directly at Stacey. She moaned again, looked away, and began to cry into her knees. The older girl was maybe five years old, and her younger sister was Marley's age.

"Oh, sweetheart," I said softly, quickly looking away from the toddler's penetrating gaze, too. "I'll get you out of here." Stepping on the gas to pass the tractor, I realized the little girls next to the road were probably just mesmerized by seeing a black Suburban with two "English" people in it crying, but the timing couldn't have been worse. I wondered if we would ever be able to look at another child Marley's age without wincing in pain. I passed the tractor, accelerating down a long, cornfield-lined straightaway, trying to put as much distance between us and Amish country as I could.

My phone rang. It was Ed.

"Dude, are you getting close to the hospital?"

"Yes," I said quietly, turning my face away from Stacey.

"The detectives are questioning your mom. Something's not right. I overheard one of the paramedics tell a nurse that judging by

Marley's core body temperature, she had been deceased for hours by the time they arrived." I turned my head as far away from Stacey as I could, praying she hadn't overheard.

"Okay, Ed," I said calmly, for Stacey's benefit. "We're almost there." I swallowed my panic, clicked my phone off, and dropped it in the console so I could navigate the city traffic.

Seeing the sign for the hospital—the same hospital where my sister was born, the same hospital I had ridden my bike past a thousand times to go fishing—I felt like I was going to pass out. Was I going to make it the devastating, nearly two-hour drive, only to black out and crash into the ER sign? One look at Stacey trying to emotionally pull herself together as we turned into the parking lot spurred me to do the same. I wanted everything to just stop for a moment so I could begin to process what was happening. I needed things to slow down.

But when I saw my dad and Ed smoking cigarettes in the parking lot at the ER entrance, I knew they were about to speed up.

"What's going on?" I asked Ed.

"I'm so sorry, brother," Ed replied, throwing his cigarette on the ground and giving me a huge hug while fighting back the tears. I was numb. I looked back at Stacey, and she hadn't moved from beside the truck. Ed then moved toward her, breaking into tears and an embrace.

"I'm so sorry, Stacey," Ed said, swallowing hard and wiping his tears from his cheek and stubbly blond beard. She barely registered it.

I turned to my dad. The Clint Eastwood vein on his forehead that would bulge when he got mad and used to be so intimidating as a child now was barely noticeable under the suntan and liver spots of old age. He took a long drag off his generic menthol cigarette, exhaled slowly, and looked up at me with tears in his eyes.

"I'm sorry, Brad."

"I know, Dad."

That was all we could say. He gave me a tight hug and whispered in my ear again that he was sorry. He stepped back, and then I saw

the cranial vein give rise and gorge as his sadness flowed backward into anger.

"What the hell did your mother do?" He reached for another cigarette with his previous one still smoking at his feet. It had been a nasty divorce, and he had never forgiven my mother for her marital transgressions. Although he had learned he wasn't supposed to trash his ex-wife to his children, it was obvious he had nothing but contempt for her. Watching his face twist with pain and anger, then partially disappear when he exhaled cigarette smoke into the broiling, muggy air, I wondered if he might have brought his pistol.

"Dad, you can't do anything in there."

"I know, Brad, but what the hell did she do to Marley?" She was his only grandchild.

"I don't know, Dad, but please don't make it worse."

He nodded and put his free hand under his glasses to wipe his tears away. I looked back at Stacey, still leaning against the truck, hiding behind her sunglasses. Ed was holding her, but he might as well have been consoling a mannequin. The part of my wife where love and adoration lived had died right in front of me, and there was nothing I could do. She was withering in the July heat of a hospital parking lot, and the only shade was inside the hospital where our daughter lay dead.

Two men approached me from the emergency room entrance.

"Are you Brad Orsted?"

6

Run for the Hills

I had never expected to be a father, husband, or family man. The route to the Brad Orsted of June 2009—the summer of Marley's birth—had been as circuitous and hair-raising as a mountain road.

There was a manifest "fuck the world" feeling in my hometown, and in my junior year of high school after my parents divorced, I began to embrace it. I was no longer the kid who spent time with church friends in youth groups or doing homework. I began hanging out with a different breed of people—kids I had looked down on in the past. This new gene pool of friends had no lifeguard on duty. The new crew hailed from homes like mine, broken. They smoked, drank, and did drugs. They didn't care about school or their futures, only the next party and getting as drunk as possible while listening to heavy metal. There was a genuine angst in this crowd I could now relate to. The same people I had once viewed in the high school's smoking section as "rats" were now my influencers. It was liberating. They asked nothing of me except to bum a cigarette, to see if I had beer money, and to party. This new FTW crowd felt like my kinda people, and I was welcomed in like cherry vodka.

Up to this point, I had excelled in school with little effort. Sophomore year, I had played football, run track, and made honor roll even when my dad left that spring. Junior year, my grades plummeted as my absences rose, and I was done with sports. The only classes I would show up for and do well at were the ones I enjoyed (literature, newspaper, and weight training). My parents were frequently called into the school to discuss why I had gone from an honor roll student to getting Fs.

Our English department was led by a flamboyant husband-and-wife team. They were products of the '60s with a flair for the dramatic. They also led the annual Shakespeare trips to Stratford, where there were reports of kids getting to drink a little. In both English and American literature classes, we read from the classics and journaled extensively. The journals were free-form but had to be turned in every week to verify that we were doing the work. Both teachers had commented on my creativity and encouraged me to pursue writing. I wrote about weekend LSD trips along Lake Michigan while listening to the Doors, and they never said a word. They kept my secrets, spurred me on with secret reading lists like Rumi, Keats, and beat generation writers. They helped me write stories as the opinion page coeditor for our school newspaper and gave me a glimpse into the creative counterculture world so far away from being an attorney in Iowa—like my cousin, the family role model. The man I was supposed to take after.

By the time the spring of 1988 and my high school graduation rolled around, I had missed almost as many days as I had attended, been suspended numerous times for various infractions, and had gone from honor roll to barely graduating. Most of my old childhood friends would be heading off to college in the fall, but with my graduating GPA, I would be heading for the trailer factories. I knew early in my senior year that I wasn't going to college, so I hadn't bothered to apply anywhere. I had bigger plans—to match

the epic journeys I'd been reading about and get my education in life along the way. I would take the aesthetic creative path toward my destiny, not the lame, institutional route. College was for people who wanted to learn about the life I planned to lead.

After several years of grueling factory work coupled with a few misdemeanors and a near-fatal motorcycle accident, I began to rethink my approach. Life had gone wonky kind of fast. I was working in manufacturing to get enough money for essentials and to party—a hand-to-mouth and foot-to-ass existence. It was then that I started to look at some of the people I had been getting wasted with, passing out next to, and burning brain cells with since late high school.

I saw mostly good people already in the court system for petty crimes. Drones who slaved away at dangerous trailer factory jobs and whose lives were beginning to look like their parents' already. It was a life of quiet servitude with little hope of change. By the time I was out of high school, nearly a dozen classmates had died in tragic accidents, with more to come. Some were close friends.

Life was all about chugging alcohol in garages and doing as many of whatever drugs we could get our hands on until we were fucked out of our skulls and racing Camaros down county roads screaming along with Judas Priest on the Pioneer tape deck. There had to be something better out there besides wrapping myself around a telephone pole while on acid in Amish country—like a local kid had done.

I finally left Indiana, wandering from New Jersey to Arizona before settling in Colorado. I fished, bought camper vans, got engaged and never followed through, went to concerts, hiked, and partied with friends. I had girlfriends, but trout fishing with my dog and drinking beer with buddies came first. If my bills were paid and I had a hundred dollars in my pocket at the end of the week for beer and bait, I was golden. My dog and I would be off with friends to camp and fish in the Rocky Mountains.

I liked my twenties so much, I extended them into my thirties, bouncing wherever the wind blew with no obligations or regard for anything except myself and a dog. I would stay in Colorado for a few years, then head back to Indiana to see friends and the lakes and woods I missed. I'd make some money painting or in the factories in Indiana, then bolt back to Colorado before I got sucked into a marriage, mortgage, or meth problems. I wasn't happy, but I wasn't terribly unhappy either. I had a pretty good job as a paint rep for a major coatings corporation in Colorado.

Companies love to move the goalpost on sales commissions right before the financial quarter ends. I had made a onetime massive paint sale for a new complex of high-end condos in the mountains. I'm talking about thousands of gallons of paints and exterior stains plus all the sundries and hand tools. When the quarterly commission checks came around, I got screwed over by some indecipherable algebra. All those sales in one quarter blew away my quota, but because it happened at the end of a business quarter, they split the sale into two quarters. In the end, I didn't get the $5,000 that I was owed—I got zero.

Okay, so that's how we're going to play this, I thought.

After explaining the dilemma to a friend also in the paint business, he offered me an outside sales position at his paint store in Kalamazoo, Michigan. It meant moving back east and would keep me a safe few hours away from the trailer factory hell of my hometown in Indiana. But Kalamazoo was also a good jumping-off point to northern Michigan, where I wanted to explore. He offered me enough money to pay all my bills and cover moving expenses. *They have trout in Michigan, right?* I could paint houses on the side, and since I never expected to have a family of my own, the life of a single angler / house painter was a good fit.

I decided to go, but true to that FTW scorched-earth motto that

shaped my trailer-mouth upper youth in Indiana, I simply couldn't go quietly.

That night, I bought enough Crown Royal, craft beer, and contraband to stunt a Cape buffalo's growth. All I had to do was put in my two weeks' notice the next day. I assumed they would ask me to turn everything in and leave immediately. I would then have a week or so to hike, fish, and get blitzed a few last times with mi amigos before heading east. This was going to be easy, so we cranked up the volume and partied like Vikings. Somewhere in the wee hours as the substances began to run low and the room swirled, I decided to do some creative writing for our entertainment. After all, I'd always wanted to be a writer.

My colleagues and I had often fantasized about what we would really like to say to our district manager when he berated us. I decided it would be fun to actually write it up while the jet fuel in my brain was burning off. Even more fun, I would CC the entire store as well as the district manager's boss, and while I was at it, I had the VP's email from a previous thread, so why not throw him in the party. A catchy little subject line that would lure them in . . . and voilà! I'd tell them what greasy little souls they had.

I woke up to my phone vibrating and my face on the desk. I was still somewhat seated amid the half-empty whiskey glasses, overflowing ashtrays, and some sort of partially consumed casserole. It was just starting to get light out, and my phone was going apeshit. There were multiple text messages, but the first one I checked was from my assistant manager, Dan, and it read:

> *Holy fuck you actually did it!!! You are my hero! Also, they called the police, and you should probably turn everything in ASAP.*

What the hell was Dan babbling about? I had a few more hours to slam some water and sleep before I made an excuse for why I was going to be late. Then I would saunter in, give my two weeks' notice as the warehouse workers cheered, and Richard Gere would pick me up and carry me out the front door. It was going to be unforgettably romantic and highly cinematic, how this kid from the trenches rose through the corporate ranks only to snub his greedy superiors right before he drove off with his best dog over the dusky hues of moral high ground.

What? I texted, snapping out of my delusions while having some trouble landing my shaking fingers on the right letters.

Check your email.

Since my face was already sandwiched between my laptop and an ashtray it, was easy to open my browser. Then I saw my catchy little subject line on the company email ("SUCK IT") with one terse reply from my immediate boss stating that *we need to talk ASAP!*

Oh shit.

Vague snippets flashed through my head like some B movie. There had been country music, yelling, laughing, and beer bottles everywhere. Somewhere a TV was looping nude scenes, and someone was vomiting on the porch as we applauded from a smoke-filled room. There were hazy images of too many people packed in a tiny bathroom doing illicit things. Was that real? I tried connecting the dots. Then a disturbing memory surfaced: me composing a scathing email—referencing my bosses' black souls—reading it to my sideways compatriots to cheers, jeers, and chants of "Send it, send it, send it!" With the last high of the night burning brightly, I had hit Send, closed my laptop, and passed out.

I pulled myself together and drove the company car to the office, still high. I gave back everything and left quietly in lieu of a

restraining order and probable DUI at 8:00 a.m. They were ready if I gave them any reason to believe I might follow through with any of the bizarre and disturbing threats from my "resignation" email. It was imaginably tense as I cleaned out my desk. I'm pretty sure the manager dialed 91, his finger ready to press 1 again, and itched for me to make one comment or hard move for the rubber mallet I had alluded to wielding in the previous night's note.

To middle management, I was a dangerous scourge; to the hourly crew, I was the only guy with the cojones to tell it like it was. I'd like to think they still sing folk songs about me at family cookouts while their children listen eagerly about the rebel without a clue who told the brass to get bent one blurry night. One thing was certain: it was time to get going down the road before they changed their minds on that 911 call. I packed my truck, and within a few hours, my German shepherd, Blake, my grouchy bowels, and I put Pikes Peak in the rearview mirror and hit the gas.

Twenty hours later, I crossed the border into Michigan, where I finally let out a sigh of relief. Kalamazoo looked like the perfect new life chapter to fish, photograph, and leave the tumultuous past where it belonged.

I was living in a shady apartment complex off I-94 near a city park. One rainy, dark morning, I let Blake out just as the sky illuminated and lightning cracked. When my eyes readjusted to the darkness, Blake was gone. I shouted and searched in the pouring rain to no avail, until I had to leave for work. The next few days were a sleepless mix of posting flyers, running down leads, trips to shelters, trying to work for an unsympathetic boss, and basically feeling lost, like my dog. Blake, my best friend, was missing and my world was fractured. We had been together since I took him from a poop-stained trailer bathroom at six weeks old. I was depleted after several days, wondering

why the hell I had moved to Kalamazoo. Nothing was lining up. I hated the job, didn't know where to fish, and couldn't meet any decent women. Online dating was proving a futile endeavor in the Mitten State, and now my dog was gone in a city neither of us knew.

Five days after Blake went missing, I answered a call from a girl who thought she had found him miles away. I prepared myself. There was a $500 reward (money I didn't have), so I fully expected some false positives. My heart was in my throat when I answered the door. But here was Blake and a beautiful long-haired girl, both backlit by the late-afternoon autumn sun. Blake let out a yelp and jumped on me.

"I guess that's him," she said. We both began to cry, and I fell to the ground with my dog smothering me.

"Thank you, thank you so much," was all I could muster through the tears and laughter.

The girl turned to walk away as Blake and I lay in a pile on the floor at the apartment door, so happy to be reunited. Blake smelled horrible, but I refused to let him go. My bestie was back, and I felt like bluebirds.

"Wait!" I yelled after the girl who had just made me so happy. "The reward!"

She turned briefly to face us with a giant smile on her face and tears streaming down her cheeks. She gazed at us for a bit, then waved goodbye and walked away. *Angels abound,* I thought, scratching my dog's disgusting belly.

Blake drank an entire bowl of water, ate a bowl of food, then went back for more water before he flopped on the floor and fell into a deep sleep. I wept, watching him eat, wondering what he must have been through over the past five days. Once I knew he was full and fast asleep, I opened my computer to send a mass email with the subject line: "Blake Is Home." It was then that I noticed a message from my Yahoo! online dating account.

I wasn't really having any luck, so I had let the account lapse.

Now a gorgeous woman had expressed interest, and I couldn't respond because I hadn't paid the monthly premium. I figured this was probably a shameless attempt by Yahoo! to get me to give them another twenty bucks or some sociology experiment being conducted by Western Michigan University to see how many lonesome losers will reactivate their accounts if one pretty girl says hello. But I was feeling lucky with my dog home, so what the heck.

The problem was my checking account had a negative balance, so I would have to go to the bank, cash my check, and deposit the money in the account to pay Yahoo! After a nap, I loaded Blake in the truck, and off we went to the bank, park, and Steak 'n Shake to celebrate. Maybe my luck was changing. Steak 'n Shake had caramel apple shakes for a limited time, and Blake was scarfing a bacon cheeseburger in the back seat like wolves were coming. Once the money hit my account, I sent a reply to the girl from Yahoo!

Things went back to normal, more or less, once Blake was home. I continued to work during the week, and on weekends, we would explore the woods and lakeshore of West Michigan. Much to my delight, the girl from Yahoo! ended up being real. After several instant messaging sessions, we eventually spoke on the phone. She seemed smart and classy. Surely an attractive, intelligent woman who laughed at my stories could not be the real deal. A woman like that would see through my bullshit.

My first date with Stacey took place on Sweetest Day, October 2006. She offered to make me dinner and insisted I bring Blake to meet her golden retriever, Lola. Things were off to a good start. She asked if a vegetarian menu would be okay.

"Sure, it's not like I have to eat meat," I said, though I wasn't sure I really meant it. But off I went with my dog to see the gorgeous girl from online dating and eat whatever a vegetarian dinner was. With the Notre Dame football game on the radio, Blake and I headed out for the hour drive north to Grand Rapids.

Autumn was my favorite time of year in the upper Midwest. The corn was cut, hardwoods were ablaze with color, and the evening light was soft and angular. Gone were the mosquitoes and hot summer stagnation, replaced by the long shadows of fall and the cool evening breeze. The drive reminded me of what I loved about Michigan, and I was soaking it all in with the sun setting over the big lake. Then I spied a Wendy's and wheeled into the drive-through.

"Welcome to Wendy's. Can I take your order?"

"I'll have a double Baconator, plus two cheeseburgers for my dog, please."

Blake and I wolfed down dinner, I tossed the wrappings in a bin, then proceeded toward Stacey's house. The directions took me along a scenic river drive where lights from the homes reflected on the water, steering me into an upper-middle-class neighborhood of stately homes. There were leaves in the yards, and Halloween decorations lit the gathering dusk. If this girl was for real, I was way out of my league. This neighborhood took the art of family to a high-end professional level.

Nervous as hell, I pulled into the driveway of the address I'd been given and grabbed the flowers I'd bought, holding them behind my back as I approached the door. If she was anything other than what she had represented through pictures and conversations, I was out of there. Online dating was still fairly new, and I was skeptical after having been the target of a few scams. This definitely seemed too good to be true.

I rang the doorbell and stepped back. A dog barked, then I saw the girl from the pictures through the glass door. So far, so good. She was walking down the hallway toward me.

"Brad?" she said, smiling at me. "And this must be Blake." She laughed as he pushed his way in to meet her golden retriever.

She was warm and friendly with a radiant smile. Her house was

a mansion by my shithole apartment standards. We drank wine, snacked (vegetarian, of course!), and laughed easily.

Stacey was too good for me, but fortunately, she didn't seem to realize it. We had spoken on the phone several times, so we had conversation starters, and the rest just fell into place. It's still the most memorable first date I have ever had. Maybe it was the titillating mixture of Baconator, red wine, and Miles Davis, but falling in love was effortless that night.

Our budding relationship progressed quickly. Autumn in Michigan is the perfect time for new love. The air is crisp and cool, and the smell of burning leaves fills the neighborhoods. On Sunday evenings, families gather around harvest tables to eat and laugh, and that's just what we did. After several dates and probably numerous background checks, Stacey finally introduced me to her two young daughters, Mazzy and Chloe. They were eight and five years old, and the most darling little girls I'd ever seen.

Seated in their living room one Saturday morning with giant oak leaves slowly falling outside the window, Stacey chaperoned her little dandies out for our first meeting. I wasn't sure who was more nervous: I was hoping not to say the wrong thing, and they were hoping not to say anything. They cautiously made eye contact when I asked them their ages and if they liked school. Mazzy was the eldest and had light brown and naturally curly hair like a tiny Greek goddess. Chloe was slightly smaller with a brown bob and a small mole on her nose where the Creator must have kissed her when she was done. After they politely fulfilled their mom's request to meet me, they went back to playing upstairs and probably forgot all about me. But my endearment for Stacey quickly grew to encompass the girls, and I felt like Superman and yet oddly normal spending Sunday afternoons raking leaves and cleaning gutters with them.

Stacey and the girls lived in a charming, two-story brick home along the Thornapple River in a coveted neighborhood. The girls' school was a few blocks down the road, and bald eagles perched in the trees near her house. The entire area was full of old-growth oak, towering beech, and stoic sycamore trees. It was picturesque. I would stay in Kalamazoo and work all week, then spend weekends with Stacey and the girls. Stacey and I would cook homemade meals and enjoy long walks with the dogs along the river and fall more in love every step of the way.

After a few months, I went from only staying with Stacey and the girls on the weekends to spending most weeknights there, too. The hour commutes each way seemed a minor inconvenience for the new love and appreciation I was feeling, but I wondered if we were going too fast. One Sunday afternoon, Stacey and I were raking leaves while the kids and dogs jumped in our piles. The last of the big leaves from the ancient oaks standing guard in the backyard were down, and the breeze off the river had turned consistently chilly. Leaning on her rake while watching the kids and dogs play, Stacey looked at me very seriously.

"Why don't you just move in?" she asked without hesitation.

"Okay," I said, glancing at her only briefly while raking now-leafless grass. I tried to play it cool, as if hazel-eyed beauties with their hair spilling out over a tweed scarf like a caramel fountain asked me to move in several times a day. Hours before, I had worried we might be moving too fast; now it seemed we might have taken the brakes off completely. And I couldn't have been happier.

"Once we get these leaves burned"—Stacey paused, leaning on her rake again—"let's take the girls to get cider and homemade doughnuts." She said it loudly enough for the girls to hear.

"Yes!" Mazzy and Chloe yelled with excitement from the leaf pile. "Doughnuts, doughnuts, doughnuts!" they cheered with a rising excitement, inciting the dogs to join in, running circles and barking. I

laughed and joined the enthusiasm by raking as quickly as possible. All the girls laughed, and we cleaned the backyard in record time with fresh cinnamon-sugar doughnuts and milled apple cider on the line.

In the spring of 2008, Stacey took a job on the east side of the state as the executive director for the ALS Association, so we moved to White Lake, Michigan, to be closer. We rented our first house together on Bogie Lake with a long, private lot that extended down to a sandy beach. Our new setting seemed straight out of a magazine article about someone else's life. Bogie Lake was a secluded, private lake with a wooded corner and deep, clear water. We were living where the lake met the channel, and the lots were narrow but deep. With our freshly mowed lawn, two beautiful little girls, two dogs, and lakeside fires under cyan sunsets, we must have looked like models posing for a catalog photo shoot.

My life was changing. While there were some growing pains and struggles to let go of old, immature ways, the stability was something that had been lacking from my life. It gave me a place in the universe to call home finally. One Sunday morning, I finally got down on one knee in that little johnboat and proposed to Stacey in the middle of Bogie Lake. Stacey said yes, so I cranked up the electric trolling motor until we almost made a wake (not allowed) rushing home to share the news with friends and family. I couldn't believe I was getting married to a gorgeous, successful, wonderful mother of two adorable little girls. We talked to Mazzy and Chloe and decided on a September wedding.

Besides the normal nervousness accompanied with getting engaged, I was very worried about being a good stepdad to Stacey's little girls, now six and nine years old. I hadn't had many positive role models when it came to a healthy homelife, but Stacey had faith in me, which gave me faith in myself. I didn't want the ugly abuse I was raised under to ever surface in their lives. It was one thing to

be the fun boyfriend, but I was crossing into another dimension of responsibility by becoming their stepdad. I took it to heart as we made wedding plans at the kitchen table with the girls.

After decades of running wild and moving way too many times to count, having a home and being engaged with kids and careers seemed like the next phase of my life, and I was all for it. We started venturing into northern Michigan on weekend road trips with the dogs and kids in tow. We were planning our wedding, and Stacey got pregnant.

We moved to a rustic log home on a wooded lot full of one-hundred-foot-tall beech trees, across the street from Lake Macatawa and a mile or so from Lake Michigan. The home had enough bedrooms for all of us and one for a nursery. We found out we were having a girl. As a family, we landed on the name Marley. I stripped the wallpaper in Marley's new room and painted it a warm melon in hopes that it would be soothing. Stacey's family helped with a crib and all the necessary hardware needed for a new baby, and the nursery came together quickly. The girls were excited and eager for a little sister. Marley's room was right by theirs. I was going to have three daughters. I embraced it all, happy to be a part of a loving family for the first time in my life.

"Yes. I'm Brad Orsted." I squinted into the cool shadow where the voice came from.

"I'm Chaplain Mot. We spoke on the phone." He was in khakis and a black dress shirt. He motioned to the man in aquamarine hospital scrubs next to him. "This is Nurse Yoder, who you also spoke to on the phone."

"I'm so sorry to be meeting you under these circumstances," Nurse Yoder said. "If you'll follow us, we can take you to Marley."

I looked back for Stacey, but she was already making her way

toward me. She had heard the only words she was there to hear. She walked up and grabbed my hand, and the four of us made our way down a corridor. Stacey and I walked hand in hand as we passed out of the shade and into the flickering fluorescent world of a hospital emergency room. Nurse Yoder led the way past bustling hospital staff and seated civilians. Empty gurneys pushed by blue scrubs wheeled by, and an important-looking machine with tubes and knobs shot out of one room and into another.

"Where's our daughter?"

"Right this way, sir." Nurse Yoder was now visibly nervous. He livened up his step. We were brushing past staff and plain-clothed people alike. A few turned to give us dirty looks, but once they saw a slightly psychotic dad with his grieving wife still hiding behind her Ray-Bans and clinging to his arm with both hands, they quickly went back to what they were doing.

"You see, Mr. Orsted," Chaplain Mot began again, trying to keep up with us as the intercom pumped a coded hospital language. "Your daughter's death is under investigation, so you won't actually be able to touch her."

Stacey moaned. I squeezed her hand.

I could feel the stares and glances from the hospital staff. We were the parents of the toddler killed at her grandma's house under mysterious circumstances. Everyone seemed to want to get a peek at us, whether from behind a counter or a clipboard. Stacey and I strode and stared straight ahead, stone-faced, making eye contact with no one. All around us, ER equipment whizzed by, television corners flashed images, intercoms beckoned, someone wailed in pain, and a bed zipped by with an unconscious elderly woman whose bones poked through her thin skin. The smell of antiseptic and air freshener seemed to emanate from every passing room, but none of it fazed us. Stacey and I were on a mission to find our dead daughter in this maze of flickering lights and blue-green ants. Anyone who

looked up promptly got out of our way; the rest got pushed out of the way.

We passed two plainclothes detectives, one man and one woman, with badges and pistols on their belts, interviewing a hospital ER employee in a lounge area. The female detective looked in our direction when she sensed the push of energy being created around us. She was the only person I made eye contact with, and her sadness was palpable. She turned back to her interview, and I wondered what they were questioning the nurse about.

Then I saw my mom. She was slouched over and staring off into space with a white hospital blanket wrapped around her. My stepdad, Marc, leaned over her with his hand rubbing her back. He looked up at us with a mix of shock and sadness, then leaned back down to say something to her. We walked right past, and she never even knew it. In the mad shuffle to get to Marley, I glanced over my shoulder one more time to look at her and didn't recognize her. She looked catatonic.

"She's right here," the nurse said, stopping at a room and extending one arm like he was inviting us to dinner. "Now, as the chaplain said"—he swallowed hard—"I'm so sorry, but you can't touch her, or it could interfere with the investigation."

There she was, our angel Marley, wrapped in a clean, white hospital blanket with only her ashen face showing. Stacey and I walked up to either side of the bed. I looked into her open eyes. The blue was gone. The glorious blue of intrigue and a life shining bright was gone. Her eyes were glazed over and gray. Marley's vibrant blue had escaped, replaced by the lifeless gaze of stones, already sinking back in her head.

Kindred Spirits

The mouth of Buffalo Basin professes to be nothing more than any other Montana microcosm that backs up to everything wild. The basin rises gently from a wide glacial valley floor and sidles up to a fabled blue-green river, chock-full of back-eddying caddis flies and complex trout. Where the basin eventually veers from the Yellowstone River, a gravel road twists through antisocial juniper, and cedar trees turn their backs on the intrusion. Northern flickers and black-capped chickadees spread shrill rumors between the scrub trees and homemade fence posts. I was driving that road as it crossed a brisk chattering creek named for someone long dead, hoping to see some grizzlies.

My reason for being there the summer of 2015 was to film an unusual phenomenon occurring near the back of the basin, where meadow turned to mountain. There had been reports of as many as two dozen grizzlies within the same meadow simultaneously digging up and feeding on these nutrient-rich roots. It's incredibly rare for grizzlies in the Lower 48 states to congregate and feed together in plain sight, as opposed to their Alaskan cousins, the brown bears, who stand gape-jawed at the top of waterfalls hoping

a spawning salmon leaps into their mouth while the shutters click from a viewing platform meters away. I had been filming grizzlies since I met Doug Peacock: Green Beret medic, celebrated author, intrepid explorer, international grizzly expert, and fellow resident of Park County, Montana.

It had taken three unrelated professionals to recommend that I read *Grizzly Years* before I finally picked up a copy. My biggest question was why I had waited so long.

Grizzly Years by Doug Peacock had been strongly recommended to me by my physician, psychoanalyst, and new friend, Dr. Jesse Logan, within a few months of arriving in Yellowstone in 2012. After Marley died, I had gone from someone who read books regularly to someone who couldn't focus long enough to finish a greeting card. The letters and words were there, but reading became a chore like trying to pass an eye exam in the ophthalmologist's office. I saw the letters but couldn't take in the words. I was familiar with Peacock's hyperbolic role in Ed Abbey's stories but knew nothing of Peacock personally. I had been reading some works about Yellowstone. Since *Grizzly Years* was at least in part based in Yellowstone, I finally gave it a try, though I didn't see what a wounded Vietnam War veteran suffering from PTSD and I could possibly have in common.

I eventually took *Grizzly Years* with me into Yellowstone the summer of 2014 and read it in part while leaning against my backpack and gazing out into Pelican Valley, seated on a six-hundred-thousand-year-old rhyolitic lava flow perch overlooking the Firehole River. The pages seemed to turn themselves as I read about someone deeply traumatized by life, whose PTSD made escape from the trauma of war impossible. I saw a reflection of my pain in Doug's words. I had read the nature writings of Thoreau, Leopold, and Muir, but that wasn't what I was seeing inside myself and out the back door. Peacock was not only describing what I was surveying in

Yellowstone but finally putting words to what I was feeling inside and in the wild.

I finally felt like I wasn't alone.

When Jesse, my friend and fly-fishing mentor, offered to introduce me to Doug while doing some casual fly-fishing along the Yellowstone River, I leaped at the opportunity. I brushed up on some grizzly facts with a few stories of my own and wondered how I would tell him the same thing thousands of others must have—that his book gave me the will to carry on when I really needed it.

Jesse made the introduction on the banks of the Yellowstone one drizzly May afternoon. I let Doug know that not only had Jesse, my physician, and my ex-psychoanalyst recommended I read his book but I had seen them all in the audience at Doug's reading for his latest book in Livingston. We fished, drank warm PBRs, and talked bears while making plans to fish the Lamar within a few days. I must admit looking down the Yellowstone River seeing George Washington Hayduke casting to a back eddy was more than a bit surreal. I'd expected the ornery beer-chugging renegade eco-warrior from legend. What I found was a very charming, engaging, and soft-spoken human being who genuinely cared about people and everything wild. I sensed that maybe he had softened with age, but I would occasionally see a flash, a spark, like when discussing the local landowner who liked to bully people off their legal river access. The landowner had recently walked down with a pistol on his hip to intimidate Jesse. Jesse invited him to call the law and stick his gun up his ass. Jesse knew his rights, but this tripped Doug's trigger, and he began a minor lecture on subversive tactics as he tied on another elk hair caddis with the final notes trailing off as he cinched the knot.

"Fighting fair is a great way to lose," Doug announced, turning his head sideways and snipping off his 5x tippet. "If you know your

rights, you gotta be willing to kick 'em in the balls and bite their ankles if you really want to win."

Jesse and I both laughed out loud, as did Doug. But Doug's laugh was accompanied by a sideways glance, a fire behind his eyes, not unlike Old Horn's, that I would come to know, fear, and love.

Over the next few years, I stayed in touch with Doug. What I found was that same human being I met on the river that day in 2014. Doug lives and breathes the importance of all things wild but especially grizzly bears. I'd seen some people dedicated to conservation work, but it was different with Doug. He doesn't schedule in time for saving grizzly bears—they are just a part of his life. His fight to preserve them is a two-prong strategy that involves creating grizzly awareness and changing hunting and conservation laws. As Doug freely admits, most of his fights these days are in state and federal courtrooms. A different kind of trenches from Vietnam, but possibly no less precarious.

Grizzly Years, in a nutshell, was about healing in the wild, and I knew the wild was healing me, I just hadn't pulled it all together yet. That grizzly bear on Swan Lake had been the only thing capable of instantly snapping me out of my fog and altering my trajectory. I owed him. Maybe it was my midwestern upbringing, but one hand washes the other, and we paid our debts. The thought of that bruin from Swan Lake, who could have and probably should have beat the shit out of me but instead gave me another chance at life, being murdered because he crossed some arbitrary, invisible boundary out of Yellowstone made me sick. I believed, like Doug, that the bears needed help.

At his house one afternoon, over a French Bordeaux (wasted on my palate), I asked him what I could do. He smirked like Yoda when he was imparting wisdom and told me to film and photograph grizzlies. To keep journals and maps of habits and vegetation. To follow family units and see if their habits/diets were changing and to film

it. Most of all, film grizzlies being grizzlies but shoot sequences for a project. Wait! What had he just said? Did he actually hint at working on a project together? I tried to be nonchalant. "Cool, man," I think I said or something equally witty before I gulped that expensive Bordeaux.

For several years, from late summer through fall, grizzly bears were congregating in one meadow where they would feast on an invasive plant, thought to be caraway, that had made its way into the cattle-grazing pastures. I had witnessed a lot of grizzly activity in and around Yellowstone, but this was radically different. My coworker and I were filming upward of seventeen grizzly bears in the meadow rooting and feeding together like Alaskan brown bears wading through salmon. There were single bears, mothers with cubs, sets of bears traveling together, and big males cruising the feeding grounds. When a big male, called a *boar,* started making his way toward a female with first-year cubs, I told my cameraman to turn his focus on this quickly developing situation. From my experience, when a boar comes anywhere near a sow with cubs, there is usually a hasty retreat by the female, or she engages the boar in a fight to protect her cubs. Boars will kill cubs to bring the female into estrus and mate. What happened next would have even bear biologists scratching their heads.

The big, dark boar waddled into the meadow with the cowboy swagger that only a big grizzly wears well. When I saw the mother with cubs lift her head, look at him, and not run, I figured there was going to be a bear fight. To my complete astonishment, she let him strut right in and feed close to her cubs. She kept a watchful eye on him, but after about twenty minutes of feeding, the big male was closer to her tiny cubs than she was. We were shocked and kept checking the camera to make sure it was recording. So began a new wildlife detective story to unravel.

One of the grizzly families we watched was a mother with three

COY (cubs of the year). All cubs are born sometime in January or February, and they are called COY for that first year. Grizzly sows usually give birth to two blind and hairless cubs weighing less than a pound. All grizzly cubs are basically born premature and rely on their mother's high-fat-content milk to start putting on weight quickly. This mother grizzly seemed reluctant to venture deep into the meadow with the other bears and would run with her tiny cubs into the nearby willows. She stood up to look around more than any bear I had ever seen. Her three, little mini-mes would mimic her and stand also. The ranch manager fondly called this mama bear Nervous Nellie. We did our best to film her, but she made herself and her little clones visible infrequently.

I spent nearly every day from late summer through the fall in the Buffalo Basin tracking and filming the grizzly bears. The terrain in the northern Rockies can go from lush, verdant valleys to some of the gnarliest and ruggedest terrain on the planet. It is vaster than it appears when you traverse it on foot. The gentlest-appearing slope up an unassuming foothill will have you gasping for breath before you reach the first crest. Add seventy pounds of camera gear on your back and you begin to feel more like an out-of-shape pack animal that might keel over on the trail well short of the destination.

Most of my time, though, was spent on a hillside that overlooked a horse barn, a windmill, and a nightly congregation of grizzlies sharing a meadow with the ranch's Ancient White Park cattle, elk, and occasional moose. It was surreal to see a dozen grizzly bears sharing space with seventy head of horned white cows with black button noses, while bull elk bugled over their harems on the outskirts and moose browsed the willows. Red-tailed hawks dive-bombed the dying ground cover for exposed rodents making a run for it. Pockets of quaking aspen trees shimmered in the early-autumn dusk and popped amid the stands of deep green conifers. I filmed, photographed, and took notes, trying to get my head around what

I was seeing. Besides being outside and engaging my mind, filming grizzlies helped me maintain some semblance of sobriety—at least during the day. But at night, alone with my thoughts, depression and addiction would impolitely barge into my abode. Together, we poured Russian vodka straight over ice in pint glasses until the feelings didn't feel anymore.

Winter hit southwest Montana with a vengeance by early November of 2015. The bears feeding in the meadows disappeared with the exhausted food source, and the season's first significant snow covered the digging grounds. We had filmed as much as we could of the grizzly phenomena, and my mind shifted toward another winter season of sore knees tracking mountain lions.

Around the third week of November 2015, I learned that a mother grizzly with three COY had been shot and killed by an elk hunter at the back of the basin where I'd been filming. I was told the mother bear had stood up, looking around, as bears do, and the elk hunter took it for an aggressive move and shot her dead in front of her cubs. Was this Nervous Nellie standing up to get a better view like I'd seen her do so many times? This was the worst-case scenario for a bear family. Montana Fish, Wildlife & Parks (MFWP) would now most likely try to trap the cubs and euthanize them as they often did when sows were killed. My heart sank. The news of the killing opened my still-festering wounds. No matter how well I was functioning in the Yellowstone wild world, there were still far too many nights I indulged in drinking, self-medicating, and finally self-flagellation. The pain of losing Marley and the ultimate betrayal by my mother were never far away.

Now another senseless tragedy had brought it all full circle.

I isolated myself and cursed God for taking away so many things I cared about. I tried to write, something I'd wanted to do since high school, but my vodka palsy made anything more than incoherent babbling and preschool penmanship impossible. After

screaming, scribbling, pounding the desk with a ravaged fury, and breaking everything within arm's length, I would take a last swallow of straight vodka from a now-empty fifth and pass out amid swirling memories of Marley's death.

"Please come back to us, Marley. We love you so much. Mama and Papa are here," I blubbered out loud, my words getting lost in the tears and mucus. Then the room started to move. The hospital machines, the tubing, the window, the pastel wallpaper, it all started to spin as the edges of my vision began to blur. I felt like I was on an escalator, moving backward from Stacey and Marley, gliding out of the hospital room. Marley was wrapped in white, like the day she was born, and my mind started confusing her birth and her death. Visions of her first night at home, our first proud walk in the neighborhood, Marley on the swings, giggling at the beach, and the last time I saw her alive at my mom's, sleeping away peacefully in her pack and play with her two middle fingers in her mouth. I saw flashes of our road trip west, Marley splashing in her blue pool on the deck, and the most painful were images of Stacey, Mazzy, Chloe, and Marley all together, laughing at the beach on a giant striped towel under a teal umbrella, Marley wearing her blue sun hat. My body went numb while my mind raced until I had to grab the handrail of Marley's bed to steady myself. I stared hard down at my daughter, and the escalator ride stopped. In an instant, I was back in the hospital at Marley's bedside, looking to my wife to see if she noticed my brief mental hiatus.

She was looking at Marley, crying and leaning in.

"Please, Mrs. Orsted," Nurse Yoder begged, "I'm so sorry, but you can't kiss or touch her because of the investigation." Stacey brought both hands to her face, staring in disbelief at her departed blue jewel with tears streaming down her face. I came around from

the other side of the bed and put my arms around her. She was trembling from somewhere deep within, and we both began to weep openly, repeating Marley's name while staring down at her.

"I just want to kiss my baby," Stacey pleaded with the nurse.

"I know, I'm so sorry." He looked away uncomfortably.

Squeezing Stacey, I felt that animal ire building inside of me again. My crippling shock and deepening despondency were catching fire when I saw what this was doing to Stacey. I pulled her close, raised my chin to the ceiling, and yelled into the room, "Can someone please tell me what the fuck happened to our daughter?"

No one said anything or even moved. I felt uncomfortable yelling profanities in front of Stacey and Marley, but I couldn't hold it in any longer. The nurse and chaplain were now accompanied by two other large men dressed head to toe in white, who I assumed were security. My outburst had also caught the attention of two hospital employees in white coats and stethoscopes chatting in the hallway, who both paused, gape-jawed, then looked down and shuffled away when they realized what was happening.

"Hello?" I demanded, now staring at the four men in the doorway. "Can any of you tell us what the fuck happened to our daughter?" The words were horrific, guttural sounds gorillas make when their babies are stolen from them by poachers, and in an instant, I knew their madness. I wanted to beat on my chest, cry out in pain, and thrash the landscape, too. Stacey squeezed my hand and brought me out of a near-blind rage.

We stood there sobbing, holding each other but not Marley.

Stacey and I walked out of the hospital into a strange world. A world without our daughter. The hours had cooled the intensity of the sun, and robins flitted between maple trees lining the parking lot, but none of it seemed real. The only vehicles left occupying that section of emergency room parking were our three. It seemed nothing was an emergency anymore. Hospital employees fresh off their

shifts were walking out together, engaged in conversation, but it was all babble to me. The sun was going down on this wretched day, and we still had a gloomy drive home.

I held Stacey as we walked to the car. She felt different. Something was missing. She was lighter, like something had left her body, taking all the connective tissue with it. My wife would never be the same. This was all my fault. I had one job in life, and that was to protect my family. I had failed horribly. I had placed the well-being of our daughter in someone else's hands, and now she was dead. The fallout of my misplaced trust was now trembling in my arms as I loaded Stacey into the car for the hour-and-a-half drive home without our daughter. How was this even real?

The next morning was a blur after a sleepless night spent crying and holding each other. Stacey and I lay in bed like two shattered dishes on the kitchen floor just looking at each other's broken pieces. We were surrounded by Stacey's family and our friends, but I was numb and hovering. The grief was an out-of-body experience at times. Hearing Stacey burst into tears while hugging Marley's blanket and saying her name brought me right back.

My mom was supposed to be going in for follow-up questions with the detective that morning. The detective had told me at the hospital she would call me the next day after the interview. She was intent on getting us the truth. Between pacing in the garage and collapsing next to Stacey in bed, I kept my phone close and on vibrate.

We had anywhere from six to ten visitors all morning, and every time my phone vibrated, the room went silent while everyone stared at me. We were all on pins and needles waiting to learn what had happened at my mom's house, but my phone was blowing up with friends and colleagues calling with their support and sympathy. Worst of all, reporters were calling us. We decided as a family that we would not speak to the press about our tragedy. This was our daughter and my mother, not their fucking headline.

My phone rang and vibrated on the kitchen table, startling everyone. I had the ringer turned all the way up so I wouldn't miss any important calls. I looked at the number.

"It's the detective," I said flatly, not looking at family gathered around the kitchen table.

"Hello, this is Brad."

"Brad, this is Detective Rodd with the Elkhart County Sheriff's Office. We spoke at the hospital. I'd ask you how you are doing, but I can imagine."

"Yes." I cleared my throat. "It's been rough."

"Are you with Stacey and family now?"

"Yes."

"Good. I have some information for you guys if you're ready." I looked at everyone gathering around the kitchen table.

"We're ready as we're going to be."

She took a deep breath. I held mine.

"Your mom came in for more questioning with pretty much the same results. She has changed her story so many times we're having trouble keeping track. When something didn't fit, she would change it. While she was quite lucid on some of the events, we feel she is being purposely evasive about corresponding events in the timeline."

I had to turn away from the intensity of all the eyes.

"Because this is an ongoing investigation, there are details I cannot share with you, but I want you to know I told your mom how much this is hurting you and Stacey, not knowing what happened to Marley. I told her no one was mad at her and everyone loved her, but we need to know what happened since Marley had been deceased for hours when paramedics arrived and none of her stories fit. Brad, she just shrugged at me."

A knot constricted my throat.

"I promise you we will not give up on this, but you and Stacey need to prepare yourselves for the possibility that you might never

know how Marley died—unless the autopsy results provide something definitive."

I thanked Detective Rodd and hung up. As I relayed the message to everyone around the table, I started to cry.

"Knock it off!" an elderly relative snapped at me. "Men don't cry." I looked at her husband, a World War II veteran. He shook his head in disgust at me.

I answered everyone's questions—or at least I addressed them. My lack of real information was causing tempers to flare. I became increasingly aware that I was currently the only person in the room related to my mom.

About a week after the mother grizzly was shot and killed, MFWP did a flyover in a fixed-wing aircraft and saw that the bewildered cubs were still in the area with their dead mother. She had been left where she was gunned down. With a severe blizzard and dangerously low temperatures settling in, MFWP would not attempt to rescue or euthanize the cubs if it meant putting any of their employees at risk. Even though grizzlies are protected from hunting, no fines or penalties are applied in cases where hunters (or anyone else) kill a grizzly in self-defense. They were satisfied that this was a case of self-defense by the elk hunter and seemed content to let the defenseless cubs fend for themselves.

I couldn't accept that. I *wouldn't* accept that.

Casey and I met at the Nest—a geodesic dome on his property that we had converted to our makeshift headquarters—for a quick early-morning catch-up before going our separate ways for family Thanksgivings. I nursed a bitter coffee as we discussed the orphaned cubs. Then my phone pinged with a text. A fixed-wing pilot for MFWP had done a flyover on the Nervous Nellie murder scene and had radioed back the worst possible news. Nellie's three tiny cubs

refused to leave their dead mother's side. They had traumatically watched their mother's murder, probably witnessed an obviously lame and perfunctory investigation of a grizzly bear death by more gutless humans with guns, and still refused to leave their deceased mother's side through the arctic nights. Casey and I stood hopeless. Tears welled up in both of our eyes. I knew he was seeing what I was: starving, freezing, terrified grizzly cubs bawling out next to their bloody mother.

"We could dig a snow cave," Casey said, his voice probing.

"And do what?" I asked.

"Drag her in it," Casey started. "Maybe the cubs will follow when we leave and den on top of their frozen mother until spring." Given the other option of doing nothing, it seemed reasonable. We knew bears had denned in just about anything, and surely a mother bear had died in a den before, so maybe Casey was onto something.

"But how do we find her?" I asked, pondering the vastness of the region. "Do you have GPS waypoints?"

"No, but I drew a pretty good map on a bar napkin at Chico the other night, and I think I can find the area—if snow and wind hasn't completely covered everything by now."

Winter had come hard and fast that November of 2015, with several feet of new snow in the high country and temperatures at night close to those at the summit of Mount Everest. Her cubs may not have eaten in weeks. I was overtaken with a sense of urgency.

"Let's go," I blurted. Casey chewed on a fingernail, head cocked sideways, contemplating.

"Let's go," he finally said with that wry, crazy smile I associated with both pain and beautiful amazingness.

So we did. We set off with snowshoes and shovels, clinging to a loose set of directions and a very sketchy bar napkin map. We were very aware of what we were about to do. Since grizzlies were federally protected under the Endangered Species Act, dragging a frozen,

dead grizzly into a freshly dug snow den and trying to affect the behavior of her cubs could be punishable by law. But, unlike the authorities, we decided the juice was worth the squeeze to try to save the cubs. After all, those federal protections weren't really protecting them.

When we started moving, we found several inches of fresh snow on top of an already-packed and deep base, not to mention minus-twenty-five wind chills that burned exposed skin. Snowshoeing across those wind-loaded snow cornices under bluebird skies with shovels across our backs while looking for a dead grizzly mother had seemed like a great idea from the warmth and safety of the Nest, but actually doing it was another story. We slowly approached our first steep and sketchy slope. Sustained katabatic winds had created the mesmerizing lines on the snow ledge that German car engineers look for in wind tunnels. It was easy to forget while admiring the wind-driven curves on the snowy edge that if that beauty collapsed underneath us, we would free-fall hundreds of feet before slamming onto the rocks below. Casey had way more experience here, so he was in the lead, as I made sure to only step with my snowshoes where Casey had stepped with his, hoping he hadn't just loosened the façade below me.

We snowshoed farther that day through brutal conditions than all my other snowshoe adventures combined.

Taking a break at an overlook, I walked off to see what kind of small animal tracks went through the timber, and I nearly fell into a very deep tree well, or spruce trap. I looked back toward where Casey was last, but he had already left, heading back up the hard side of the mountain. Had I fallen in the spruce trap, I would have been on my own and possibly buried alive under feet of snow. I could suddenly hear my father asking his favorite question: "If your buddy jumped off a bridge, would you, too?" Most often he would ask it from under the Chevy while changing the oil and trying to

Grizzly COY (cubs of the year) hiding beside their mom (Yellowstone 2019)

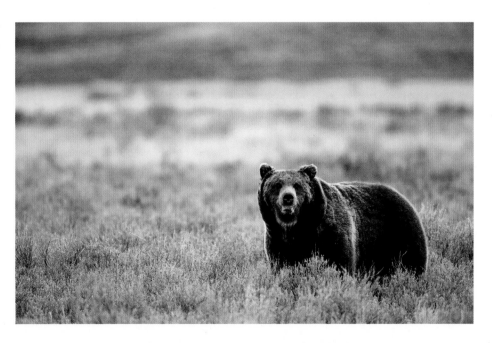

A big male grizzly on Swan Lake Flats (2019)

John Orsted, my adoptive father

Light breaks over a stand of cottonwoods in the Lamar Valley. (Yellowstone 2014)

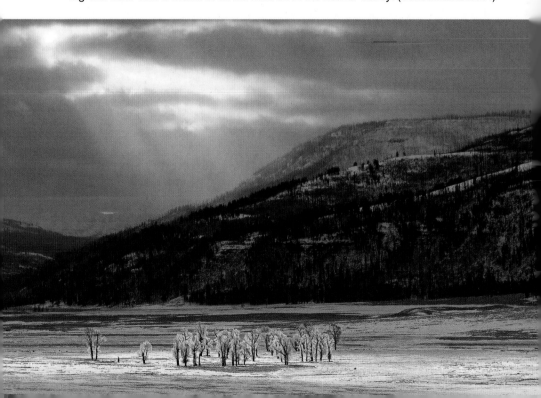

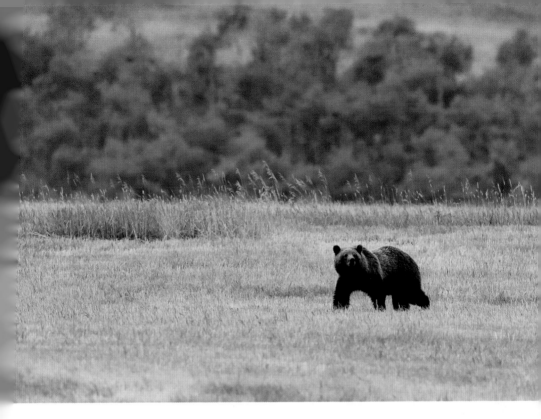

The last image I took of either of the orphans (Montana 2018)

A precious moment captured between Marley and her daddy (Michigan 2010)

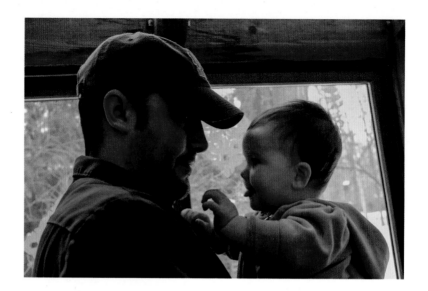

(Above) Me and Marley playing the stick-out-your-tongue game (Michigan 2009)

Marley in her bear onesie at Glacier National Park (2009)

(Below) Marley loved to play in the water. (Michigan 2010)

Marley was always such a happy baby! (Michigan 2010)

(Below) Marley playing piano with her sisters (Michigan 2010)

(Bottom) Marley was entranced with the river otters at the John Ball Zoo in Grand Rapids. (2010)

(Above) Marley never sucked her thumb—it was always her two middle fingers. (Michigan 2009)

Marley was so excited on her first and only birthday. (Michigan 2010)

(Below) A mother grizzly nurses her cubs in Yellowstone. (2019)

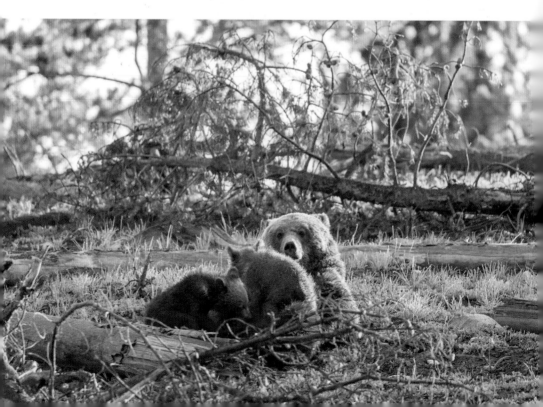

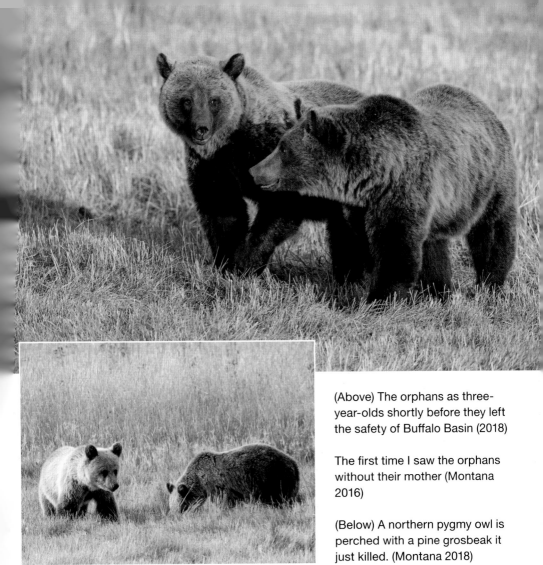

(Above) The orphans as three-year-olds shortly before they left the safety of Buffalo Basin (2018)

The first time I saw the orphans without their mother (Montana 2016)

(Below) A northern pygmy owl is perched with a pine grosbeak it just killed. (Montana 2018)

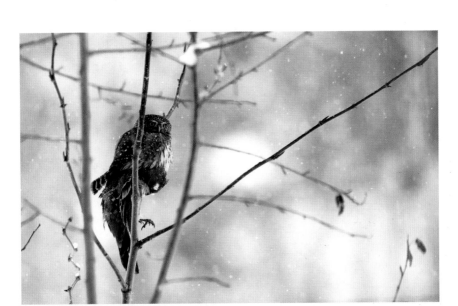

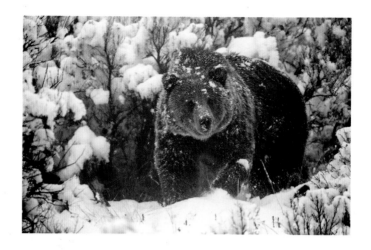

(Above) A big grizzly popped out of the snow-covered sage and filled the lens. (Montana 2013)

A Wapiti Lake Pack wolf pup looks right down the lens. (Yellowstone 2020)

(Below) My family's new backyard in Yellowstone National Park (2012)

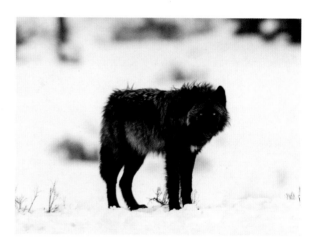

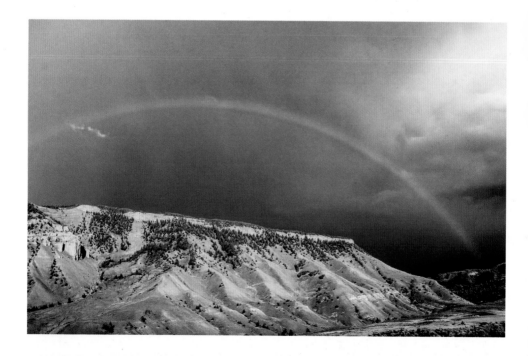

teach me to think for myself and not do the dumb stuff my dipshit friends were doing. I wondered what Dad would think of Casey. And I knew deep in my gut that if Casey jumped off a bridge, I'd be right behind him.

Every so often, I stopped and tried to use my binoculars, but the winds instantly turned my eyes to tears, rendering them useless. In fact, the sun's reflection off the pristine snow was nearly unbearable even with sunglasses. The mercury hovered somewhere around minus three, and wind chills stung exposed skin, and it was only manageable if we kept moving. We snowshoed miles over endless ridges in search of Nervous Nellie and those poor starving, orphaned cubs. If we could just dig that snow cave and drag her into it, we believed the cubs would join her, then fresh snow would cover the opening, and Mother Nature would do the rest. They would sleep on their dead mother all winter and emerge in the spring. It wasn't foolproof by any means—in fact, it might have been downright crazy—but it was all we had.

By the end of the day, we stood on the highest point around, devastated. Defeated. There were no signs of a dead bear and only two small sets of unidentifiable tracks far in the distance and another day's snowshoeing away. We had no choice but to turn back short of our mission. Hiking out, we discussed the possibility that the elk hunter had actually killed four grizzly bears that day. He just hadn't admitted it.

I arrived home, broken and exhausted in the dark. My family had given up on me for a shared Thanksgiving meal and had left to join friends. I microwaved a bowl of carrot-ginger soup from a postdated container in the refrigerator and washed it down with a pint of Stoli vodka on the rocks. But no matter what I did, I couldn't get warm. Still fully clad for subzero weather, I found the bottom of the glass and slipped out of consciousness on the couch with my boots and gaiters still in place.

Hard Side of the Mountain

That winter, I spent nearly every day following and filming our mountain lion family for a future film that would end up on the Smithsonian Channel. While I was actively tracking the lion family, it was easy to stay in the moment, but every time I sat in a blind, waiting for the lions to come back to one of their kills, my mind drifted back to the orphans. I wondered if they had stayed close to their mom or wandered off to die alone. Their fate was not my responsibility per se, but I felt like I'd let them down when we couldn't find their mother.

When summer arrived and I began to explore the back of the basin again, I wondered if I would find four dead grizzly bears. It was an image I wasn't looking forward to capturing. But as luck would have it, no sooner did the last mountain lion track melt out with the final remnants of snow in the high country, then I was off to Africa with VisionHawk to film lions for a Dereck and Beverly Joubert project. I had mixed feelings leaving Montana for Africa. It was a dream job for a wildlife filmmaker, but with potentially dead grizzly cubs in the basin and a critically wounded marriage at

home, I wondered what I would come back to after six weeks in the Okavango Delta.

August of 2016 found me trying to hide from the African heat in a canvas-walled tent when I received a text message from a friend informing me that two yearling grizzly cubs without a mother were feeding in the Buffalo Basin meadows area, down the road from the main congregation. She texted me an image. I walked excitedly, looking over both shoulders from our filming camp of canvas tents to the office structure where the limited Wi-Fi was the strongest, hoping the images would come through.

Under a single buzzing, flickering light bulb in the Okavango Delta, with the sun going down and lions calling from under a nearby acacia tree, the first image loaded. There were two fur-ball yearling grizzly bear cubs that could not have weighed more than one hundred pounds with no mom in sight. One was darker and slightly larger than the other. The smaller cub had an almost pure-blond coat. Had two of Nervous Nellie's three cubs survived one of the toughest winters on record? These were definitely year-ling cubs and should be with their mom, as grizzly cubs stay with their mother for two to three years. In all my time observing grizzly bears, I had never seen two cubs this small on their own. Could this be the cubs we had tried to save? I wanted to believe that they could have survived against all odds, that a miracle could have happened, that the world was still a kind place, but I also knew better than to get my hopes up.

After a life-changing six weeks in Africa, Montana and grizzly bears might as well have been on a different planet when I arrived home in August of 2016. I made it back, horribly jet-lagged, but Stacey met me at the airport and took me to *An Evening at the Arch* a few days later: a concert, four years in the planning, to celebrate the one-hundredth anniversary of the creation of the National

Park Service. A fine welcome home with six thousand other fans. Emmylou Harris and John Prine performed under the watchful, rhyolitic eye of the Roosevelt Arch. Forest fires burned in the distance, hazing the air, and the arch glowed like hammered metal in the setting sun. While I tapped my feet to the country-and-western beat, breathing in the strange new smells post-Africa, I stole sidelong looks at Stacey. Her long hair blew slightly in the wind, and she swayed to the music. I still loved her, and I thought she probably still loved me, but I knew something had changed. Maybe it had been a process, a fracture that had spider-webbed a long time ago and I was just now able to see it. To admit it.

That night, we went home to the former hunting lodge we'd bought a while back. It was surrounded by Forest Service land and included a ten-by-fifteen-foot miners' cabin that had been rescued from the hills and transplanted onto the property, a perfect studio for me. Stacey could cross-country ski and I could track predators right out the front door. When we first went to look at the property, the girls went in the house as I stayed outside, walking the perimeter and finding an old mountain lion kill cached next to a boulder. Just then, Stacey opened the second-story window and called to me.

"Hey, Brad, don't you want to come upstairs and see the *inside*, too?"

Pointing to the old mule deer carcass, mostly bones, I replied, "No, we'll take it!" The Realtor laughed, and my girls just shook their heads.

This was our first home purchase as a family. The girls picked out their rooms, and like we had done so many times already, we packed everything and moved. But this time, we were home. Our marriage had been flailing, but we both hoped the change in scenery, the anchoring of ourselves into the Greater Yellowstone Ecosystem, would give us the solid foundation to rebuild. There was even the small miners' cabin at the edge of the property, which I

could use as a man cave. It would be my impetus and sanctuary for a thousand short stories and poems. There would be evenings spent by the toasty woodstove, reading Keats and sipping Irish whiskey while the children played outside, and the dogs delighted in my gentle demeanor. I could envision my doting wife, calling to me from the porch of the house to tell us all dinner was ready. This was going to be so idyllic.

Maybe it started out that way, but the old miners' cabin I claimed as my creative jump room extraordinaire quickly became the alcoholic isolation wing of our new mountain estate. I had tried to keep my drinking away from my family, and now I had my own structure where I could claim to be reviewing footage and sending important emails. Instead, I mostly drank and ruminated. Staring at the rough-timbered walls of the miners' cabin, I pondered how many previous owners, also spiritually bankrupt and physically exhausted, had done the same thing: drink rotgut booze and wonder how they got there.

The cabin was where I retreated after the concert to imbibe as I contemplated our marriage and the future. For the past year, Stacey had been working for VisionHawk, having left her job at the park, and our work tied us together. But now that I was back from Africa, Stacey was beginning a new venture: building a lodge and café in Gardiner called Wonderland. The girls were growing older and were ready to move on to college. As ties that bound us together slipped away, the core of our marriage grew smaller.

I believed there must have been a day, time, or moment where Stacey and I, either full of love or hate, decided as a couple that our marriage was over, but try as I might, I couldn't pinpoint it. A sea change moment in a wounded relationship so full of hurt where we knew from there to go our separate ways even as we stayed together. I wanted something climactic or cinematic that I could store away for later editing—but it just didn't happen that way. It was as futile

as trying to pinpoint where my Crow sweat or griz encounter happened—I couldn't identify the exact emotional waypoints to bear down on. The harder I tried, the more it eluded me. As did the way forward. Would we stay like this forever? Together but apart?

For months, I had spent more time in the company of animals than humans, and that night, I drank alone with the demons I hadn't yet shaken. Two days later, I took the familiar drive up to the Buffalo Basin meadows. Things felt different now even though the basin scenery was the same. Western meadowlarks serenaded the afternoon from miles of buck rail fence that paused only for iconic ranch entrances with country-mile-long driveways. This was the setting for a thousand mountain west drainages, but as the scrub and juniper gave way to timber, the land opened to rolling pastures and large cattle ranches: a natural washbasin of mountain peaks standing guard over the fertile valley. A view with a sense of how things used to be, long before fences, if you squinted hard enough. Africa seemed like a dream now compared to the very real Montana basin I was driving through full of log homes, cattle, and mountain peaks. I had gone from looking for five-ton elephants in the tall grasses of sub-Saharan Africa to searching for less than one-hundred-pound fuzz-ball grizzly cubs in meadows of the American west.

Pushing deeper into the rising landscape of sparse cattle ranches, the back of the basin came into view where the towering hills turned to mountains. The sloping foothills bent to their masters of stone— the formidable granite peaks at the hindquarters of the basin that created a natural cul-de-sac where all roads and ranches ended. The back of the basin was my stopping point, too, where some say the densest population of grizzly bears in the Lower 48 exists.

If God had pets, they would be grizzlies, and she would let them play here, at the back of Buffalo Basin. Seated atop a fifty-million-year-old petrified tree that is buried still upright above the rhyolitic ash flow that helped form Yellowstone, I imagined whoever first

coaxed bears into existence from the night sky and breathed life into them surely took great delight in watching them gather in the high alpine meadows to romp and feed on biscuit-root and glacier lilies. Here, in the company of the Sheepeaters' ghosts, I sought refuge and a place to film grizzly bears under the matriarchal nod of their Creator.

The grizzlies were in trouble. In March 2016, the U.S. Fish & Wildlife Service (FWS) announced plans to remove Endangered Species Act protection for Yellowstone's grizzly bears, paving the way for state-supported trophy hunts. There had been a sixty-day public comment hearing, but the results had not yet been published. If the states of Wyoming, Idaho, and Montana had their way, the orphans, as well as every other grizzly bear in the basin, could soon be hunted as décor for someone's trophy room. The very sanctitude of the basin seemed in jeopardy if the resolution passed.

Yellowstone grizzly bears had been placed on the endangered species list in 1975 when their numbers crashed after dumps and public feedings in Yellowstone stopped abruptly and with little consideration for the species, much to the chagrin of naturalists like Frank and John Craighead, brothers who were some of the first to initiate an in-depth study of Yellowstone grizzlies. The brothers warned that closing the dumps and public bear-feeding events without weaning the bears away from this unnatural food source first could have devastating effects on the species, and they were right. Grizzly bear populations dwindled to less than a few hundred in the entire 2.2-million-acre park as good bears became problem bears and were relocated or killed in record numbers.

In 2007, after needing over thirty years to repair the man-made damage done to their numbers, grizzly bears were once again in the spotlight as FWS removed their protection from under the Endangered Species Act. This seemed an incredibly myopic move by state and federal authorities for a species arguably not out of danger. And

"argue" is what some of my newfound friends in Montana did; with the best available science leading the way and eventually prevailing, grizzlies were restored to the Endangered Species Act in 2010, coincidentally the same year we lost Marley. Now, in 2016, the powerful trophy-hunting lobbyists were once again itching to get grizzlies in their crosshairs.

Before I reached the back of the basin, where most people parked to view the bears feeding in the meadows, I saw some cars pulled over along the dirt road. I had never seen cars stopped here, several miles short of the meadows, reducing the road to one lane. Pulling up, I asked the first woman I saw what they were looking at.

"Grizzly bears!" she exclaimed enthusiastically, motioning with her camera.

"Oh, cool," I said, lifting my binoculars and scanning the horizon. "How far out are they?"

"You don't need those," she said, pointing to my binoculars. "There's two grizzlies on the other side of the fence right next to the road."

Lowering my binoculars, I looked through my windshield at the dozen or so people gathered and where their phones were pointed. Several people had binoculars around their necks, but no one was using them. Were people really so close to grizzly bears they could film them with their phones? I wondered with a rising tension building inside me. All I could see was humans under the spell of a good gawk with extended arms under hat brims and bills, oohing and aahing in a semicircle with their backs to me. What were they looking at? I hastily put the car in park and stepped from my vehicle onto the dusty Montana county road.

To my astonishment, there were the two yearling grizzly bear cubs I had seen in that text a week before. They were about sixty feet off the road in a field of cut hay with their heads down eating, while watchfully eyeing the excited crowd. True to the photo I had seen,

one was slightly larger with a classic, light brown, silver-tipped grizzly bear coat while the other was very blond, almost resembling a spirit bear of the Pacific Northwest. With their heads down and front feet raking the dirt for tubers, grubs, and roots, the hump of muscle above their front shoulders that made all this excavating possible was very pronounced. There was no mistaking these were grizzlies. Instinctually, my attention turned to finding their mom. If she was napping away the summer heat in the distant creek bottom and rose from her slumber to find her kids within a stone's throw of a dozen humans, this could get very ugly, very fast. Grizzlies are known to run at a speed of thirty-five miles per hour, and sows are fiercely protective of their cubs. Scanning the vast, open fields, first with my naked eye, then with my binoculars, I saw only more meadow.

Nervously, I turned my binoculars back toward the cubs, who both still had their heads down, grazing on the grasses. Pausing momentarily to admire the lighter cub's coat with my high-powered binoculars, it lifted its head and looked right into my soul. Through the magnification, it appeared as if we were face-to-face. Its nose was covered in wet mud, and I could see flashes of its pearly-white teeth while it chewed on nutrient-rich grass. It looked like a furry piglet whose eyes were much too small for its head, causing me to chuckle.

About the size of golden retrievers, they looked so diminutive and vulnerable against the backdrop of wilderness they came from. Both cubs continued eating with only a buck rail fence between them and the people. Leaning my head back into the breeze coming off the mountain peaks, I investigated the bowl where the previous fall a mother grizzly had been killed in front of her cubs. My mind replayed what the MFWP pilot must have witnessed when, days later during a flyover of the scene, he saw three tiny and terrified grizzly bear cubs weighing less than thirty pounds each in the

subzero temps, probably hungry, yet refusing to leave their dead mother's side.

I could imagine an elk hunter tucked into the timber along a game trail, calling in his trophy bull. Snow falling across an opening, he sees movement in the flat light, then hears branches breaking. He takes a series of involuntary short breaths, then slows his breathing, knowing this could be his chance to fill his freezer with elk meat. He slowly lifts his rifle to his camouflage-painted face. A mother grizzly, desperate for final calories before hibernation, hears a distressed elk call. She moves cautiously toward a last possible food source to help her produce more milk and protein for her cubs—enough to last them over the winter. She sees a slight movement in the timber across the snowy meadow and pauses with her cubs, standing on her hind legs to get a better look. Neither hunter nor grizzly see what they expect to see. A nervous hunter realizes he's called in a grizzly in lieu of a bull elk; he panics and pulls the trigger.

My mind flashed to the pilot's aerial view days after the incident. A dead mother grizzly in the fresh white snow, surrounded by a dark bloodstain. The three cubs must have looked like dots as they cried out and nudged their frozen mother, maybe even attempting to still nurse her lifeless, frozen corpse in their confusion and desperation.

I tried to imagine them striking out alone, leaving the only love and protection they knew dead in a snowfield behind them. I could see them huddled together and bawling out against the cold—lonely, hungry, and exposed with only Ursa Major above to keep them company. Emerging from their mock den in the spring, there would be the immediate need for food. Instinct and abbreviated lessons from their mother would have to suffice. In their quests, they would have surely had first encounters alone with wolves, mountain lions, and other grizzly bears who would kill them. If these were the orphaned grizzly bear cubs, how had they possibly managed to survive? The

other dreadful question was, if these were they, what had happened to the other cub?

Grizzly cub mortality is around 50 percent, meaning around half of grizzly bear cubs won't make it through their first year. Grizzly cubs stay with their mothers for those first few formative years, learning seasonal beats, how to avoid danger, and where to go for food. In springtime, the cubs would move through south-facing valley slopes that would produce wild edibles, while searching for winter-killed animals. Summers would be spent fattening up in the high country before one last autumnal search for food in the lowlands, then denning again to complete one of the most in-sync rhythms of nature. All the river crossings, places to avoid, where to sleep, where to find buffalo berries and chokecherries at their peak of ripeness would be taught to them by their mother. Mom would know when the wolves were nearby or when a big, male grizzly who might harm her brood was in the neighborhood.

Alone, these cubs would have had to rely on the few lessons they were able to glean from their mother before her death, and the rest they would have to learn along the way—or die trying. I could relate to them instantly. I knew what it was like to bawl out against the night, wild, alone, and confused. The gnawing hole of a motherless life was my fate as well, and in this bond, a tether was born between us. A smile stretched across my windburned face, and my eyes filled with tears at the thought of these two orphaned grizzly cubs making it through a brutal Montana winter, alone but together, and now filling their little bellies on a seemingly endless supply of summer's fare.

"There's even more bears up the road!" a man with a dingy white T-shirt said, turning momentarily, pointing toward the back of the basin and snapping me out of my daydream.

"Thanks," I said, nodding lazily, "I'm good here."

He smiled, then returned to his filming stance.

Easing back into my reverie, I took a seat on the hood of my car just outside the gathered crowd and watched the two bears. Whether the dead bear at the back of the basin was Nervous Nellie and whether these were the cubs we tried desperately to save the previous fall didn't matter anymore. These two had been here for several weeks on their own with no mother. Although they didn't look like it, fat and fuzzy with admirers all around, these two or-phaned grizzly bear cubs were little miracles.

Then someone in the crowd moved too fast. Both bears jerked their heads up at the same time to look at the offender. It was the first time I got a good look at both of them, and I laughed out loud. They were the epitome of cute with their curious, yet slightly fright-ened gazes. Both cubs had mouthfuls of green vegetation and were frozen in mid-chew. Judging by the amount of shutter clicks from cameras and collective *awws* coming from the crowd, you would have thought you were at a baby's first birthday. I considered grab-bing my camera but knew I could not capture the moment and instead chose to be fully immersed in watching. Photographing meant trying to figure out aperture, pulling focus on my subject, and using my brain. All I wanted to do was enjoy these grizzly cubs thoroughly, without having to wonder what f-stop to shoot at. No matter their history, these two had an undeniable will to stay alive in some of the roughest country outside of Alaska, and they had survived together. As they went back to fattening their expanding bellies, I decided to drive up and see if any other bears were out at the usual spot.

When I arrived at the bear-viewing area where the previous year only a few locals had congregated, I was shocked to see dozens of people and cars from all over. What the hell had happened? It seemed our little secret was out. People were tailgating with coolers, grills, and lawn chairs, watching bears through spotting scopes.

"How many bears are out there tonight?" I asked a young man in

Hawaiian shorts and flip-flops. He turned from his group of friends with a beer in his hand.

"Bears, beers, whatever . . . I'm just here for the party!" he exclaimed, raising his beer in the air as his mates followed suit, laughing and cheering.

The residents of Buffalo Basin had tried to keep the bears' presence quiet. Word was that a photographer got pissed off that no one had invited her up to the "locals only" bear viewing. When she finally uncovered the location, she broadcast it on social media. A once peaceful and respectful place to view a rare behavior was now being polluted with beer-swilling party animals, and by late summer 2016, the unique feeding grounds for bears had become a three-ring circus. I saw someone grilling brats on a hibachi with the grasses around him bone-dry and twenty hungry grizzlies downwind. So much had changed in the basin in one short year.

I wanted to observe and film the two orphaned grizzly cubs without the tailgating experience. The orphans were too small to go to the main meadow alone, so they stayed off to the side, which was perfect for me. I adapted my schedule around the best times the bears would be out but the people wouldn't. On weekday mornings, it was just locals if anybody, but by midafternoon, tour buses would begin to roll up, and the spectacle would start all over again. I captured some incredible footage in the mornings, but when the crowds began to congregate, I would usually pack my gear and leave.

One sunny and warm afternoon, a handful of us stood on that dusty Montana road, appreciating the orphans as a jacked-up flatbed truck headed our way, trailing a dust storm behind it. The truck's tires slowed as it neared us and idled to a stop.

"Those grizzly bears?" a voice barely audible asked over the loud exhaust.

"Yep," I replied, seated on the hood of my car and not turning to look at the driver.

"That little blond one sure is cute," the bodiless voice said.

"Yep," I said, still staring at the bears.

"I hope they delist grizzlies so when I see her in the back of the basin this fall when I'm wolf hunting," he said boastfully, like he was building a punch line, "I can put a bullet in her gut and let her bleed out. She'll make a gorgeous rug!" His pals broke out laughing.

Now I turned to face the idling truck with five-hundred-degree blood surging to my head. The driver was a scruffy white male in his thirties with chewing-tobacco-stained teeth and a camouflage hat with an energy drink logo on it. His two passengers seemed about the same age and acumen.

"What the fuck did you just say?" I turned to face him.

"I said, if I see that cute little blonde this fall," he started slowly, then looked to his passengers for support to finish his statement, "I'm gonna make a rug out of her." The three erupted into all-out laughter inside the cab of the truck.

My fists clenched, and I felt an Old Testament wrath build inside of me.

"Get out of the truck," I invited him, leaning back on the hood of my car with open arms. My temples began pulsating with hot blood. The mood had changed from mean-spirited joking in the truck to just mean, as the two passengers glared aggressively over at me from around their stunned driver. The driver's face had changed from a brown-toothed grin to a cur's snarl. He looked at his friends, who were trying to intimidate me with their scowls as well.

"You're fixin' to get your ass kicked, old man," the driver sputtered through a wad of chewing tobacco and saliva. The three punks stared me down from their smoking diesel truck in dead seriousness. Jeez, now what? For Christ's sake, all I wanted to do was sit peacefully in the sunshine and enjoy the orphans.

"I didn't stutter, fuckhead. Get out of the truck, big mouth, and let's see what you got if you wanna kill grizzly cubs," I half whispered,

like I was addressing kindergarteners, while rising from the hood of my car to approach the idling truck. I had a plan in my head. If the driver was stupid enough to open his door and swing his legs out, I was going to kick the door shut as hard as I could on his shins, then grab his face like a bowling ball and drag him from his shit-stained seat. The driver made a feint toward me like he was going to get out of the truck, but I stood my ground.

"Fuck you, asshole," he said as the occupants began to push each other and laugh again. "You ain't worth our time."

I stood unmovable while they all laughed, but I think the driver saw a little crazy leak out of the bulging blue-green vein rising across my forehead and decided to keep moving. He let off the brake and called me a "pussy bitch," flipping me off as they drove away still laughing down the dusty road. Waiting until they were out of earshot, I yelled some profanities back at them and turned, satisfied with myself.

Then I saw a man my age with his arm around a boy about ten years old, standing just feet from me. I recognized him from earlier as one of the few people watching the orphans from a respectful distance. I didn't realize that he had moved closer to me.

"I'm really sorry for using that language around your son," I apologized, startled.

"It's okay," he said to me. "Sometimes we have to do that to get our point across. I just wanted you to know I agree with what you said, and I had your back if those punks got out of their truck." He pulled his jacket from around his waistband ever so slightly to reveal the wooden butt of a revolver handle.

Jesus, I thought. That could have gotten out of hand quickly.

"Thanks, man, I really appreciate it," I said to my new friend with a gun. "I think I'm just gonna head home now. That's enough excitement for one day." I sighed and shook his hand.

"Okay, brother." He smiled. "I'm here if you need me."

I smiled back and nodded to him and his son. Climbing in my car, I took one last, long look at the orphans and then headed down the dusty, gravel road myself.

Driving home to our mountain town of thirty-seven people, I pondered my outburst and why I had become so incensed at prodding mongrels trying to goad me into that exact reaction. I had dealt with people threatening to kill wildlife plenty of times before, whether it was legal or not, and had always been able to maintain my composure, thus nullifying their efforts to piss off an animal lover. Temperance usually negotiated some common ground with antagonists, and we would part ways with a new, albeit marginal, respect for each other. However, this crew that made a comment about turning one of the orphans into a rug made my blood boil. Why?

Maybe it was because the orphans reminded me of Marley. Maybe it was because I had failed to protect Marley and it cost her her life that I felt so protective of these cubs. Maybe it was because I could relate to not having a mother. Maybe I thought I knew what it was like to be lost and alone, motherless, crying out in the wilderness. I could not imagine having to go through the pain of watching something I cared for die in front of me again. An old, familiar anxiety welled up from where bad memories live, and I realized I was grinding my teeth. So once I turned off the pavement and onto our gravelly Forest Service road, I cranked up "Maggie's Farm" by Bob Dylan and cracked open a beer. I jammed the can between my legs and pounded on the steering wheel to the beat of the cacophonous twang as I tried to quell my growing rage, a feeling that had been hardwired into my DNA since Marley's death.

The media had gotten hold of the "Toddler Dies at Grandma's House" story, and reporters from all over the world, as far as Australia, were

calling to ask for interviews. We set our phones to go straight to voice mail and we hunkered down with family, friends, and grief, trying to get through one hour at a time. The final straw came when I shuffled out to get the mail shortly after she died, and a car stopped as I reached the mailbox.

"Are you Brad Orsted?" the driver asked.

"Yeah," I snorted. "Who are you?"

"I'm so-and-so with so-and-so, and we were wondering if we could get an interview about your daughter's death?"

I wanted to punch him in the face. I wanted to drag him from his shiny sedan, up our stairs, into our bedroom, and make him look at my wife, paralyzed by unspeakable sadness. "There!" I would scream in his face, "There's your fucking interview!" But I couldn't muster the energy to do anything more than wave him off with one finger and stagger back to the house.

Inside, everyone scurried around, babbling and confused, wiping down already-clean counters and asking questions with no answers. Stacey stood up and left the room, heading for the sliding glass door and the outside. She moved languidly through the door's threshold and paused momentarily, staring at Marley's blue pool on the deck. I had seen it earlier. Having had the same reaction, I had meant to move it to the back of the house. Now Stacey was frozen in a paralytic mid-stride moment of remembrance. She stood frozen, staring down at her dead daughter's pool while the morning breeze moved the shimmering sunlight across the water's surface like nothing had happened.

Like Marley wasn't lying right then on an autopsy table.

I walked outside to Stacey on the deck, putting my arm around her waist, but there was nothing there. She felt so hollow it seemed like my arm almost went right through her—like she was a ghost. I pulled her closer, but even her body felt empty, a husk of the once-vibrant mom who relished her time on the deck with Marley in

her pool. We stood there crying together at Marley's little blue pool with the chickadees flitting about and Marley's tiny inflatable toys doing slow laps on their own, completely unaware how everything had changed.

"I'm sorry," I whispered through the dark hair falling in her face. "I meant to have that emptied and stashed behind the shed before you got up."

Stacey gave no indication she heard me or that I was even there. She stared directly into the pool. When I pressed my face against hers, I could feel the dampness of her hair, laden with tears that didn't know where to go. I kissed her on the cheek and turned to go inside the house when she spoke.

"No," was all that came out. I hesitated at the sliding glass door to look back. After a pause that left me wondering if she'd meant to say that out loud, she finished in a monotone. "Leave the pool. I want it there for a while." She never broke her gaze on Marley's pool, and I wasn't even sure her lips moved as she spoke. I tried to coax her back inside, but she stared fixedly at the pool as if trying to will Marley back into it. Everywhere I turned, I felt helpless, so I turned to the one thing that helped: alcohol.

There was so much love around us that day, but my mind was a war zone of conflicting emotions. My hurt turned to anger. Every time I slumped into thinking about Marley, I was jolted upright and pacing, running through my mind what happened. I knew my mother could never hurt Marley on purpose. I also understood it might be the hardest thing she ever had to tell the truth about, but if it was an accident, why not tell the truth? I cried for what my mom must be going through, but when I saw the horrific effect her evasiveness was having on my wife and her family, those tears quickly dried. I was being torn apart on the inside. I wanted to be able to accept that this was a horrible accident and console my mother, but

my mind was like an out-of-control freight train barreling down the greased rails of "what if . . . ?"

Wandering the house aimlessly, I found Stacey and her friend lying in our bed, curled up with Marley's blanket and crying.

"Oh, sweetheart," I choked, seeing Stacey this way.

"What must your mom be going through?" Stacey asked, to my astonishment.

"I know," I said, starting to cry and sitting on the edge of the bed next to her. "I was just thinking about her, too, and felt sick."

"I want to call her and see if she's okay," she muttered into Marley's blanket, not looking up.

"Okay, sweetheart." I would have agreed to anything if I thought it would make her feel better.

Unaware that I had already called my mom's house several times and got the answering machine, Stacey tried calling with the same results. We could only imagine what they were going through, and I wondered if the press was calling them as well. Our phones were ringing nonstop with concerned relatives, well-wishing yet curious friends, and unknown numbers. I feared that my mom was getting the same barrage while also being under the scrutiny of law enforcement. We began to worry about her health. Stacey called a few of her friends to see if anyone was with her besides my stepdad and if there were any updates on her condition. No one had heard anything from either of them.

The girls were visiting their dad in Montana, so he would have to tell them the news. I was enraged at the thought of their overwhelming sadness at losing Marley. I was enraged when I saw Stacey suffer. I was enraged at my mother, who wouldn't talk to me. Between rage surges, I wondered if any of us would ever be whole again.

The next few days were a distortion of visitors and raw emotions. Funeral food and flowers came from everywhere. Edible baskets

with strawberries and pineapple skewers adorned the kitchen is-
land with a sympathy basket of cut lilies on the kitchen table. Stac-
ey's family made me BBQ ribs, baked beans, and coleslaw, but I had
no appetite. Friends brought cut watermelon and garden vegetables,
but Stacey and I managed only a few bites, then we were back to our
bedroom to weep or out to sit on the deck in a trance, mesmerized
by the bottomless water in Marley's pool. We still had heard noth-
ing from my mom, and with it now being a weekend, the detectives
would be taking a break from the case. All Stacey and I could do
was crawl like slugs from our bedroom to the kitchen, where Stac-
ey's mom and grandma would be waiting for brief visits, then back
to our bed and a world without Marley.

Three days after Marley's death, my stepdad finally called me.
He explained that my mom was catatonic with grief and unable to
speak or leave the bed since her last police interview. He told me
that she had had a seizure and wanted to tell me that—but only that.
She was too tired, medicated, and confused to tell me anything else.
I was stunned. I knew she'd had a seizure by her behavior at the
hospital, but was her seizure the cause of Marley's death or a result
of it? At this point, it didn't matter to us as long as she was alive. I
asked my stepdad to tell her we wanted to make sure she was okay.
It felt so weird, like I was a journalist being prepped for an inter-
view and not Marley's dad. He relayed the message to my mom and
then handed her the phone.

"Brad?" Mom was barely audible.

"Yes, it's me. How are you doing?" I asked, starting to cry.

"I had a seizure," she said in huffs, then broke down crying and
trailed off.

"I know," I said with an avalanche of emotion: love and pain for
her. I was gasping myself. "Please let them take care of you."

"Brad?" I now heard my stepdad's voice on the phone again.

"Yes?"

"That's all she can really muster," he offered. "She's rolled back over in bed and is crying now."

Was he trying to make me feel guilty for bothering her?

"Oh my god, please take care of her and keep us posted."

"I will," he said and then hung up.

Neither of them mentioned Marley, and it was the last time I would ever speak to my mother.

While keeping watch over the orphans, I would think of Marley. All baby animals reminded me of her. Baby birds, baby elk, bison calves, but especially lion kittens and little bear cubs. I could almost see Marley's equally chubby-cheeked face in her bear onesie in the orphans' faces. The fact that the orphans were about the same age as Marley when she was killed was not lost on me either. The pure joy I felt watching them chase butterflies and bathe in the irrigation ditch brought Marley to life in my mind's eye. Seeing the orphans' elation as they sloshed and splattered in the muddy irrigation trench was so reminiscent of that same innocent bliss a drenched Marley seemed to experience splashing in her little blue pool on our deck back in Michigan. They were both so innocent, soaking in the youthful carelessness of summer.

Filming and photographing the orphaned grizzly bear cubs became my obsession. Yes, I was filming them professionally, but it was more than that. When I wasn't fulfilling my filming commitment, I would relax and watch them chase and wrestle each other like the sun watched over the valley. They seemed to prefer the closeness of the road over the vastness of the wilderness around them. I speculated that the foraging next to the road was better because they had it to themselves. Other bears were warier of people

than the cubs, who hadn't been taught to fear us. Since other predators chose to stay far away from the road, this also seemed to be a safe zone for the cubs.

However, as a wildlife filmmaker, I knew better than to let my guard down and get close to my subjects. The camera was a buffer between me and the stories I was trying to tell, especially when it involved the often-brutal circle of life that is a regular part of nature. Becoming emotionally attached to anything I was trying to document could skew my focus. Besides the professional perspective, I wasn't ready to admit that I could let anything in emotionally either. I couldn't begin to ride the high of caring, because with it would come a hard fall when the object of my affection went away. I wanted to protect them and make sure they made it into adulthood, but at the same time, I knew these were wild bears, and every day they were together and alive was a gift.

I watched them play and watched the small crowds they attracted delight in two chubby, fuzzy grizzly bear cubs wrestling in a mountain meadow. In the evenings, the backlit bugs and amber shafts of sunlight lit the very tips of their summer coats while they rooted and chased each other. The smaller, lighter cub rarely moved far from its sibling and seemed to defer to the larger cub when making decisions where and when to go. For no particular reason, I believed that they were brother and sister with the bigger cub being the male. Doug Peacock had warned me against naming them, saying only that it deprives them of their wildness. So they remained nameless and genderless. I tried to keep an emotional arm's length, but at night, after everyone had left, I said a prayer asking the wild to keep them safe until the next time.

When the snow started to fly in late October 2016, there was the usual exodus from the digging grounds as the food source became depleted and bears moved toward their den sites. Sightings of the orphaned cubs became less frequent until I didn't see them anymore.

I wondered where they would den for the winter. I worried that as comfortable as they were getting with people, they could meet a similar fate as their mother. Now the waiting game started. If all went well, we would see them in another nine months.

I waited and hoped and imagined the morning the orphans would reappear. The sun would be peeking into the basin, and the bears would be together, chasing voles through the meadow of fresh-cut hay.

9

Dirt Prayer

n the late summer of 2017, the orphaned cubs appeared again, now as two-year-olds. A friend who lived in the basin called to tell me they were digging and rooting in the same location as the previous fall. My heart rose as she described how much bigger they looked, but she also warned me that the crowd of admirers had grown substantially, with even more outsider onlookers. Little did the orphans or other grizzlies feeding in the meadows that summer know they had once again lost their federal protections under the Endangered Species Act. Wyoming jumped at the opportunity and immediately scheduled grizzly bear hunts for the fall of 2018, while Montana and Idaho sat quietly, not tipping their hands yet. Now there was a very real possibility that any grizzly stepping out of Yellowstone boundaries could be "harvested."

When I reached Buffalo Basin that summer and witnessed two dozen people standing thirty feet from two now subadult and much larger grizzly cubs, I saw red. There were over twenty vehicles spread out along a quarter-mile stretch of the road. A large group of people were close together yelling and clapping their hands to get the cubs to look up for a picture. Others who had arrived just before I had

and parked farther away were running with their phones out for pictures and videos of the orphans. There were dogs barking from trucks, and a few people had set up lawn chairs. This once sanctuary had become a tableau.

Didn't these people realize that this was someone's private land they were encroaching on and for the love of all things wild—*those are two grizzly bears*! The rising tide of protective anger swelled in me as I struggled to comprehend what was unfolding before my eyes. Sitting in my idling car, I saw a sweaty, portly man break from the already-too-close ranks and approach the bears at less than thirty feet. Now both bears' heads swung up to see what this fool was doing.

I was instantly out of my car, almost forgetting to put it in park.

"Get the fuck away from those bears!" I said in my most authoritative yet cracking voice, slamming my car door shut, surprised myself by my command. The crowd turned to face me.

The main offender, in bib overalls and a red T-shirt with the sleeves cut off, looked angrily at me and said, "What the fuck did you say?"

I then noticed how small his Canon DSLR camera looked in his enormous farm hands that could have passed for petite London broils. There were several other large men none too pleased with me.

"I said," I began as if speaking to a group of foreigners, "move back and away from those bears. Those are grizzly bears, and even though they seem cute and photogenic, either one of those bears could end your life in an instant."

If I had any trepidation in confronting the mob, the thought of something happening to one of the orphans propelled me forward. Grizzly bear and human conflicts usually end very one-sided with the bear paying the ultimate price for human ignorance. Even though I was nearly in a blind rage, I had enough wherewithal to

make this about the crowd's safety and not my affinity for bears. If this got violent, I would need at least a few supporters.

"Look, I'm sorry for the profanity," I offered the crowd, now seeing there were young children in the mix. "I've seen and interviewed grizzly bear mauling victims, and it's not a pretty sight. I don't want any of you to be my next interviewees."

The look on a few of the moms' faces changed from pursed lips to furrowed brows as they pondered their children being slashed and devoured by bloodthirsty grizzly bears. Even the main offender lowered his camera, dropped his sweaty head, and started huffing his way up to the road, muttering under his short, wheezy breaths. There was some murmuring, and a few called me an asshole, but they generally started back to their vehicles. I looked over at the orphans watching the scene and snuck a quick wink to them. *Not on my watch,* I thought to myself as my new, portly compadre glared at me while driving away. I knew I was being a dick, but I didn't care. My first instinct was to protect the orphans, and the world could kiss my ass if they didn't like that.

Two things I had learned from spending time near apex predators are to never show fear and to own your space. Few predators, human or animal, really want a fight. Animals would be great financial advisers because they understand return on investment better than most people. If a wolf gets kicked in the face by an elk during a pursuit or a grizzly bear breaks a leg in a fight over mating turf, the result could be a long, slow, and painful death—not very cinematic. Animals prefer a sure thing. Even with a mouthy photographer. I used the same mentality with the mob of onlookers surrounding the orphans, and it had worked, although a gentler approach may have yielded the same or better results. I had snapped, and if this was my initial reaction to people getting too close to the orphans, it was going to be a long and arduous bear-viewing season for me.

Once the dust settled and the crowd moved away or moved on,

I sat on the hood of my car, watching the orphans feed. I had my camera with me, but now didn't seem like the proper time to film. It would look like I ran everyone off on purpose so I could have the orphans to myself, which wasn't too far from the truth.

I couldn't believe how much they had grown. To anyone viewing them for the first time, I'm sure they looked like babies, but I had seen them since they were a few months old. Now they were the equivalent of teenagers. One was still darker and slightly larger. The smaller, lighter-colored sibling continued to look to its bigger sibling when it became nervous or they were going to cross the road. I was sure that the larger one was a male taking care of his little sister, although I still had nothing to base this on besides a gut feeling.

I continued to follow the orphans and document the grizzlies of Buffalo Basin, but without a paying project, a strong marriage, or the ability to string more than a few days of sobriety together, any kind of routine was fleeting. In the evenings, I would make my way up to the meadow where the larger bears congregated to help dispel myths propagated by the rising numbers of spectators as to why so many grizzlies gathered at this one ranch. There was speculation that the ranch had purposely planted food to attract grizzlies. When I explained what a hardship the inadvertent invasive weed had caused the working cattle ranch that strived for coexistence, people came to understand that the phenomenon was not planned and something of an inconvenience for the residents. Many of the multigenerational families in the basin understand that having livestock in a predator-rich paradise comes with challenges and have met them head-on with responsible ranching via low-stress livestock handling.

I wanted to tout the basin's shining example of coexistence, but my heart just wasn't into it. I felt that it was important for the bear viewers to know that this basin still practiced range riding—where ranchers are out on horseback with their cattle in lieu of simply

turning them loose on federal land and hoping for the best. In years past, I saw how it enriched people's experience when I explained that the back of the basin butts against Yellowstone Park, and for these bears, that's a completely arbitrary line. I pointed out that if the government allowed grizzly hunting, the same bears that visitors to Yellowstone viewed from the road in the morning could be killed that afternoon if they stepped across an imaginary line. Education about the wild had always been my passion, but I struggled to rally any real zeal for my message.

At this point in my journey, I had parted ways with the production company I had helped to start, and my marriage was a ghost. Stacey and I were focused on building Wonderland, but most of my free time was spent trying to expunge a hangover on the trail or drinking in my cabin, wondering what was next. The constant stress and anxiety, coupled with the haunting trauma, made me think I might finally be going insane. Drunk and alone at night in my cabin, I began to hear voices, so I spoke back. I pleaded for my life, for the lives of the cubs, and I asked where Marley was. But the voices refused to comply and demanded more booze, always more booze. I'm sure the coyotes and great gray owls I had for nocturnal neighbors must have cringed, hearing the drunken, deranged rantings of a sad lunatic coming from somewhere inside a dimly lit cabin. I had tried so hard to find some peace with Marley's death, but it was always an emotional country line dance, one step forward and two steps back. I was coming apart again and had no business even being on the dance floor.

Late summer in 2018, I made my way to Doug's house, and we talked about the miraculous journey of the orphaned grizzly bear cubs. Now three-year-olds, they were again visible in the basin and drawing lots of crowds and too much of the wrong kind of attention. I was worried that someone would get too close and get charged or worse, and the bears would pay with their lives. Spending a good

portion of their time close to the road foraging also made them an easy target for anyone with an axe to grind or who was just trigger-happy. Removal from the endangered species list was finalized, and Wyoming, Idaho, and Montana were working on fall hunting protocols. Unless the courts stepped in, the cubs could be fair game in a matter of months. Word continued to spread about the congregating bears in Buffalo Basin. The local papers wrote about the bears, and more tourists lined the road, drawing way too much attention to this quiet, family ranching basin. This much recognition couldn't be good. It was August, with several months to go before they would den again. Expressing my concern to Doug, I asked him what to do.

Doug stared at me with a sideways glance again, then sat quietly. I wondered if he could see behind the curtain to my most recent bouts of depression and general ennui. If he knew I'd spent the better part of the last week drunk when I wasn't with the orphans. I wondered if he could tell I'd slept in my car the previous two nights and hadn't showered in a week.

"Let's make a film about their story," Doug finally said, pounding his fist on the kitchen table. "We gotta tell their story up until now in case something happens to them—we'll have documentation they're good bears."

I was ecstatic. But I really couldn't believe that Doug Peacock wanted to do a film about the orphans with me. Nevertheless, we got down to mapping out what the film should look like. This was going to be my introduction into grizzly bear preservation work at the feet of the master, the guy who had started it all. Doug had consciously decided to stop filming grizzly bears decades before. He felt he had bothered them enough during his years archiving enough footage to share their plight. Now we were creating a shot list for a grizzly bear film. I was awed that Doug would consider taking me under his wing. We were both all about long shots and anything

that overcame all the odds to survive—so this orphan narrative was something we could relate to.

We agreed I would spend as much time as possible filming and photographing the orphans while they were still around. Now that they were venturing into the main meadow with the bigger bears, they had shown they could go anywhere. At three years old, they may leave and never come back or become unrecognizable among their peers, and they would likely separate at some point, as grizzlies are solitary creatures that only come together to breed. It was imperative I capture as much footage as I could while they were still there. At Doug's kitchen table, we breathed preproduction life into the film, *The Orphans of Grizzly Valley,* and went straight into filming.

Sitting on the hood of my car, watching the orphans play under the autumn sunset like I'd done dozens of times before, I shut my camera off because there was nothing left to film. There were only a few locals watching them now since summer had ended. The Greater Yellowstone Ecosystem breathed a sigh of relief post–tourist season, and peacefulness returned to the basin. The breeze coming off the granite monoliths at the back of the basin went chilly when the sun sank behind the mountains. I watched one of the local ranching family's small daughters admire the orphans as they played before her. She was holding a piece of grass in her hand, in dirty muck boots, and pointed at the orphans while saying something to her mother. She was about seven years old, the same age as Marley would be, and it hurt terribly, but I smiled. Her mother, also wearing muddy boots and jeans, crouched next to her. With two grizzly bear cubs in the meadow and Montana spilling out all around them, Mom whispered something back in her daughter's ear that only the evening's first stars were lucky enough to hear.

Eventually, everyone left. I was losing light quickly and could barely see them moving away from me in the distance. The last bit

of light at the back of the basin faded, taking with it the remnants of a mediocre sunset. I knew what I had to do. The weight of my task settled over me, and I began to cry as the stars emerged in the all-seeing Montana sky.

Meanwhile, on August 30, 2018, my heroes, including Doug Peacock, Earthjustice, and WildEarth Guardians, were in Missoula asking a federal judge to block the proposed grizzly bear hunts slated to begin in Wyoming and Idaho within days. In a monumental win for grizzlies and the wild, U.S. district judge Dana Christensen ordered a fourteen-day block on any grizzly bear hunts while they reviewed the science behind it. My mentors were blazing another path into grizzly bear conservation, and I was ready to answer the rally call both from my heroes and from within.

Yet saving grizzlies would not be enough for me. I had to face the remaining cunning and baffling demon that would grab hold of me whenever there was an opening. I had to face my alcohol addiction. Pharmaceuticals had been out of my life for years, but alcohol, that sweet, numbing elixir, had been my go-to my entire life. If I was going to fight for grizzlies and the wild, I had to get sober. If I was ever going to move beyond the pain of losing Marley and find joy in my relationship with her, I had to do it sober. Not doing it would lead to death by drink, or worse. The stars were aligning, and the wild that had saved me once was creeping back in.

So, on that dirt road, with night encroaching and grizzlies in the meadow, I got down on my knees and prayed. I begged the Creator of the night sky and heavens beyond for help—like so many times before, begging forgiveness and bargaining with my maimed soul. I asked the same gods that had blessed the land with grizzly bears to please take care of Marley until I could be with her. Kneeling in the dirt with cows mooing in the distance and a nighthawk's nasally *peent* call breaking the still air, I made a sobering vow to Marley and my Creator.

Then I had the overwhelming urge to stand. It was a splendid night, and I was done cowering in the dirt. There was a jolting empowerment—an awakening that I was a part of this land, not apart from the land. That everywhere the night sky stretched was home to me. I felt Marley close. Not in me but of me, not around me but in everything that pulsated around me. The light of the rising moon crept across the meadow, and the night stage seemed to vibrate with me. I took a few deep breaths, then wiped my dirty face on my shirt sleeve and drove home, knowing what I needed to do. On that lonely stretch of Montana back road with two orphaned grizzly cubs in the mountain darkness that surrounded us, I promised Marley and my Creator that I would get sober and tell our story if they would stay with me through it.

The next morning, with a waning gibbous moon still hanging in the sky, I checked myself into rehab. After a nearly thirty-year drunk that had hit new levels of acceleration and depravity, I was ready to get sober and truly face my feelings for Marley, my mother, my wife, my life. The thought of sobriety made me nearly as sick as the thought of dying a sullen drunk, doomed to blather my sad story in shithole bars, but I was certain that this was my last chance. Four days a week, I drove an hour each way for intensive outpatient treatment.

I would bake the graveyard shift from 1:00 a.m. to 5:00 a.m., then drive forty-five minutes to the basin where the orphans lived, spend as much time with them as possible, pack up my equipment, and continue the drive north another forty-five minutes to treatment, come home and take a nap, and repeat the process the next day. I poured myself into sobriety, huckleberry scones, and the orphans instead of pint glasses. Afternoons when the cravings for alcohol crept in, I would grab the trail near our house and hike straight up into the timber. On one hike, I found an old Douglas fir tree that leaned out over the backcountry. That first day, I needed the tree's compan-

ionship for shade, but it quickly became my sit spot to be still and meditate. If I hustled up the trail, I could outrun the cravings and arrive at the tree, covered in sweat. Out of breath, with my quadriceps burning, I would crest the last hill, and my Douglas fir would come into view like a reliable friend. I spent hours seated under that tree, observing and listening to the wilderness before me and the wildness within.

While in outpatient rehab, I realized us ol' drunks are a dying breed. The majority of the mostly court-ordered attendees were abusing pharmaceuticals. There was meth and heroin, but the drugs of choice seemed to be benzodiazepines and opioids. Pills purchased or stolen from wherever to be smoked, snorted, or injected. I was shocked. Some looked at me in disbelief when I claimed to only have an alcohol problem. One teenage peer even exclaimed, "Man, I wish I only had a drinking problem. You're so lucky!"

I hadn't considered myself lucky in a long time.

The participants in the program recited canned pledges geared to recognizing the error of their ways, claimed that they would fill their lives with healthy activities instead of addiction from here on out, and promised that this was their last time in jail. I had become pretty good at reading wild animals, and one glance told me that most of these people were really itching for their next fix. Talking about it made them want it more.

At one meeting, the counselor asked us what activities we were doing to fill the void of addiction. A few people offered court-friendly responses. A few others were too out of it to even make anything up. When it got to me, I told her.

"I have a sit spot under a giant Douglas fir tree a few miles up the trail from our house that overlooks millions of acres. I like to sit under that tree and think of nothing. That and spending time filming two orphaned grizzly bear cubs in the wild is how I fill the gaps."

My approach seemed to get the attention of even the out-of-it

addicts. Even meth granny stopped fidgeting and snapped her head up when she heard me mention grizzly bears. I looked around at my fellow addicts and saw their pain. Some wanted a fix, some wanted help but were stuck, and some seemed gone forever, but one thing was for sure—the program didn't seem to be inspiring any of them. It made me wonder if a week or two in the backcountry (possibly after a chemical detox) wouldn't be more beneficial. The wild had given me the space to feel safe, where past and future don't exist, where a person can just be. It seemed to me that the first step toward sobriety might not be group talk and discussion but a space to be free of trauma and guilt. A place where a person could feel awe.

Less than a month into my sobriety, I realized that the professional rehab available to me was not helpful and decided that figuring it out on my own was probably my best option. I was cautioned against white-knuckling sobriety alone, especially with so much on the line. . . . But I would not be doing this alone. I had two grizzly bear cubs, my pledge to Marley, and a Douglas fir to keep me on the path. I focused on work and on tracking the orphans. I retreated into a monastic schedule that allowed me to dodge people in a healthy way with time for self-reflection. I started journaling, making notes, log lines, and story beats during those third-shift baker's hours. It felt centering to be filling our bakery with lemon-glazed huckleberry scones. Working the graveyard shift gives life a mysterious "operating in the shadows" feel, and it was the perfect crease for me to find refuge in while sobering up.

As Wonderland began surpassing its goals in 2018, Stacey and I could not have been living more interactive yet separate lives and schedules, while cohabitating under the same roof. Now that I was sober, I believed we could save the marriage and that it was worth saving. I asked Stacey if she would take a sober healing journey

with me. Not that she ever drank like I did, but I realized I couldn't stay sober with alcohol in the house or with a partner who drank regularly. Our marriage deserved a break from the booze if we were ever going to make it. My sobriety was brand-new and fragile, and I welcomed the graveyard shift that helped keep me away from the tempting spirits. It started at 1:00 a.m., when I would drive to Wonderland to start baking. But many of those nights, Stacey was still out with staff, unwinding from her day. And it wasn't like I didn't understand her need to unwind, especially after I saw her at dinner hour for the first time. The contrast to my solo stint through the night was crazy.

I stopped in to grab elk burgers to go for me and our dog, Phoenix, after a long hike in the mountains. Phoenix and I were usually in and out of there by 2:00 p.m., so I could get a nap before baking. Today, we were late, and I couldn't take my eyes off my wife in the frenetic mess of a peak-season dinner rush with backlit tourists waving their sweaty, sunscreened arms and the golden light from Yellowstone pouring into the café's south-facing windows. There was a line out the café door, standing room only, and all her staff ran around like rats on crack. Stacey, however, moved through the complete insanity with ease and dignity. She was handling both advice and praise from visitors with an equally warm smile, while simultaneously busing a table and picking up someone's bill on her way to the kitchen to check on table seven's baked mac and cheese. She was magnificent.

She didn't notice me amid the chaos, and I hid in the corner under one of my grizzly images, waiting on our burgers to go, and admired her. I knew someday old age, then death, would take my memories. *Please don't take this one,* I thought, watching her navigate a café chair from nowhere while balancing a tray of drinks— her highlighted brown hair falling in her face. I wanted to hit Pause on the current movie and tell everyone in the café she was my wife,

that she had built this from a vision, and I was so proud to be her husband. I also wanted to tell them our marriage was falling apart, and I didn't know what else to do except watch it.

The only times we would really see each other were in the mornings when I came home from my baking shift around 9:00 a.m. and she was just getting up for her day shift.

"I filled all the guide scone orders," I said one dreary gray morning. "And all the 4:45 a.m. pickups went smoothly."

Stacey was seated on the couch, nursing a cup of coffee and scowling at Trump on the TV news. She didn't look my way, but I kept talking.

"The bakery case is stuffed with huckleberry and raspberry scones, savory muffins, blueberry muffins, and cowboy cookies with backups of everything on the speed rack." I took off my boots and black apron covered in butter and flour.

"I hate him," Stacey snarled, glaring at Trump in stunning 4k definition. And she really did. It was upsetting to see her so upset, but even though we were in the same proximity, we were in different worlds. She didn't acknowledge me, and I didn't acknowledge her.

"I'm going to get some sleep. I'll flip the cabin when I wake up, then I'll help with any housekeeping at Wonderland," I said to no one really, heading up the stairs.

"Okay," Stacey replied, never looking away from the TV.

When two people agree to start a sober journey together, yet only one of them gets in the canoe and starts paddling, it can be very awkward for both parties, especially under the confinement of the same domicile and heaviness of a family business. Like so many daily café receipts piling up, our love had become digitized and transactional. A mere assortment of little hand-signed pieces of emotional IOUs that somehow at the end of the day now weren't reconciling, and in fact may have been running at a deficit for a

while. Our language of love, the weights and measures of a marriage, became no more exciting and only slightly less predictable than our weekly Sysco food orders. We became business partners exclusively. It's called survival when tragedy has scorched the land and all that is left in the autumn of a marriage are husks and brittle exoskeletons attached to dying vines. We were living on opposite schedules and growing in different directions. The heaviness became unbearable as the relationship's elasticity, from so many hard stretches, was finally wearing out. How many times could the same two hearts break?

I wish we would have cried and held each other, thrown dishes against the wall, something, some pent-up emotional eruption to end it all, but we really just drifted apart like two rafts on the same widening river. All the yelling and throwing of both dishes and lifelines had already happened. In the end, there was a mostly peaceful acceptance as the currents took us in different directions. I tied a little part of my heart to her raft when she wasn't looking, and when the river forked and I lost sight of her, I saw she had done the same to mine. Some things will never die—it's only a round river in a timeless flow.

My favorite place to hide those days, aside from my Douglas fir companion, was in the basin watching, filming, and documenting the orphaned cubs. It was hard to believe they had made it this far and were still together. Now that the cubs were three years old, this would probably be the last season I saw them together. Most grizzly mothers unceremoniously kick their cubs out around this age so they can mate again. Occasionally, cubs will stick together those first few months after being separated from their mother, but eventually, as solitary creatures, they go their own way. Knowing what trauma the orphans had been through, I wondered if they might

stick together a little longer than usual, but because they were three years old, the pull of nature would likely prevail, and they'd strike out to breed and continue the cycle.

My favorite time was racing the rising sun to the basin after baking all night to see if I could be the first one there and find them where I had left them the night before in that forever golden, evening light. Right after working a shift was the time I was at my thirstiest, but I felt a sense of accountability to Marley, the orphans, and telling our story. To do that, I needed to spend as much time with the orphans as possible, and to do that, I needed to be sober. These sessions were my kind of AA meetings. I would find the cubs chasing each other, wrestling, digging up roots, eating grasses, hunting gophers, and taking mud baths in the irrigation ditch. Increasingly, they would go where the adult grizzlies went, always together.

Weeks slid by, and I was either knee-deep in huckleberry scones or had my eyes on grizzly bears. There was an electricity wrapping up my shift, filling the bakery case, putting away night poems and freshly scribbled notes in a Moleskine journal and switching from an apron for a hot kitchen to wool for a chilly basin. With the first hint of dawn, I would trade in my mixing bowls for a backpack, driving in the dark to the basin with anticipation, in hopes of finding the orphans exactly where I had left them the night before.

Slowly driving a road predawn with binoculars in hand is an activity that would get the police called on you anywhere but Montana. Scanning for wildlife is a Treasure State pastime. My goal was to get to the orphans before there was enough light to film so I could get set up, relax, and take in the new day with them before I got to work. Once my tripod and camera were set up, I could sip coffee and nibble a huckleberry scone while watching the ravens and magpies heckle the orphans on their morning commute. Behind the orphans, in the soft blue light, a pair of sandhill cranes greeted the day with outstretched wings, drying the night's crystalline frost

from their silvery and auburn-tinged flight feathers, all while chortling to each other in their Zen-like, ritualistic dance—an ode to the dawn. There was a fresh stillness to the day as the basin came alive. Anything was possible, and nothing was predetermined. The basin became my cathedral. I stood mesmerized in quiet reverence as the sun began to illuminate the tips of the granite peaks crouching forlornly in the Gallatin Mountains to the west while the orphans grazed before me, seemingly without a care in the world.

Most mornings, I could find the orphans near where I'd left them the night before. Some days, though, they were not readily visible. Did they cross the road and head into another pasture, or were they in one of the many swales that made up this undulating landscape? Although I got nervous when I couldn't find them, I didn't panic, knowing they had the wild and each other. One of my favorite moments was to pull up after nighttime rain squalls and find two little sets of grizzly tracks in the muddy road. You could see where they crisscrossed, walked parallel to each other down the middle of the road, and where they must have wrestled each other under the protection of darkness and the pouring rain. The tracks in the mud told the story, and all I had to do was follow along to find them. Then there they would be, out in the distance, covered in mud and digging up roots while the storm clouds hung low above them.

One morning in the chilled, still darkness of the basin, I stopped my car and killed the headlights right where I had left them the night before. In the tall grass, I thought I could see the cubs in the same spot doing the same thing, eating. I chuckled silently that if they had been feeding all night, there wouldn't be much to film as they would be napping all day. Squinting in the low light, I slowly crept closer with my still camera in hopes of getting a close-up, even if grainy, before another car came by and spooked them back. I felt like a sneaky dad trying to get a quick peek at the kids playing without them knowing. There was a slight movement in the grass,

and then I knew they were there. Those tubby little shits had been stuffing their gullets in the same place all night! I slowly lifted my camera at about fifty feet, hoping to not disturb them.

Then I realized exactly what I was looking at.

One of the largest, darkest grizzly bears I have ever seen, startled by my approach in the waxing light, snapped its head up. I gasped and clumsily recoiled a step, nearly dropping my camera. His massive head seemed to be the size of one of the orphans. I had made a naive and rookie mistake. Now I stood frozen in terror and staring at a grizzly with only air between us. The jet-black griz started to rear, with his front feet coming slightly off the ground, as he tried to figure out what the hell I was. Grizzlies have mediocre eyesight and rely heavily on their sense of smell. In the stillness of the early morning without a breeze, he couldn't scent me, so he was trying to get a better view of who dared sneak up on the king of the valley in the inky dawn. Would he charge me or retreat? All the adoration I had felt, my gleeful hope for a cute photograph, drained away, replaced by a grim reminder the wild is not a day care and has little patience for hubris. Even though I was getting happy feet and felt like making a dash for the car, I stood frozen while a six-hundred-pound grizzly bear decided my fate.

When he dropped to all fours, I braced for a charge. Instead, he wheeled and ran in the opposite direction. I knew he could easily change his mind and return, so I didn't move a muscle. Then, at about one hundred feet, the black blob moving away from me paused and looked back. When I saw the look on his face, I was finally able to exhale. I must have scared the shit out of this poor, terrified grizzly nearly four times my size. In the predawn murkiness, the bear must not have been able to get a read on what I was, so even though he was above me on the food chain, he decided that retreat was the best option. Grizzly bears are amazing creatures for their size, strength, and speed. They are not especially graceful, though. Watching this

bruin's big butt speed-waddle away from me for the timber made me laugh out loud. It's much easier to enjoy a grizzly running away from you. Something or someone had clearly been looking out for me again.

I wondered if it was a petite, blue-eyed cherub acting as my guardian angel in grizzly country.

Once the big grizzly was out of sight and the rising sun shed some light on the basin, I resumed my search for the orphans. What I saw made my blood run cold and gave me a second fright of the day, and it wasn't yet 7:00 a.m. If what I was seeing was correct, I needed to get a visual on the orphans right away. The impressive grizzly that ran from me might not have extended that same courtesy to the orphans. As the light grew brighter, I was able to clearly see the big boar's tracks on top of and all around the orphans' tracks in the soft mud along the road. Backtracking the large male was easy since his heavy foot was over twice the size of the orphans' paw prints. I placed my size-thirteen boot next to his tracks in the dark, compliant mud. Scanning toward the direction in which he'd disappeared, I did a quick look over my shoulder to make sure he wasn't on his way back. Our feet were nearly the same in width and length, with his only slightly larger. But that was where the similarities ended. Small dots a few inches in front of each toe's impression, like someone had shoved a sharpened pencil into the pliable mud, revealed his several-inch-long claws and made him a clear winner. I looked over my shoulder one more time into the now-well-lit meadow where the bear had disappeared. Steam from my heavy breathing hung around my face in the chilly morning. Once it cleared, I lifted my binoculars with shaky hands for one last look in the direction in which the griz had disappeared.

I was frantic. I had to point my top lip out and exhale down to keep the quickening steam from fogging up my binoculars while I searched for the orphans. I was starting to hyperventilate, so

I lowered my binoculars, closed my eyes, and began slowing my breathing while I tried to put the wildlife puzzle pieces together in my head.

From what I could glean, a big male grizzly had come in during the night and went everywhere the orphans had gone the previous day. Not only did he follow their tracks along the road, getting a good nose-full, but he also followed their scent through the tall grass, bending it where he went as if a four-wheel ATV had motored through. He stayed right on their path through a waist-high grass maze, probably swinging his bulky head side to side while breathing deeply through his nose and mouth at the same time to "taste" the scent of the orphans. There are a lot of bears in the area, and this was hopefully nothing more than a big guy checking things out. At least this is what I told myself.

I searched vainly for several hours while trying to convince myself the orphans were tucked in safely sleeping somewhere, oblivious to any potential threat that might have moved through in the night. I wanted to believe that the big boar was their dad or a grandfather bear coming to check on them, and not a big dude looking to breed or take out smaller competition. I also hoped that if the bruin's intentions were not benign, I had thrown him off their trail by startling him. It looked like he hadn't followed them any farther.

My concern reminded me why, as a wildlife photographer, it is imperative not to develop an emotional connection to the subject matter. I believed that it not only skewed my ability to tell a story but also that being emotionally involved meant that I could set myself up for heartbreak. It seemed that every time I let my guard down and began to care about something, it died. But I did care, and passionately, about these survivor cubs. I scanned everywhere I had ever seen the orphans, half expecting to see brown and blond lifeless lumps lying together in the distance, but there was no sign of them.

As the sun rose higher in the sky and day nudged morning out of the way, I had to abandon my search and get some sleep. I felt sick as I drove away, but I had been up all night baking scones, and the coffee was wearing off. I needed some rest to repeat my ritual that evening, but mentally, I began to prepare myself, just in case I never saw the orphans again.

I woke from a restless nap that late afternoon to a text from a friend who was also spending time in the basin with the orphans. Was I ready for this? Was it bad news? Should I bury the phone in the blankets and go back to sleep? Maybe it was completely unrelated. When I clicked her message, it read: *Orphans out playing next to the road but a few miles up from their usual spot. You coming up?* I was out of bed in an instant, fully dressed and frantically looking for a second sock. *Thank you, God. Thank you, Jesus,* I thought to myself. *The orphans are okay.* I was halfway out the door before I remembered to text my friend back. *Yes! I'm headed that way now. Please tell the orphans to text me directly next time. I was worried about them. Lol. Will explain when I get there.*

I am told the San, the Bushmen of Africa, believe that the first time you see an animal, a very thin thread is formed between you. The next time you see the animal, that thin thread becomes a line. The next time you see the same animal, the line becomes a rope, and so on. It's this very thin thread that ties us all together, living on the same planet under the same sun spinning through the same cosmos. I'd broken my professional code, and a thin thread had turned into a luminous tether between the orphans and me. It was scary and exhilarating to care deeply again. Maybe it was okay to care about a couple of orphaned grizzly bear cubs who would eventually follow the setting sun into the backcountry to live out their lives far away from the road.

10

North Star

During my years watching the orphans, I often thought of Marley, but would push those thoughts out because I was filming for a project and needed to stay focused, or because I didn't want to feel the pain of loss at that moment. I would save it for later, when I was alone in my cabin and could drink. But now, sober, it was different. I was filming for myself, and Doug had advised me to spend lots of time just watching the orphans with the camera off, noting tics and nuances. He also wanted me to be there, fully in the presence of grizzlies. To abandon the camera and be entirely with the bears in their world. In the wild and in the moment, comforting thoughts of Marley came to me. There were mornings I had no choice but to not film because my eyes were so full of tears of joy I couldn't see to pull focus.

The film *The Orphans of Grizzly Valley* was shaping up, and Doug and I sized up the best way to present their story and have the final edit ready to go before elk hunting season began. One of our biggest fears was that the orphans would be shot by a scared elk hunter, like their mother had been. A far more sinister threat came in the form of those who supported grizzly bear hunts. All it would

take is a handful or less of twisted individuals who would relish taking out well-known and beloved bears. In Grand Teton National Park, Thomas Mangelsen has photographed one particular sow for over ten years. Sadly, there have been social media posts by people threatening to kill her at the first opportunity.

Fortuitously, on September 24, 2018, Judge Christensen ruled that grizzly bears be placed back under federal protection of the endangered species list. Therefore, the states of Wyoming, Idaho, and Montana would not be able to set grizzly bear hunts. For the moment, the bears of the Greater Yellowstone Ecosystem were safe from trophy hunters. This was a monumental win for everyone in the conservation world and a small private win for me. For the first time in many moons, I felt like I was at the right place at the right time. I had found my life's work through an immeasurable tragedy that plagued my days. Now, it felt like Marley was watching. We were winning for the bears, and I was winning my personal battles, feeling stronger every day. I celebrated the victory with a cold Pellegrino and a huckleberry scone.

While we were still in edit for the film, two grizzly bears matching the orphans' description were seen on a road-killed deer well out of their zone of tolerance. It was early October, and I was visiting with a friend, Jason, over a late breakfast in an old saloon with bighorn sheep heads on the walls. Their dead-animal expressions seemed puzzled, as if looking for their missing bodies. The mealtime bar chatter was broken with nearly every one of the dozen patrons' cell phones chiming and buzzing simultaneously. Looking down at my tweeting phone, I saw a text from a friend who lived a few miles away—a video of two subadult grizzly bears tearing apart a road-killed deer. *Where?* I texted back. *Right by my house!* was his reply. Several people driving by had stopped and were filming the action.

"Dude, that's right down the road before the rest area," I heard from the table behind us.

"I got my .300 Win Mag in the truck," was another's response. It was nearing rifle season for elk in Montana, and everyone seemed to be sighted and itchy.

"Let's go," someone said as I heard chairs scudding across a rough-timbered bar floor, but I was lost in the video clip.

I watched the video again and again. It showed two bears aggressively fighting over a carcass. They were making the kind of terrifying, guttural sounds that lead people to sell their tents after camping in grizzly country. There was no way this was the orphans, although it was dangerously close to their home range and a natural direction for them to travel if they were to leave the safety of Buffalo Basin in search of food.

The dozen-plus diners rushed to pay their bills. The batwing doors were nearly squeaking off their hinges as the bar emptied. I sat stunned. My breakfast companion could read the concern all over my chicken-fried steak and deep sighs. He knew my connection to the orphans, but I could tell he was also excited about seeing two grizzly bears rip apart a deer and possibly each other right next to the road at high noon.

This was, after all, Montana.

"Do you want to go see if it's them?" Jason offered sheepishly, holding both of our bills.

"We probably should, but it doesn't look like them," I said, trying to convince myself.

"Great. I'll pay, and you start my Jeep," he said, leaping from his seat as I joined the rush outside. My phone was in my pocket while my boots kicked stones across the parking lot, but the video clip was on loop inside my head. Engines started, and big trucks lurched onto the highway belching black puffs of diesel smoke behind them, racing for the scene. If this was the orphans, everything was about to change. Even in Montana, grizzly bears feeding along a busy road

are not tolerated; the state gets involved, and the outcome is usually not a pleasant one for the bears.

It wasn't hard to know exactly where to go—if you could keep up. The speeding caravan ahead of us was doing over ninety miles per hour in a beeline south along the highway. The long line of cars at high speed on a winding country highway made it look like a state of emergency sans sirens. Turning up a paved road off the highway, I saw cars doing slow laps up and down the road. This was typical behavior for tourists in Yellowstone when there was a bear sighting, but it seemed oddly out of place in the valley. We fell in line and scanned the ditches next to the road.

"They're gone!" a rosy-faced woman said, walking up to our line of vehicles. "They took off across that meadow about fifteen minutes ago when all the people started showing up," she finished, running out of breath and pointing to the distance.

"I live up there," she exhaled, turning to point at a small, log home. "And I've seen them out here eating on roadkill for the past week. I called the state and said if they don't do something, one of the neighbors has already threatened to kill them himself." Now she seemed genuinely worried. "He's at work right now; otherwise, I don't know what he might have done.

"The state had better get out here and do something. I mean, someone is going to get hurt, and then what . . . I got kids and . . ." She trailed off, still talking to anyone who would listen, but I couldn't. It was a straight shot, looking from where we were, up the valley and into the sanctuary of Buffalo Basin. Any bear could have covered that distance in a day's stroll. Given the fact food was dwindling in the basin, could this be the orphans?

I didn't want to believe they would grow up to be ferocious and leave the safety of the valley, but I think Doug knew better and had a pretty good instinct that it was them. I watched the texted video

dozens of times, each time more uncertain than the last, as I tried to convince myself this wasn't them. They hadn't been seen in Buffalo Basin for a while. More reports were being made of two grizzlies the cubs' size taking advantage of apples left on the trees and the ground, pet food and trash left unattended on porches, and root vegetables left in abandoned gardens. There were ample rewards in the valley for a naive bear trying to consume thirty thousand calories a day to deny. This phase of incessant feeding, sometimes up to twenty-three hours a day, prior to denning is known as *hyperphagia*. As bears prepare to be in their dens for months at a time, their bodies need calories to sustain them during that time even though their metabolism slows.

Even though I was getting texts and phone calls about two grizzlies being seen and photographed at very public places, because it seemed so far from their home, I refused to believe it was them. There had to be two other subadult grizzly bears roaming the neighborhoods and matching the orphans' exact descriptions. These bears could not be my orphan cubs. The orphans would surely, almost predictably, appear in their favorite meadow one evening like they had done so many times before, and everyone would breathe a sigh of relief. I went back to the basin, back to the magical meadow, back to that stretch of road where I took my vow, back to that place in my mind where the orphans chased each other in the soft predawn light, but it was just a working ranch meadow now with cut hay and grazing cows.

I continued my monastic ritual of baking by night and waiting for the orphans by day until snow began to fly and I couldn't stare at that empty meadow anymore. I was seeing videos on social media of two grizzlies near a popular river access, being filmed with phone cameras. There was another phone video of two subadult grizzlies eating apples from an abandoned orchard along the river.

I heard grumblings about two young bears getting into non-bear-proof trash cans and pet food left outside residences.

Even with the mounting evidence and the hundreds of hours I'd spent with the orphans, it just didn't look like them in videos now being filmed by seemingly everyone. These two youngster grizzlies in town climbing in and out of dumpsters looked bigger and more like, well, grizzlies, as odd as that sounds. The two in town looked like wild grizzlies fresh from the tundra and possessed by hyperphagia that had stumbled upon a boon of calories and were eating everything in sight like some zombie movie.

The two subadults I knew rooted and dug for their food with little urgency or preoccupation. They hunted pocket gophers and voles in the cut hayfields with ridiculous inaccuracy. In most cases, they took their time, spooked easily, and were always ready for a nap. The bears in town were more like two rambunctious teenagers left alone for the first time, having a blast trying to eat everything in sight while exploring their newfound freedom. They moved with purpose and were being seen on porches and in the parking lot of the local tavern at closing time. The orphans spent days and days in the same meadows, leisurely munching and sniffing the wind. There was no way the orphans were in town chasing people's dogs and eating free samples of puppy chow off the deck. There was no way the orphans would feed on a rotten road-killed deer in a ditch next to a highway in broad daylight with cars whizzing by.

In November, we released *The Orphans of Grizzly Valley* on social media and Save the Yellowstone Grizzly's website. We told the story of how a new mother grizzly bear was killed in front of her months-old cubs for standing up to get a better look around. How three cubs became only two that following summer, but those two had stayed together and survived against all odds. How, for many people, the orphans were the only grizzlies they would ever see, and

it changed their lives for the better, and what a shining example of coexistence their home basin was. We asked for tolerance and compassion as bears tried to spread out and reconnect with each other from their genetically isolated island populations. Doug made a heartfelt plea to please help him save the grizzly bear from extinction. We hoped it would serve as an educational piece and keep both grizzly bears and elk hunters safe in the basin that year. The film ended with our news that the orphans had not been seen in over a month and that their story was "To Be Continued."

One sunny afternoon in early spring, I sat in Chico's saloon, six months sober with a club soda and a burger. The mountain bluebirds were back. Bitterroot was up, and every angler in the Treasure State was awaiting the first caddis hatches of the year along the Yellowstone River. Sobriety was still a new thing for me, and I felt very exposed as the only table without a beer on it in a saloon. I had my built-in excuse if I saw anyone I knew. I would tell them I wasn't drinking because I was on antibiotics. This had worked before without raising much suspicion.

Halfway through my black-and-blue burger, a lanky cowboy I knew from Buffalo Basin came into the saloon with his wife.

"Hey, Brad. How's things?"

"Good," I said, wiping mustard off my face.

"I was so sorry to hear about your orphaned grizzly bear cubs," he said awkwardly, shifting his weight.

"Yeah, me, too," I said a little confused, thinking he was referring to the fact they had been orphaned. "Wait. What do you mean?"

He looked at his wife. "I'm sorry. I thought you knew."

"Knew what?"

"The state of Montana killed both orphans last October. We just found out. I'm really sorry to have to be the one to tell you, partner."

This is Montana, and men don't cry over killed grizzly bears, at least not in public, so I sat planted to my stool staring at my half-eaten bacon cheeseburger as he patted me on the shoulder.

"I know you cared a lot about those bears," he said in his most stoic Montana rancher voice, and then he walked off to the bar behind me.

Why? Why had this happened? I loved this community. This was my community. We resided under the same Park County, Montana, banner. What had gone so horribly wrong in a matter of a few weeks that had left the orphans in a position where the only option was death? These were good bears that had found their way among good people. What the hell happened? Why had they not received at least a stay of execution pending a rerelease hundreds of miles and several mountain ranges away from garbage and people? Now they were both dead?

Then out of nowhere, I thought of Marley standing wobbly, taking her first steps in a high alpine meadow, on a south-facing patch of Shasta daisies and glacier lilies. I'd had this vision out of nowhere before. The breeze is an upslope one, rising from the warm valley floor, and her wispy brown hair lifts as she smiles blue-eyed, wobbles, and reaches for a tiny handful of daisies to steady herself. Then there, coming upslope with the swirling thermals, are the orphans. As many times as I've thought about Marley and the orphans in unison, I'd never pictured them together in the same frame.

I felt sick. Old wounds began to trickle and then bleed out inside of me, making sobriety unrecognizable in the carnage. I studied the spar-varnished wood grains and knots of my table as every moment I had spent with the orphans over three years came to me in a flood at once. I considered ordering a pint and a shot. How could this be? My mind reeled as the mental movie of every morning spent alone with the orphans looped. Then I saw Marley's face in her bear onesie in the ramping sequence of orphans jump cuts, and I freaked.

Sliding a twenty-dollar bill under the red burger basket, I grabbed my keys and phone off the table and bolted for the front door before I had a complete meltdown. I needed to get to a liquor store and the privacy of my dark, rough-hewn cabin pronto. I had given sobriety a valiant effort. No one would fault me for relapsing, given the circumstance. Driving home paralleling the Yellowstone River through Yankee Jim Canyon, I could already taste tequila and smell the pleasant, fruity aroma of imminent annihilation.

Memories of afternoons in the golden backlit basin with two little grizzly bears soured as my mind went to them in culvert traps, terrified and alone, separated for the first time in their short, free lives. Suddenly, I could hear them bawling out in the darkness of a corrugated metal trap just before a stainless-steel rod entered their skulls. There was no country for old men or young explorer bears. A bolt to the brain or needles full of repose would end the miracle of the orphans and my sobriety. I was okay with that. I needed a good drunk.

By the time I could think clearly, I was already home and had forgotten to stop at the liquor store, the one rural place to buy booze between Chico and home. Now five miles up a bumpy Forest Service road, the idea of driving back only to relapse seemed like too much work. I would just roll the biggest joint possible, smoke it to the greasy end, and hopefully fall into dreamless sleep for the night. Tomorrow, I would relapse when I was feeling better.

I awoke early the next morning to my phone ringing. For a lovely moment before consciousness kicked in, Marley and the orphans were okay. Then the dread of reality washed over me. I reached for my phone to silence the ringing so I could prepare myself for a good day drunk in peace. It was Rachel Old Coyote calling me first thing in the morning. Rachel was my Crow sister and sober coach, so the call wasn't unusual, only the hour was. Grudgingly, I answered the phone.

"Hello."

"You were going to drink last night," Rachel said sternly and without even saying hi.

"What?" I asked.

"You heard me." She took a sip of what I assumed to be coffee. "You were going to drink last night, weren't you?"

"Yes," I sighed.

"I know," Rachel said. "I knew you were going to drink last night. After you've worked so hard at sobriety? So I prayed and did a ceremony for you. I told Creator you were a good man who has had more than his share of tragedy and had been working very hard to stay sober and find his way back. I asked Creator to please take your urge to drink away from you for just one night."

I was flabbergasted. For the second time in just over twelve hours, I sat stunned as my brain short-circuited trying to figure out what was going on. I was still in a dreamlike state after hearing wildlife services had murdered the orphans, but I had come straight home, talked to no one last night, and went to bed too high on indica to even drool, let alone speak. So how did Rachel know I was planning to violently fall off the wagon?

"I'm confused. Did I call you last night?"

"No, you didn't call me," she said, annoyed. "I knew you were going to drink, so I asked Creator to take that away from you last night. The reason I'm calling you early is to warn you that I also asked Creator to give you back the urge to drink twice as hard today, so you have to get back to earning it—so be ready. Get up and wash your hands and face. My dads used to tell me the sun doesn't greet you with shit in its eyes, and you shouldn't either. Get yourself up and be thankful."

These were the kinds of things that happened to me when I would black out drunk and call people late at night. I would be puzzled the next day as to why an old friend was calling early to check

in on me, until I vaguely remembered I had drunk-dialed them the night before and carried on like a blathering idiot.

"Did I call you last night?" I asked again. "Do you know about the orphans?"

"Look, I don't know anything about any orphans; all I know is *you* were going to drink last night. I gotta get back to work. I love you. Get yourself up and get ready for the day." Then she hung up.

I didn't forget to buy alcohol. This time, I had allies and very powerful Crow medicine to guide me through the darkness.

Between the media harassment in the days after Marley's death and the unbearable waiting for more information that would not bring Marley back, Stacey and I decided to head north for a few days. We booked a room at the Perry Hotel in Petoskey, Michigan, so we could be by the beach. We needed privacy and a break from even our well-meaning friends and family.

The first night, we sat together by the marina and watched the sky explode into dusky hues over Lake Michigan. We had spent so many sunsets at the beach with Marley. Now this once-celebrated family ritual ached with dual meaning. I watched Stacey doing her best to take some solace, but I knew that nothing would ever be the same for us. Other couples were out enjoying the dark blues of dusk as well, doing what lovers do, full of hope and anticipation. I remembered when that was us. I didn't know how that would ever be us again. There we sat by the lake with our pain and a painted sunset—a gulf of grief already growing between us. A small, pale blue butterfly drifted by on the lake breeze, out too late, it seemed, with evening approaching, and both Stacey and I nearly lost it.

As we sat by the marina, watching the light disappear in the gathering darkness, I saw a couple with a little girl about Marley's age playing and headed toward us. I felt dizzy and sick. This was the

first baby I'd seen since gazing upon Marley's lifeless body, and it was a new level of hurt. I grabbed Stacey, pretty sure she'd seen the toddler, and we headed for town to walk around before bed. I didn't see what kind of a future we would have with sunsets, butterflies, and babies making us so sad.

Returning from the north, we now had the unfathomable task no parents should have: planning their child's funeral. Our very dear friend Michele came from Chicago and took care of us. She paid bills, gardened, grocery shopped, made us meals, made sure we ate them, took us to the beach, and coordinated everything for Marley's service. She also did her best to keep my drinking in check. I'd started hiding bottles of vodka in the garage, and there was always beer in the refrigerator. It seemed that the only way I could begin to process what had happened was when I was intoxicated. Thinking about our daughter dying while in my mother's care and running possible scenarios over and over in my head was unbearable when I was sober.

Stacey and I both knew right away it should be on the beach at Holland State Park, where we'd spent so many joyous moments as a family. Marley loved the beach, the attention from admiring beach-goers, and especially the swings. Now the thought of having Marley's service on the beach, where we'd picnicked, laughed, and relaxed, put a gray cast over memories of blue skies and happier days.

Our other two daughters were still with their father, Robert, in Missoula. He and his new wife had broken the horrible news to the girls right after the tragedy. Stacey and I had both spoken to them on the phone through much crying and sobbing after they had a moment to process the horror. I could hear the hurt confusion in their tiny voices. They loved their baby sister so much and doted on her every chance they got, and now she was gone forever. They both wanted to know what happened, but we had only speculation. I feared even at their tender age, the damage being done to them

emotionally would leave permanent scars that would haunt them for the rest of their lives.

In these moments, my grief turned to anger. Anger at my mother, who seemed to be covering her own ass as usual, despite the damage she left in her wake. I figured I was already ruined, doomed to slog among the botched and bungled, but now my mom had damaged perfectly good merchandise. I saw and heard the devastation and deep pain she was causing in my wife and other two daughters, and my fists clenched inadvertently into balls of rage fueled by a sadness set on fire.

On July 31, we held Marley's memorial service on the beach at Holland State Park. Mazzy and Chloe were unable to attend, as they were still at their father's in Missoula. We thought, given the continuing turmoil at our house, it would be better if they finished their visit at their dad's. A friend played guitar, Marley's cousins read *Goodnight Moon,* and a minister said some comforting words, but I can't tell you what they were. Stacey and I sat through the service vacant and lost, staring at an enlarged, two-dimensional photo of Marley with her blue eyes staring back at us. I felt like she was asking me, "Why, Papa?" I had no answer for her and could only squeeze Stacey's hand and look away.

Only weeks earlier, we had been leading normal lives, joyful at the sound of our little baby girl giggling on that same beach. The giggles and joy were gone forever. I did my best to talk to people and thank them for being there, but I was a zombie. After the beach service, we had Marley's wake back at our house. I listened to people talk as they do at such events, the conversation turning away from death.

They spoke of their jobs, the weather, and end-of-summer plans. I wondered how they could talk about such trivial bullshit when my daughter was dead. Who gives a fuck about your cyst or seasonal allergies when my daughter was somehow killed, cut up, and now her

tiny body would be incinerated? Then I wondered how many times I'd been to a wake or memorial service and done the same thing. No one knows what to say, because there is nothing to say to the anguished. All I could think as we stood on the deck among the barbecue and beer was that this is where Marley laughed and splashed in her little blue pool. I would never hear her laughter again.

Endeared friends and family tried to comfort me during Marley's wake, but they were speaking the tongues of a universe that didn't exist anymore in my shadowy world. I kept an eye on Stacey, who was surrounded by loved ones, too, but also seemed unable to hear the language of love that was all around her. There was a crack, a crevasse, in our picturesque landscape that Stacey and I had fallen into, and everyone there was up top, looking down into the chasm onto us, trying to lure us out of the alien depths with hugs, chitchat, and too much potato salad.

"You need to eat something—and no beer!" Michele ordered, snapping me out of my reverie. She must have seen me staring at the coolers full of ice-cold beer.

"Thank you," I said sheepishly, averting my gaze from the cobalt cooler to Michele's sincere, teary blue eyes.

"Please eat something," she said, her voice now trailing off but still stern. She had been my rock and a staunch guardian of both my stomach and liver since her arrival over a week prior. She forced a smile and winked at me before weaving her way through the crowd to go check on Stacey. I picked at the barbecue chicken, rolled a few peas around from a homemade salad, and choked down a few chunks of fresh-cut cantaloupe before tossing my plate on top of all the other baked-bean-stained paper plates in the trash can.

Eventually, after doing everything they could, everyone left, leaving us with dozens of shellacked deviled eggs and what seemed like half of an uncooked cow in our garage refrigerator. Michele had put her own life on hold and run to us as soon as she heard the

news. Now it was time for Michele to get back to her life and husband in Chicago. I was afraid my one tether to stability was leaving. I was immune to everyone else's warnings about grief drinking and would get defensive, but I knew where Michele's heart lay, and it broke mine a little to see her go.

In the weeks following Marley's memorial service, through conversations with my stepdad and ex-girlfriend, and ongoing discussions with the detective, we were able to glean at least a few of the details, if not what exactly happened. What we discovered sent me reeling.

We learned that my mom had not been truthful about her health or the safety of children in her care. From my ex-girlfriend, we learned that while my mom was babysitting her three-year-old twins, she had a grand mal seizure and fell on them in the bathtub. My stepdad had to pull her thrashing body off the girls. We were also told by my ex-girlfriend that my mom confided in the twins that they could not tell anyone what happened or they would not be able to come back to her house. The twins eventually told their mother.

We also uncovered that it had not been a year and a half since she'd had her last seizure. My stepdad secretly told me she'd had one six months prior in her doctor's office. In fact, the doctor's appointment she took Marley to was a follow-up to that seizure, but she'd told us the appointment was nothing more than a general checkup. To top it off, and contrary to what my mother had told me, my stepdad did not know that Marley was coming to visit until he saw her when he got home from work the day I dropped her off. He told me he would never have agreed to my mom having Marley alone, yet he'd gone to work that next day, failing to share his concern with anyone.

Talking to my stepdad on the phone in the garage, these revelations sent me to the refrigerator full of dead meat and beer. He said I couldn't tell anyone about these facts, that the detectives were on

a witch hunt and gunning for my mom. I told him he could trust me, knowing the whole time I would have to tell Stacey and the detectives. It was a new level of sickness, feeling I may have to betray my mom to get justice for my daughter. Why was I being put in this situation, and why wouldn't my mom just be honest? The cold beer quenched the gnawing fire inside, and I pressed my stepdad with the question everyone wanted answered.

"So what exactly happened, Marc? How did Marley die?" I asked after finishing half a beer in one gulp.

"Brad, whenever I ask her that, she just clams up and rolls back over in bed," he half whispered as if someone else might be close by now.

"She's told you nothing?"

"No, Brad. She only says she doesn't want to talk about that part."

"Okay," I said, "please tell her we love her. We just really need to know what happened to Marley."

I opened another beer and said goodbye. Was all of this really happening? Standing in the garage crying, drinking beer, and ruminating on what the hell could have possibly happened that fateful July afternoon when Marley lost her life was quickly becoming my new craven pastime.

We also found out from the police report that the EMTs found Marley on my mom's bed and the Cartoon Network was playing on the TV. Marley's portable bed was in the guest bedroom, broken. But the most bizarre and hurtful twist came when we learned from detectives that my mom had hired a lawyer and refused to talk to investigators anymore. There was talk of a grand jury investigation by the sheriff's department.

We were in shock. My mother had lied to us about virtually everything leading up to Marley's visit, lied about her care of Marley that day, and now that she'd been caught in her web of deceit, she refused to talk to anyone anymore, including us. Stacey was still

optimistic that everything was simply a huge misunderstanding, but I was more skeptical. Stacey had only seen my mom since we'd been together. The woman she met was a drastically and markedly different person from the mother of my youth. My mom had been caring, helpful, and very attentive to my new family, especially since Marley's birth. I began to wonder if it was all a façade and whether a tiger could really change her stripes.

As I was learning more about my mom's untruthfulness, but getting no more information on how Marley died, the stirrings of the deadly guilt began. Had I missed something about my mom's new persona and played a dangerous game of trust with my daughter's life? I wanted my mom to tell us what happened. That was all. What happened? We did not think that she harmed Marley intentionally, but learning about the multiple lies she told to get Marley to her house for a visit, and her unwillingness to cooperate with the investigators, made me question everything. The fact that my mom had been abusive and violent with my sister and me and never took full responsibility for it made it worse. But that was a long time ago. She was younger then. She seemed to have mellowed toward us. I knew from firsthand experience that my mom had been capable of a lot, but it seemed as though she had changed in my absence.

After Marley's memorial service, all the friends and family who had put their lives on hold to support us needed to get back to their beckoning families, jobs, and homes. When the people who have been providing you comfort leave, when they have done all they can to transition your mourning, the house groans, and you begin to wilt like a daisy once full and bursting in dappled light but now past its prime, unable to soak up any more nutrients. Family gone, best of friends gone, and all we had left was way too much food we'd never eat and way too much empty house we'd never fill, with reminders of Marley everywhere.

Simple, inanimate objects can bring as much pain as the sight of

a toddler prancing on a bay at sunset. The kitchen table where she watched you from her chair and ate her first solid food. Her new backpack in the corner. Marley's room became a temple. I could still feel her there, almost see her, almost hear her laughing. I could smell her in the bedding and on unwashed clothes. I would find Stacey in Marley's room, sitting in the chair she nursed her from and staring out a window with the curtains drawn, crying. She would hug her arms to her body like she was holding Marley, but there were only fragile memories left to cradle.

We had a week or so before Chloe and Mazzy returned from visiting their dad, so we fled back to the sanctuary of the Upper Peninsula. Petoskey had given us some solace from crashing waves of despair, but I wanted to go farther north and gaze at that inland ocean, Lake Superior. There was such unbearable sadness in our little house. We needed the big outdoors. We needed sand and expanses; horizons of eternal summer much different from our own. We needed wooded hills and some time to stick our feet in the water, feel the breeze off the lake, chase sunsets, and sleep under the starry sky. Without hesitation, we packed the cooler and truck and headed north, always north, to find some relief.

Jumping on 31 North in Holland, we buzzed past Traverse City and Petoskey and merged onto 75 North and the Mackinac Bridge. As we came off the bridge over the Mackinac Straits, we both breathed a sigh of relief to be off the gently rocking bridge and back in the Upper Peninsula. It was late in the day and the sun was starting to angle its way toward the horizon. Our first stop was the mouth of the Two Hearted River, where we camped for the night. Passing through Newberry, I wondered if maybe a stay at the old state mental hospital might provide more adequate accommodations for me, though.

The next day, we ventured over to Grand Marais for a beer at the Dunes Saloon before heading to Pictured Rocks so we could hike

the lakeshore to Au Sable Point. From there, we ventured through Munising and Marquette over to Baraga and camped for a few days while we explored the Keweenaw Peninsula. Outside of L'Anse, there is an Anishinaabe cemetery of small cedar houses. We spent several hours there meandering and pausing to sit quietly and think about our Marley in the sanctuary of the Anishinaabe people, the Great Lakes' first Indigenous people. In Eagle Harbor, we watched the northern lights over Lake Superior while sitting on the beach. Which one of those rays of colorful lights was Marley? Farther west, we moved past Ontonagon and parked at the trailhead for the Porcupine Mountains for a long day hike with a view of Lake Superior.

Coming down the Porcupines, we were hot and sweaty from the effort and late-summer humidity. There was a beach right off the road near the trailhead. Raw emotion was welling up again, and tears began to sting my eyes and blur my vision while I spread out a beach blanket for us.

"I'm going to take a swim," I hollered toward Stacey as she came down the dune with our dog.

"Okay, be careful. Those waves look pretty ominous."

I had been admiring Lake Superior from the trail. I needed to dive in and submerge myself entirely. Not wanting Stacey to see me cry and make her cry, I waded into the vastness of Superior as unstoppable tears streamed down my face. Stepping deeper and deeper into the water, I had this vision of diving in behind the next big wave and letting Mother Nature wrap her loving arms around me—a big, watery hug. Maybe if I threw myself on the altar of despair, Mother Nature would feel sorry for me and heal me. I braced for the next rising wave, then dove in as it rolled over me. The water was cold against my hot, clammy skin. I heard the backlash of the wave underwater.

It felt good to have the water circulate in a rush over me. Under-

water, I was suspended, eyes closed, not breathing, not smelling, barely hearing, just hovering in fluid, knees pulled up in a fetal position. I felt at peace underwater, floating in a world I knew I couldn't stay in. I lingered there as long as I could before coming up for air. I wanted to stay there, at peace forever, and let the waves move my sadness where they pleased.

Standing up, I gasped for air and cleared my eyes in time to see a much bigger wave break on top of me. I turned away from it and was instantly slammed to the rocky bottom, where I was thrashed. I was violently tossed and bounced against the bottom several times like an out-of-control Cyr wheel. By the time I got my footing and stood up, another wave was coming at me, but I was ready for it. I crouched, keeping my weight on my feet, and let the wave roll over me. It pulled me off balance, but the water was soft and shallow behind the wave. I stood and walked to the shore where Stacey was sitting on the blanket with our dog.

My hands, my legs, my shoulder, and the middle of my back had taken hits. The bottom of Lake Superior isn't sandy like Lake Michigan. It is rocky in areas. In places, the lake floor seems like the surface of another planet welled up. The rocks have been smoothed over by time and currents, but they are still abrasive, underwater megaliths, unforgiving when the waves explode. I was bleeding from my elbow, both knees, and one ankle, with a nasty abrasion on my left shoulder from skidding across coarse rocks.

"Oh my god. What happened to you?" Stacey gasped seeing the watery blood, which looked worse than it was.

"I let Mother Nature wrap her loving arms around me," I laughed and whimpered, half out of breath.

"Yeah, it looks like it," Stacey said, trying not to smile. "Are you okay?"

"Don't I look healed?" I chuckled, holding out my arm while watery blood ran down my legs and onto the sand.

Stacey and I got good at finding places to explore around Keweenaw Peninsula. Where to camp, where to fish, where to hike, where to eat, and, most importantly, where to watch the sunset. There are many secluded stretches where we could sit silently with our German shepherd and watch the sun go down. I think we both felt closest to Marley during sunsets over a big lake. We sat silently on the beach, watching the sky change and the light in our lives fade like the evening's drowning sun. There were no words, so why try?

We had to say goodbye to the UP and pick up Chloe and Mazzy at the airport in Chicago. Their father, Robert, had been taking good care of them since he had to tell them the soul-sucking news. He made sure they went on horseback rides through the forest and mountains around Missoula and ate lots of ice cream. He made sure they had plenty of opportunities to talk and ask questions, but like the rest of us, they were broken and confused. The only question they had haunted us all: *What happened?* Now Stacey and I would walk them into their new lives without their baby sister.

When you don't see your children for a month, the first thing you notice is how much they have grown and changed, but when I saw Mazzy and Chloe at the airport, they looked smaller, more childlike, and so incredibly innocent. They hugged Stacey and immediately began to cry. This was so fucked up and unfair. They had kissed the baby sister they loved so much goodbye, expecting to see her a few weeks later, only to have her die while they were gone. Their young eyes were too full of sadness for their ages. Seeing them so heartbroken with Stacey tore another gash in my soul.

Wounded, yet together, we headed home to a house bereft of Marley, with constant reminders of her absence in every room and nook. Her toys, her food, her clothes, her room—everything was still there except her. After staring at the baby monitor for a few days, I finally unplugged it and threw it away. It would never broadcast her sweet voice again. We used to gather around it and laugh,

listening to Marley wake up. She would wake up happy, cooing and saying made-up words to herself. I loved hearing her wake up talking to herself. Now that was gone forever.

Everything was a reminder of how much she was there and how much she was gone. I would find Marley's clothes randomly in the laundry for months. I folded and tried to pair socks, but it was only going through motions. What are you supposed to do? Everywhere there are constant reminders your child is gone and never coming back. I kept thinking of the last time I saw her alive, lying in her pack and play, sleeping like an angel. Then, the memory of her on the hospital gurney, ashen and lifeless, would sear my vision while I wondered what to do with the open baby formula we didn't need anymore.

Watching the girls walk by Marley's empty room—a place previously a hub of laughter and happiness—was more than Stacey and I could take. We decided to rent an RV and take the girls north to the one place that offered us some respite. We were going back to the UP to explore, camp, and swim in Lake Superior again before the girls had to be back in school. None of us wanted to be in the house missing Marley, and open spaces and adventure were a good distraction for sore hearts. So off we went in a rented RV with a fake dog looking out a fake window on the side.

We took the girls to some of the same places we had visited a few weeks prior. Pictured Rocks, Grand Marais, and to our new favorite spot, Eagle Harbor, in the Keweenaw Peninsula. There we rented sea kayaks and paddled into the harbor. It was good to see the girls smile and laugh in the sunshine. I was so worried that joy had been taken from them. Their laughter gave me hope that they would be okay. We made no plans and let each day take us where it would as long as there was a beach and campground nearby. Every evening, we sought out a good beach for sunset and our visit with Marley.

The girls saw the deep stillness inside their mother while she stared

off into the sun setting over Superior, and they sat near her, patiently waiting for the last rays on the water. These days had no clock, no schedule, but following only the path of the sun. We ate whatever we wanted, whenever we wanted. We swam, hiked, napped, and talked. Our time together yet apart from the world was drawing to a close. The water was getting colder, the nights were getting chillier, and the days were getting shorter. We watched summer slip away but clung hard to it, not wanting to return to reality. But the calendar and obligations pulled us back to the mainland. The girls had school, and Stacey and I needed to get back to work.

I felt anxiety building the minute we drove south off the Mackinac Bridge and hooked it back on 31 South. Neither Stacey nor I wanted to face what we knew lay at home for us, so we squeezed out one more beach day at Sleeping Bear Dunes near Traverse City before the final stretch home to Holland. Our daughter was dead, and my mom was involved and possibly facing charges. We were in no hurry to get back and resume our newly wrecked life.

Once we arrived home and helped the girls back into school, Stacey went back to work, and I restarted my painting business that had been put on hold for nearly two months. Those first few weeks back were especially difficult for all of us. The very first thing the girls used to do upon returning home from school was to find Marley and play with her. Now they went to their rooms in silence. Even though Stacey and I had numerous conversations with them and made sure to give them the love and space to talk about Marley and her death, I couldn't imagine how they felt. Children are resilient, though, and they jumped into school, activities, and friends. Nonetheless, I wondered if they were keeping busy to hide from the sadness no child should have to shoulder. Some days, I could barely look at them without tearing up. I could not believe I had trusted my mom, and this was the result.

I was drinking from a cocktail of sadness and guilt from almost

the minute I woke each day. I needed to speak to my mom. I needed to know what happened so I could explain this to my family and stop beating myself up. But every time I called and asked to speak to her, my stepdad told me that she was in no shape to speak, that she couldn't remember what happened. Then my stepdad said their attorney had advised them not to speak about it, as detectives were now going to ask for a grand jury investigation into Marley's death.

Although communication with my mom had been cut off when she lawyered up, there was a part of me that ached for what she must be feeling. I did not think that she purposely hurt her only granddaughter. Yet we had learned that she had lied to us about a number of really important things, and now her behavior since Marley's death had become increasingly bizarre. My mind was a swirl of never-ending confusion and obsession. If my mom had nothing to do with this, then I felt horrible even considering that she could be to blame; however, if she did have something to do with it, then what? How could she not talk to us about this and alleviate at least one element of our torture?

The ripple effect of the tragedy extended to all of Stacey's family as well as the rest of mine. Their precious baby granddaughter, great-granddaughter, niece, cousin was gone from them forever, too. Everyone was beside themselves with grief and anger as they, too, were deprived of the truth. This was bad all the way around and consumed my waking thoughts. I lay in bed most nights replaying the events of that horrific day. My emotions and imagination ran wild. Vignettes of Marley at the beach and trying to make sense of the evidence at the scene juxtaposed against my mom's stories consumed me for hours on end. Sometimes night turned into morning as I heard birds singing and realized that I had lain awake all night trying to make sense of this completely incomprehensible mess.

I was starting to unravel. Stacey made a doctor's appointment for me. After hearing the horrible details (he had already read about

it in the newspaper), my physician, like everyone, offered his sincer-est condolences with a tear in his eye and a prescription pad in his hand. He diagnosed me with PTSD and started me on a regimen of antidepressants, antianxiety meds, and a sleep aid. I told him that I had been feeling suicidal and was seeing a therapist at Holland Hospice. But outside of some grief counseling that Stacey and I had received right after the cataclysmic blow, I wasn't doing much for the trauma except drinking. He issued a stern warning against con-suming any alcohol in combination with these powerful opioids.

Stacey and I were hopeful these professionally prescribed ben-zodiazepines would take enough of the edge off to curb alcohol cravings, get some rest, which I hadn't had in weeks, and keep me mentally stable enough to paint and deal with the ongoing investi-gation. I felt guilty that my well-being was drawing attention. I did not deserve to be freed from the misery. It was now my lot, and I had brought it on myself. There was no atonement for me this side of the grave. I had one job as a dad—protecting my girls—and I had failed.

11

Closing the Hoop

Broad snowflakes descended across the Bear Creek Valley as if they were semi-impervious to gravity, while gently blanketing the Forest Service road and mixed conifers along the creek bottom. The quarter-size flakes glided down waifishly from an oyster-bisque sky that had parked itself over Yellowstone for three days. The world was a snow globe, but it wasn't the best snow for tracking lions, so I was plodding along our Forest Service road in my own world, trying to pinpoint one individual snowflake high in the flat, gray light, and follow it all the way down to an intersection with my tongue.

"You from around here?"

"Yes," I said without making eye contact.

"You look like you're on a mission," the disembodied voice said over the exhaust smoke.

A truck had snuck up the secluded mountain road toward me. Usually, I tried to jump off the dirt road on the lee side where there was a steep downward slope before anyone could see me. Ghost in. Ghost out. Just like the mountain lions I was tracking. The truck slackened right where I needed to step downward off the vertical

side of the road. I kept staring at my feet and measured gait. The truck eventually slowed next to me, and I heard the window go down. I instantly wished I had brought earbuds so I could politely nod and shrug, then pretend whoever it was didn't exist.

"Kinda," I said. It was easy to forget when people saw me in boots, Yaktrax, gaiters, binoculars, a big backpack with a tripod strapped to it, trekking poles, and the big-mama can of bear spray on my chest in winter next to Yellowstone—they assumed I might be a wildlife biologist whose wages they pay, instead of a civilian trying to outrun depression and addiction in the wild.

"With all that gear, it appears you might be heading out there to look for something."

When the orphaned grizzly bear cubs were killed, tracking mountain lions in one of their densest populations in the Lower 48 became my AA meetings. Now just over one hundred days without a drink, I was white-knuckling sobriety and losing my grip. There was alcohol at home. There was alcohol at work. There was alcohol at the gas station and in my dreams. I went wild instead. Despite weeks of hard-core tracking, lots of waiting, and getting close several times, I still hadn't set eyes on a mountain lion as a sober tracker.

"Yep," I sighed, finally looking over at his truck keeping pace with me. He was an elderly gentleman with wispy white hair, blue eyes, and a face creased by too much exposure.

"Can I ask what you're looking for, then?"

"Myself."

He gave me the glint and nod of a man who has spent time alone in the wild. I gave him the glance of a man who needed it. I knew from his crooked smile that he wouldn't ask me any more questions.

"Good luck, son." He chuckled and drove away.

The first step off the road went straight down, and so did I, falling hard when a snow-covered rock I stepped on rolled out from underneath me. I twisted my ankle and smashed my knee on another

jagged rock buried under the snow as I tumbled down the hill be-
tween fir trees. So much for entering the china shop gracefully. Even
the black-billed magpies, who look like Montana macaws with their
exaggerated tail feathers, seemed to be laughing at me. "There, we
got that out of the way," I joked to myself, realigning my backpack
and picking prickly pear needles out of my scraped hands. Then, in
the distance, I heard several Clark's nutcrackers making alarm calls
from the mixed conifer forest down by the creek. I was used to the
birds alerting on me as I entered the woods, but this was intense
and too far away to be for me. It was mountain lion–hunting sea-
son in Montana, and the quota for my neighborhood had not been
filled. I'd recently seen several houndsmen and hounds on my trail
cameras. A few had even tried to pry my camera loose.

Every time houndsmen run their dogs chasing mountain li-
ons up the drainages adjacent to Yellowstone Park, it creates a gi-
ant wildlife plow. A pack of hounds barking and baying their way,
hot on the trail, is a sound and sight to behold. But the ecological
fallout of displacing everything from deer, fox, and elk to squirrels
and birds during the hardest time of year was very noticeable for
anyone who spent any time there. And I spent lots of time there.
I could have been blindfolded and dropped off on the flats above
the canyon and told you within a few minutes if hounds had re-
cently been through the area. It would be devoid of some birds as
they tried to find each other again to regroup, and any tracks in the
snow would be that of animals moving quickly out of the way. It's
hard to explain. The land had a different feel after a major disrup-
tion had moved through and before it had settled back down. An
area typically rich with wildlife would look more like a stand of
English woods with nary a rabbit until it backfilled with its recently
displaced inhabitants. I figured this is what the Clark's nutcrackers
and Steller's jays were alarming on and strained my good ear into
the wind for the faint bawl of a hound.

Dropping into the meadow above the creek where the juniper and cedar turned to pine, spruce, and fir, the untrodden snow was knee-deep, making the going instantly more arduous. "Only a few hundred yards of this," I huffed. "Then I'll hit the tree-lined creek, where there'll be less snow and I can grab a game trail, taking it all the way to the mouth of the canyon." It was bullshit, and I knew it, but setting goals helped the mind when the body didn't want to cooperate. Nearing the gurgling creek covered mostly in snow and ice, I cocked my good ear into the wind and closed my eyes.

Once again, I could barely hear birds on the wind alarming at something in the distance, but I still heard no hounds, nor the flurry of fleeing wildlife activity that surrounds them. The area was also popular with winter hikers who brought their pet dogs, and trappers who brought archaic brutality, so I figured the birds were bitching about one of them. Downstream toward the noise was the way I needed to go, so I pulled my hood up and readied myself to put out the unapproachable weirdo vibe in case my path crossed with whoever's.

A quarter mile down a game trail that paralleled the frozen creek, a familiar-looking set of linear holes in the snow came down the open hill like a bouncing snowball and intersected with the trail ahead of me. Could it be? Picking up my pace, I knew before I got there it was a fresh set of mountain lion tracks. Nothing else had that cadence and clean punch into the snow with no toe drag.

Examining the tracks where they met the game trail, it appeared to be the young male lion whose days-old tracks I had been following the previous day—five miles away. The clean snow and slightly warming temperatures coupled with the cover of the trees were ideal conditions for preserving tracks—and these were very fresh. How fresh? I couldn't be sure. I'd been doing this a while and had seen my share of tracks in all kinds of stages. But I wasn't one of those guys who could tell you how much change the lion had in

his pocket. Falling on my knees, I examined the tracks like they held the key to my existence. I studied the chunky toe shapes, pad depressions, and completely intact ridges in between them. I put my thumb over the grape-shaped toes to compare sizes and then pressed my hand into the cold, clean snow next to a track for scale.

Kneeling in the snow, I closed my eyes again and listened. On the icy breeze that howled out of Yellowstone and up the creek bottom, I could hear the shrill chastisement of nutcrackers and jays as they followed something—alarming the whole way. Even though I was crouched over fresh mountain lion tracks, I slowed my breathing and remembered that these tracks could mean nothing. Too many times in the wild I had raced ahead, thinking I had the puzzle figured out, only to be reminded that we had been kicked out of the Garden of Eden long ago. Hubris in predator-rich country could result in an asterisk by your name in science journals and a generic obituary. Just because there were melting lion tracks trotting down the path in front of me and birds going crazy didn't mean I should race toward the commotion. There could be other predators afoot or hazards I would fail to see in my tunnel-vision pursuit of a grand delusion.

A few hundred yards up the trail, I saw my first gray flash of a Clark's nutcracker dart from one fir tree to another while looking down and alarming. Peering over the edge of a small bump looking down toward where I had now seen two Clark's nutcrackers dart and alarm, I saw the tawny coat of something that didn't fit the landscape in shape or color. The lion was seventy feet down a gully, crouching next to some snow-covered willows, drinking from the creek at one of the few open spots. He was leaning forward with his rear end slightly raised, lapping water, which forced his shoulder blades high and together. The minor balancing act caused ripped muscles to twitch under velvety skin around his shoulders and haunches. I froze in my tracks. The end of his tail seemed to flick

involuntarily a few times like it was chasing off flies that weren't there. Then, before I could drop to the ground out of sight to get my camera ready, a bird noticed me and let out a different alarm call.

I was busted by the majestically crested mouth of a Steller's jay. The lion turned and looked right at me. Direct eye contact. Nothing in between us except anticipation. He was an easy few lunges away and looked a little surprised—but mostly annoyed—by it. I stood there breathless, feeling foolish and exposed as this square-jawed male lion sized me up. Breaking the quick staring match by looking up, the cat jumped from his watering perch and over some thickets toward higher ground. In two easy leaps, he was at the same elevation as I was, approximately sixty feet away. He paused before slowly turning and ambling away down the same game trail without a care in the world. The last thing I saw was the black tip of his tail as he crested the hill and dropped over the other side. He never looked back—not once. He just slowly walked away, sauntering like he was bored and leaving anyway. I later read about lions doing that with researchers. They are so unimpressed with our species, it's a waste of their valuable resources to even acknowledge us. Next to my griz encounter, it remains today as one of the single greatest solo wildlife adventures of my life. Even if it meant nothing to the lion.

The parting glance from the lion as he disappeared over the hill had a distinct air of "don't follow me anymore, picture boy," so I left him alone and began the long hike home in tracker bliss—that is, until my mind drifted to the recently released *USGS Grizzly Bear Mortality Report* for 2018 that had documented the orphans' killings—their only obituary. Here we had learned they were both females, sisters, and not the brother and sister I had wrongly assumed. I also learned the State of Montana killed the first orphan on my thirty-day sobriety anniversary. While I was celebrating sobriety with tacos, so proud of myself, an orphaned sister was in a culvert trap, terrified and separated from her sibling, preparing to

die alone. The bears we had refused to name because Peacock insisted that naming them deprives them of their wildness had been named by the state. The USGS mortality report for 2018 now included grizzly bears 44 and 46, subadult females, who were trapped in the Yellowstone River region and killed on October 4 and October 16, respectively. Their lives were over, but their story was just beginning.

Even though the killing of the orphans was a crushing blow, and while I ranted and raged, I did not drink. This time, the killing of something I loved so dearly would not destroy me. This time, it would galvanize me. I was done whimpering in the dirt. Alcohol sought to plunder me in the cabin, but I was already in the hills. Depression tried to keep up but was suffocated in the higher elevations I retreated to. The wild was creeping in. Even though I sat under the same Douglas fir tree day after day, misery couldn't unearth me in the mountains. I wanted to experience the magic left by the Sheepeaters high on the cliff bands where only mountain lions dare lie up, for these were the cathedrals in which I felt closest to Marley and the memory of the orphans. I expanded my lungs and heart with as much wind and wild as I could handle, hiking endlessly, farther and farther each time until my knees felt like they would lock up.

My rescued miners' cabin, which had once doubled as a mountain asylum where I passed out blotto to Alice Cooper's "Welcome to My Nightmare," became a place of quiet reflection. The rough timbers became my command center for backpacks, commissioned from dusty hooks and boots freshly laced and polished. I meditated, prayed, burned sage, jumped rope, marked up maps, and packed and repacked inside my reborn sanctuary of timber in preparation for my first season tracking mountain lions sober.

There were many days the sight of my boots and backpack made me want to toss them burning into a bottomless ravine, and slide back into the easy, liquid ways of alcoholism. Drinking meant numbing and not dealing: a tuned fiddle for me. Getting outside

meant dragging my depressed and slouching ass off the couch and lacing up still-wet boots around sore feet for another seeming death march into the void. But there was a subtle change in me each time I ventured out. Not a landslide of glaring proportion but an ever-so-delicate geological shift. Each set of mountain lion tracks I followed in the fresh falling snow led to somewhere within me. Every painful footfall was a step in the right direction, even if it led to nowhere. The wild was creeping back in.

There was a peace and calmness in wilderness I had sought out even in my youth. I fled the violence and abuse of my Indiana home for the altar and stillness of woods and water. Now with a sober mind, body, and spirit, for the first time since adolescence, I felt like that kid in the woods again. This time, however, instead of collecting rocks and feathers, frogs and snakes, I collected lessons. I took stock of how an urge to drink left unattended remained an urge to drink, but an urge to drink treated to a brisk uphill hike seemed to get lost along the way. I watched the animals lead incredibly difficult and oftentimes traumatic lives, but they persevered with only the wind to complain to. I filled metaphysical vials with these wild medicinal tinctures for later use when I couldn't be seated on a glacial erratic overlooking the Lamar Valley. The wild was creeping in, and I finally opened myself up to it with everything I had.

There was no manual for what I blindly grasped my way through. I was making it up as I went and not even sure if it was working. I was running purely on instinct and doing my best to shut down all internal dialogue along the trail, leaving room for visions of Marley and the orphans. There were bouts of depression so severe my whole body ached for a good drunk, but every time I felt the urge to drink, I leaned into the lessons I was learning in the wild and my vow to Marley. I snowshoed onto spring bluffs overlooking the remnants of a once-mighty bison herd and watched them face into the oncoming storm. I crouched in a thicket of red willows, witnessing

a mother grizzly bear hunt elk calves in the silvery sagebrush-covered hills under a rainbow, while lightning spider-webbed the sky and rain soaked me from head to toe. Leaning back against a boulder, I watched a newborn elk calf get swept away from its mother in the swift, cold current of the Yellowstone River. Just like that, her child was gone in a torrent of cutting water. Mom became frantic, racing back and forth on the opposite bank where her calf should be coming out. She pounded the earth with her hooves and, wide-eyed, let out a series of heartbreaking, unanswered calls for her baby. I knew her pain and cried in unison until she was forced to rejoin the herd and keep moving. There were lessons in the wild, and some were very cruel, but Mother Nature was honest, and that was something that had been missing from my life for a long time.

Through a process of living consciously and seeking out the wonderment of every day in nature, I was reborn into the wild, baptized and anointed under Ursa Major, the greater she-bear of the night sky. I actively and repeatedly sought wilderness and its beauty. Not necessarily the esoteric expression of gallery pieces but flashes of awe while merely sitting still long enough for the birds to go back to what they were doing. Fully engaged in this discipline, I became more aware of my surroundings and, more importantly, my place in the natural order of existence. While leaning against my Douglas fir tree, listening to the chickadees tweet everyone who spoke chickadee, something was moving in the creek bottom. I noticed there was a certain blue sky over Yellowstone that was the exact shade of Marley's eyes. For the first time in a very long time, I felt like I had found my groove, and the blue sky in Marley's eyes was my impetus to never give up.

On a frigid, wind-carved bighorn sheep game trail high above the black canyon where the junipers hang on for dear life, while following another set of big tom lion tracks in the recent snow, I renewed my vows before Marley and the first stars of evening. Not only would

I stay sober, I would also tell our story of salvation. We would protect what had saved us and share the polychromatic love that was all around us. No more pills, no more booze, no more lies, no more bullshit. We were going to accept the gifts being offered to me: to live courageously and consciously, existing only in these fleeting moments of love and compassion. If I was going to take the lead and finally heal myself, I needed to own my emotional landscape like the grizzly bear owns the meadow. I needed to be fearless and honest with myself, to live as a warrior. Like the reverential bull bison, I would turn into the approaching storm and not run from it anymore, thus depriving it of its ferocity.

Along with the anger and hurt, I left any animosity for my mother to fend for itself out in the wilderness, too. One sage bit of advice my psychoanalyst had offered was to evict my mom from my mental space if she wasn't going to pay rent. In other words, if she wasn't going to ever tell us what happened to Marley, how she died, why she died, or hold herself accountable for the ultimate betrayal, then she was the equivalent of an indigent tenant who was trespassing. Notice served. Like the cow elk who lost her precious, bespeckled calf to a frigid river crossing, sometimes, when we have done all we can do, having stomped and snorted, pounding the earth in denial, we must rejoin the herd—and the moment—lest we lose them, too. These were the lessons I was learning in the wild, and I filled my heart with a newfound love and respect for everything around me, including myself.

This was the true gift of the natural world I was spending so much time in. To finally feel like I wasn't alone anymore. Every time I ventured out with unruffled intentions, sober in body, mind, and spirit, a new, luminous connection was being formed. Or maybe it was cosmic tethers that had always been there. They just needed a rude shake-up to knock the dust off and help me feel them again. And feel them I did.

More than once, I would be clumsily plodding along, trying to out-hike addiction, feeling so broken and alone along the trail, then something would happen. Something unplanned yet as necessary as breathing. My ears would start to buzz like cicadas, and I would feel an electricity in the air. I could smell each individual pine needle I was stepping on. I would get the feeling like I was being watched—but not in a creepy way. More that everything around me—trees, rocks, juniper, and all wildlife, especially the birds—knew me, and I knew them. Like I belonged there and we had done this before. I was finally home among my kin.

Shortly after Marley's death, I avoided REM sleep because I feared my dreams. There was no break-off point between my waking life and the horrors I relived every night. There seemed to be no escaping the theater of loss.

One particular morning, I woke early from another terrible nightmare where I walked out of our house in Waukazoo Woods on a morning stroll, like I would do with Marley, but there was no Marley. I was alone, and it hurt like hell. Then I noticed our wooded neighborhood was oddly quiet. I continued to walk and weep in my dream until I couldn't take the silence anymore. Then I noticed it was the birds—or their absence, more precisely—that made everything so quiet. Our neighborhood typically bustled with robins, woodpeckers, owls, chickadees, and numerous other songbirds, but on this morning walk without Marley, there were no birds or birdsong.

The earth was completely hushed. Not even the ever-present wind off Lake Michigan blew through the giant beechwood trees. I scanned and scanned the skies and shrubs for any signs of feathered life, but I could not see or hear any birds anywhere. Dreamily, I checked the always-reliable lilac and forsythia hedges for little brown birds bustling about, but it was dead air. There were no squirrels, deer, or even mosquitos in the densely wooded lots. The

lonely revelation settled over me that I was the only living being in a wasteland, as I began to trot and panic, trying to find one other living creature in my neighborhood. It was the loneliest I had ever felt in my life.

I buried that dream deep inside of me and poured vodka on it to keep it woozy, until one boring day along the trail, my subconscious decided it was time to deal with it.

A flock of cedar waxwings flew in, moving in striking unison and calling, from juniper to cedar trees. They seemed to be following me and only emitted their collective high-pitched *bzeee* sound while in flight. Their movements were entrancing, and I began to "feel" their calls. For the first time in years, I remembered that terrible dream of a world without Marley and birds. I immediately began to cry with tears of gratitude for this flock of cedar waxwings I was sharing a gulley with. They were the most beautiful birds I had ever seen in my life. I closed my eyes and listened to their buzzing song that sounded more like a flock of giant bees, until it trailed off in circular divinations somewhere down the ravine. A strange yet calm sentiment settled over. That flock of waxwings had flown off with my deep-rooted and painful memory, replacing it with a higher vibration of love and gratitude. I felt like I was right where I was supposed to be—alive and in the wild.

It got so that I felt more at home crawling over and under deadfall pine trees than I did sitting in my living room. Nature had become a most gracious hospice. She asked nothing of me except to be present, and in return, nature reminded me I was always home and always had a home. That wherever I went, if there was dirt underfoot, I was home. Home in the mountains. Home in the cities. Home within myself. Wherever my feet touched the earth—I was home.

But that was the easy part. The hard part came when I finally had to lie down with my irreversible pain and grief. I had already quit

numbing my agony with alcohol. But like in AA, they say recovery is the opposite of surgery. In recovery, first we remove the anesthesia, and then we start cutting. Now, with the luxury of anesthesia removed, I was feeling everything, some of it for the first time, and hiking harder and harder trying to outrun these new, big feelings.

I had to embrace the grief. To understand I would never understand what happened to Marley that fateful day at my mom's house and somehow be okay with it. To finally come to terms with the fact that the loss of a child never heals—it just doesn't. I had to walk hundreds of miles and spend hundreds of hours far away from people to let that one sink in. I had to take a hard look at that place inside a daddy that he holds for his daughter. That part inside of me that had been mangled beyond recognition. So I began field surgery on it, trying to put the pieces back together again and save what wasn't maggot-filled. Without the aid of drugs, alcohol, self-loathing, or compartmentalizing, I rolled my sleeves up and started cutting away what wasn't serving me anymore.

I had to learn what true monastic suffering was, sober-style. Before we lost Marley, I thought a serious bout of food poisoning, being way too cold, or going without love was suffering. These are discomforts. Most of life's agonies are mere discomforts that resolve themselves in time. But true suffering in a healthy place is vital to recovery when the wound is so deep and permanent there is no escape. I had to come to terms that some lingering shreds of suffering and I were now lifelong mates, so let's make the best of this. Let's get to know each other and try to work together for the betterment of Brad. Let's make Marley proud as Old Horn had prophesized.

After years of searching for either external validation or internal annihilation, I began to settle within myself. I had vigorously sought therapy, drugs, alcohol, grizzlies, healers, lions, books, psychedelics, and all the way to the bone psychosis to try to cope with losing Marley. When in fact the only knowledge I needed was

already stored inside of me. The suffering had woken it up. I had to go without to go within. I was entering into an autogenous state of self-transcendence without my knowledge.

I became self-reliant; realizing that all the medicine I'd ever needed was already hardwired within me. Dedicated time in nature gave me access to the healing and agency over my predicament. However, typical to my childlike nature, I was taking the long way home—even in healing. I was a little late and my new jeans were ripped, but I had pockets full of stories with the dried blood to prove where I'd been.

I'd like to think that it was innate wisdom that propelled me out of doors, but banal despair might be more accurate. Either way, the only thing that made me feel any better for any amount of time was being out in nature. Out there, I was alone, but never lonely. I had a mother, Mother Earth, plus the birds to remind me of Marley and the wind to keep me company. Sitting next to Bear Creek with the cold spring runoff gurgling past from somewhere high in the Absaroka Mountains, there was a growing comfort in knowing that I was part of this Great Mystery that had swallowed Marley up. The equanimity came in knowing that the same Great Mystery would in due time swallow me up, too.

My Native friend says there are no goodbyes when someone dies. That soon enough we will light our own fires and join them across the stars. Sticking my feet in the icy creek, I leaned back, smiling, contemplating a cosmic homecoming, and closed my eyes in the warm sunshine.

BREATHE

A cool breeze comes out of the Snake River floodplain, ripping through Yellowstone Park and up my back. A good reminder that it could snow in Yellowstone any day of the year. I dig past a sandwich and my extra bear spray to retrieve a jacket from the bottom of my Mystery Ranch backpack. I'm reminded that *backpack* and *Jack* were two of Marley's first attempts at words. Spending so much time in cat country, I immediately feel icky bending over, exposing my back and neck in the wild—an open invitation to a mountain lion. Out of habit, I do a quick 360-degree scan to make sure I'm still alone—mostly.

But this time, I'm not in the myopic claustrophobia of cliff walls, canyon juniper, and mixed conifers home to *Puma concolor*. My views today are wide open across blue-green glacial basins to the mountains. A sea of sagebrush drops off from either side of the morainal ridge I'm hiking up onto. The snowy granite peaks to the west look like old women praying over a braided creek that chugs and dins all the way to the Gulf of Mexico—a long way from Yellowstone. There are elk in the rich valley below. Their slick tan summer coats look shiny when the morning sun hits them just right.

A frumpy bachelor herd of bull bison lies woolly and heavy-eyed on this same ridge, snoozing in the intermittent sunlight.

I'm in grizzly country. Back on Swan Lake where it all started in 2012 when a grizzly bear changed my mind about wanting to die. I wish I could say that I was instantly better, but that was the beginning of my journey—not the end.

I've had to learn to trust that journey once again. Going back to the mountains and rivers to now navigate divorce in the wild, shorn of cold beer or prescriptions.

Sadly, in 2020, just after the ten-year anniversary of Marley's death, Stacey and I decided to divorce and go our separate ways in life. The statistics for marriages surviving the death of a child are not good, but I truly hoped we had made it. Sometimes it seems like as one dark cloud rolls out, another one rolls in right behind it. But I've been through enough weather to know there will be a lot of blue skies and rainbows for both of us in between those storm clouds. Stacey will always be Marley's mommy, and my love for them both is as undying and interconnected as the multiverse it was born of. Someday we will both follow Marley's bread crumbs across the Milky Way and all be together again.

I will never forget the first time I saw Stacey with my fresh flowers and Baconator breath. In my mind's eye, where love casts a warm light, she was glowing that first date night, literally glowing with a halo of Rembrandt light all around her. Or the Earth Day evening at Holland Hospital in 2009, with that same glow, when Marley was born during a light rain while Charles Mingus played softly in the background. Or at Wonderland, a calm oasis in the madness. These golden memories of Stacey, along with countless others of a wounded family doing the best they could, are all that remain. That's why they are so cherished and valuable. I can only pray old age will let me slip through with the best ones still intact.

* * *

Cresting the fir-and-pine-pocketed ridge, I surprise a red squirrel who is working his way up a lodgepole pine tree. He immediately turns upside down and shrieks out his *cheat cheat cheat* alarm call at me, letting the whole wild world know I'm almost to my sit spot. I am told these red squirrels have two different alarm calls. One for aerial predators and one for terrestrial. His alarm on me is loud and severe since I startled him. Glassing the meadow for bears, I have to laugh at how persistent the squirrel is. He's like the town crier. Had I been tracking a mountain lion in the canyon, every animal for miles would know a flat-footed, uninvited intruder had entered the party. But today I smile at his enthusiasm and look for bear-shaped blobs among the shooting stars and glacier lilies high on my favorite southeast-facing slopes. I keep moving toward a small stand of trees next to a moss-and-lichen-covered glacial erratic boulder the mass of a full-size van. The perfect place to sit, watch, listen, and reflect for a little while.

One of our friends bought Marley *B Is for Bob,* a collection of Bob Marley songs, for her only Christmas. I used to love to put that in while driving and watch Marley dance in her car seat from the rearview mirror. I can still see the dappled light hitting her face, open windows blowing her first and only haircut around, with her two middle fingers in her mouth, and shoulder shaking it for all she was worth. After she died, I couldn't listen to Bob Marley anymore. Just one reggae backbeat and I was out of whatever room, store, or restaurant I was in, narrowly escaping a public meltdown. Thinking I could never listen to the music of peace, love, and joy again—the spirit of which was Marley's namesake—was just another punch to the gut in a seemingly endless supply of them.

While going through old totes a while back, I found that *B Is for*

Bob CD we used to play in the truck with Marley. Just holding it made me tremble—this was the last music I ever listened to with Marley before I dropped her off at her grandma's house. As much as I wanted to listen to the CD, I just wasn't ready, so I transferred it to the glove box for another time. I was still drinking then, and somehow it just didn't seem honorable to listen to Marley's music quite yet.

Native Americans say the grizzly bear was sent from the stars to keep men humble. I'm feeling that humility leaving my sit spot and hiking off the ridge through the Wyoming big sagebrush and petite yellow buttercups. Eye level with a prowling marsh hawk, my mind is sharp and senses keen from an open-air afternoon.

Eventually, I had to come to realize it wasn't the bears, the wolves, the lions, the beauty, or the horrors of Yellowstone that saved me—it was love. Love for me. Love for you. A love for the infinite web of life we are all an inextricable part of, and my place in it. We are all bits of assembled stardust, and everywhere the grizzly bear walks is hallowed ground. Every time my feet share that ground, I am filled with a sense of awe and feel Marley right there with me. All is right—if just for a moment. I pause to thank the spirits for the love all around me.

This is the gift of the grizzly. To be whole and fully aware of not only yourself but your surroundings and your natural place in the order of things. Being responsible in grizzly country means being hyper-focused and very present with your head on a swivel. To someone whose brain is constantly oscillating between the horrors of the past or dread of the future, this is the greatest endowment. To be present only in the moment. Aware of shifting winds, keyed into birdsong, mindful and upright, is how I learned to move through grizzly country and trauma simultaneously.

Bushwhacking off the ridge and back down into the valley, I pause to breathe deeply and take it all in. My Crow family also taught me

not to hoard anything—especially medicine. So I catch a heavily scented game trail, heading toward my truck in the distance, and make plans in my head for a wilderness therapy institute. A pair of ravens fly over me and squawk loudly. I take it as a good omen.

As part of my continued recovery, I've been sharing my powerful journey with special-needs kids and wounded combat veterans, helping them connect with the healing in nature that nurtured me. I've seen firsthand the power of Mother Nature working wonders in both groups. Coming up on four years sober, I've made another promise to Marley and my Creator: to carry this message of love and hope to others. I tear up feeling the vibrations of wild country and awe all around me. The trees, the breeze, the red-winged blackbirds in the cattails all come alive and coalesce under the same light that shines behind the stars—the light behind the light. My clear vision is to share what worked for me in nature with others who are suffering so they don't have to go up the hard side of the mountain like I did.

Nearing my truck, I can see the wilderness therapy institute in my head as clear as a bell. A small working ranch with daily hikes, meditation, therapy sessions next to water, and group meals prepared and enjoyed together. We'll focus on the lessons from the wild that I had to learn the hard way, to expedite healing in others. It's coming full circle in recovery. But first things first.

There are some days that are still a challenge for me. Anniversaries and holidays can be especially difficult, but I worry about my girls more than myself these days. I had to accept that the pain of losing Marley never subsides. I lost several very close friends along the way, too, and that hurt like hell, but youth, then time smoothed the splintered edges. No passage of time or distraction will ever completely seal the wound from losing a child, no matter the age; it will seep

forever. I know a part of my heart flew away with Marley that day. It's okay, it was always hers anyway.

Maybe the difference is now I know pain is part of my burden to bear forever, so I throw it in the backpack like so many boat batteries and center its weight the best I can for another long haul up the mountain. A little weight helps me stay balanced knowing I need to live consciously and to actively seek out beauty every day.

I arrive at the parking pullout, slide my pack down, and start the process of delayering gear. First my binoculars, then my camera, bear spray, and knife go on the tailgate of the truck. I've worked up a pretty good sweat, so I strip off gaiters, boots, socks, pants, and coat. Sitting barefoot in my underwear and a hoodie on the tailgate of my truck, I dig out the sandwich, shorts, and water before leaving.

Sliding into the driver's seat, I start the truck and take a deep breath. Reaching into the bottom of the glove box, I fumble for what I know is there. The cracked jewel case feels rigid in my trembling hands. I can't quite bear to look at it yet, so I let my fingers do the work. Muscle memory kicks in, and the machine does the rest as I insert the CD. Instantly, there's the staccato backbeat I've missed for a decade, and "Three Little Birds" by Bob Marley comes to life in the truck. I put the windows down and the music up, cruising along Swan Lake Flats with Marley, once again into the great unknown.

Don't worry about a thing, cause every little thing
gonna be all right.
—BOB MARLEY

Acknowledgments

Seated at a sun-bleached picnic table in Paradise Valley, Montana, with the fabled Yellowstone River coursing in front of me like a blue-green artery between the Absaroka and Gallatin Mountain ranges, I can also see the snowy peaks of the Crazy Mountains to the north, where Chief Plenty Coups of the Apsáalooke (Crow) had his fateful vision. I am constantly reminded of those who came before me and their sacrifices. A red-tailed hawk circles high above me. Another reminder.

How could men like Sitting Bull, Crazy Horse, Black Elk, or Plenty Coups have had any idea how their sacred ways could help a broken, orphaned, non-Native kid from the Midwest 150 years later? One of my Native friends likes to remind me with a wink that "we are all tribal; some of us are just on other people's land."

Therefore, I would like to respectfully acknowledge the First Nation's men and women, and their tribes: Crow, Blackfeet, Bannock, Shoshoni, Arapaho, Lakota, Kiowa, and Cheyenne, among others, who are the first peoples to inhabit this region of the West I, too, call home today. Without the life lessons many of these Indigenous cultures shared with me so freely, I may not have been here today to share with others. Their ancient wisdom prevails if we will only listen, for we are all children of rock and wind. We are stardust.

I would also like to thank the drenching, cold rain that chilled me to the bone and ignited a fire within. Much appreciation to the warm mountain updrafts complete with butterflies that dried my tears in high-alpine meadows of lupine and larkspur. Cheers to glacial, erratic boulders I sat perched on, and every jagged rock I threw into Bear Creek with a guttural roar. Blessed be the bighorn sheep trails that connected me with mountain lion families, and the gnarly junipers growing straight out of volcanic rock that will outlive us all. Thank you, Mother Earth, for the love, the medicine, the lessons, and for always being there for me.

I would like to congratulate and extend an olive branch to the pain, horror, and absolute terror that shaped my agonizing odyssey home. Without you forcing me alone into the darkest corridors of my psyche, and ipso facto out into the American wild, I would have never known what I was truly made of. Trauma, depression, anxiety, and addiction: you have been worthy adversaries and have humbled me many times, teaching me everything about myself. Thank you.

I could not even begin to formulate a comprehensive list of recognition and gratitude to all of the individual family members, friends, and complete strangers who have helped me through my struggles to find some peace after losing Marley. Mine was a dangerous and heavy load to bear. So many loved ones did everything they could to share my pain with me, taking giant chunks with them. You know who you are, I know who you are, the Creator and Marley know who you are. Without you, there would be no me. I now carry a message of love, hope, and healing to others in service of you. This is my thank-you to all who took me in and kept me safe when I had no shelter from the storm.

To Marley, my sweet little blue-eyed angel who has made her presence known to me over the entire course of writing this memoir and, in fact, throughout my recovery: You've always had my heart and

gratitude. Thank you for all the late nights letting me read horrible sentences to you until they made sense. Papa loves you.

I will never forget the magic of softly backlit, late-summer evenings spent with two orphaned grizzly bear cubs, witnessing firsthand their courage to live free. The orphans were my accountability early in recovery, and I dug in for my life with the tenacity of a grizzly.

Thank you to my Creator, who also made their late-night divine presence known to me so many times as I struggled through the darkness to write this story of hope. You've always been there. I was just too broken to see it. Now I stand before you—sober, humble, and ready to share the message of love. Stay with me.

Finally, thank you to all who struggle, and fight, and fall, and get up, and do it again. It's an honor to share this good red road to recovery with you. We do get better. *Mitákuye Oyás'iŋ.*

<div align="right">
For Marley and the wild

Brad Orsted

Paradise Valley, MT

June 2022
</div>